MarcQuinn
Evolution

White Cube

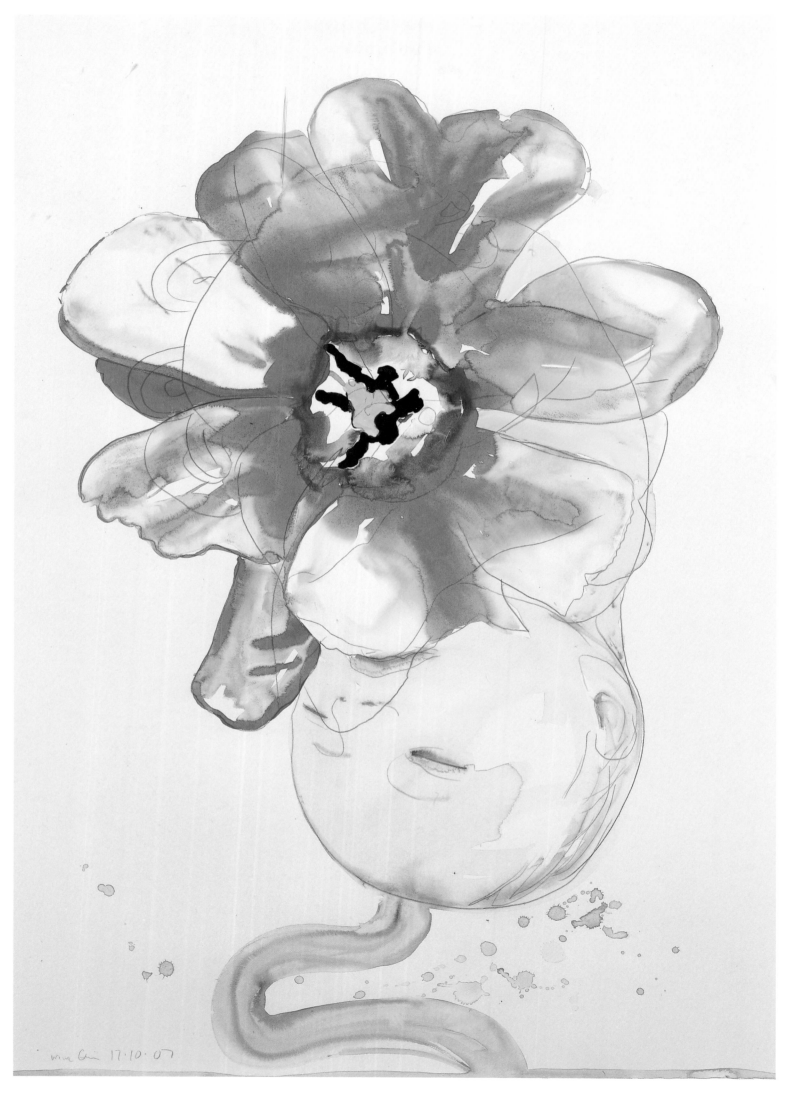

win Gin 17.10.07

From Flower to Foetus:
The Evolution of Marc Quinn

Jerry Brotton

The history of figurative western art since the Middle Ages is scattered with broken bodies in extreme states of ecstasy, pain and dissolution. The ultimate exploration and definition of the body, particularly in the sculptural tradition that runs through Michelangelo, Bernini and Rodin, is invariably defined through the plastic expression of the body pushed to its physical and emotional limits. Marc Quinn has certainly been here before, having drawn on this established artistic practice of tracing the boundaries of what it is to be human in a range of sculptures in different mediums. But with 'Evolution', his new series of ten marble sculptures of a foetus as it develops from a formless mass through to its imminent birth, Quinn makes a bold departure from his previous work – although these pieces evoke the traditional focus on the body in extremis, they also invert it.

In its content, Quinn's series invites inevitable comparison with Leonardo's anatomical drawings of foetuses, but more significantly they evoke Michelangelo's series of 'Slaves', composed in the 1520s for Pope Julius II's tomb in the Vatican. Pieces such as the so-called *Cross-Legged Slave*, now in the Galleria dell'Academia in Florence, were originally envisaged by Michelangelo as Titans, defeated in their rebellion against the classical gods and subjected to abject defeat and enslavement as they are literally ground back down into the earth. For Pope Julius, this was to be a fitting analogy for his own claims to have scourged Christendom of the theological rebellion of the heresy of Lutheranism; but for Michelangelo, the 'Slaves' represented an opportunity to lay bare the artistic process of the sculptor's struggle with the block. The 'Slaves' twist and turn, heroically resisting their imprisonment and inevitable dissolution, simultaneously struggling against and merging with the earth from which they came, and which now reclaims them. Michelangelo poses basic questions about what happens when art creates a version of life: at what point does the chisel and saw free the figure from the rock, yielding a recognisably living, sensual human form from the cold, inert marble? At the same time, the statues invite the question of when life finally leaves the dying slave, and when the human form returns to the inert matter from which it was born – when form and matter dissolve back into formlessness. The 'Slaves' ask us if their subjection means that they are 'alive' at all. If one definition of slavery is a life in death, where all the meaningful personal and social markers of humanity are denied an individual, then do these figures actually have a life?

In 'Evolution' Marc Quinn provocatively reverses Michelangelo's conceit, posing similar questions from the perspective of the beginning of life, rather than its end. Quinn's foetus reaches for liberation through constriction within the block as womb, working forwards from the state of the 'Slaves'. Where Michelangelo's figures struggle with their physical encumbrance and fade into the marble, Quinn's foetuses emerge from the block suspended and weightless, in direct inverse proportion to the mass of the 'Slaves'. Quinn's series brings Michelangelo's bodies full circle – the child is about to enter the world and be enslaved within culture, and continue the struggle in life that the 'Slaves' perform at the end of their existence. Moving from one piece to the next, Quinn asks us to identify at what point life enters the foetus. Is it there in the first piece, where the rudimentary formation of the brain stem and the spinal cord can be seen, or is it in one of the middle pieces, where

From Flower to Foetus:
The Evolution of Marc Quinn

Jerry Brotton

The history of figurative western art since the Middle Ages is scattered with broken bodies in extreme states of ecstasy, pain and dissolution. The ultimate exploration and definition of the body, particularly in the sculptural tradition that runs through Michelangelo, Bernini and Rodin, is invariably defined through the plastic expression of the body pushed to its physical and emotional limits. Marc Quinn has certainly been here before, having drawn on this established artistic practice of tracing the boundaries of what it is to be human in a range of sculptures in different mediums. But with 'Evolution', his new series of ten marble sculptures of a foetus as it develops from a formless mass through to its imminent birth, Quinn makes a bold departure from his previous work – although these pieces evoke the traditional focus on the body in extremis, they also invert it.

In its content, Quinn's series invites inevitable comparison with Leonardo's anatomical drawings of foetuses, but more significantly they evoke Michelangelo's series of 'Slaves', composed in the 1520s for Pope Julius II's tomb in the Vatican. Pieces such as the so-called *Cross-Legged Slave*, now in the Galleria dell'Academia in Florence, were originally envisaged by Michelangelo as Titans, defeated in their rebellion against the classical gods and subjected to abject defeat and enslavement as they are literally ground back down into the earth. For Pope Julius, this was to be a fitting analogy for his own claims to have scourged Christendom of the theological rebellion of the heresy of Lutheranism; but for Michelangelo, the 'Slaves' represented an opportunity to lay bare the artistic process of the sculptor's struggle with the block. The 'Slaves' twist and turn, heroically resisting their imprisonment and inevitable dissolution, simultaneously struggling against and merging with the earth from which they came, and which now reclaims them. Michelangelo poses basic questions about what happens when art creates a version of life: at what point does the chisel and saw free the figure from the rock, yielding a recognisably living, sensual human form from the cold, inert marble? At the same time, the statues invite the question of when life finally leaves the dying slave, and when the human form returns to the inert matter from which it was born – when form and matter dissolve back into formlessness. The 'Slaves' ask us if their subjection means that they are 'alive' at all. If one definition of slavery is a life in death, where all the meaningful personal and social markers of humanity are denied an individual, then do these figures actually have a life?

In 'Evolution' Marc Quinn provocatively reverses Michelangelo's conceit, posing similar questions from the perspective of the beginning of life, rather than its end. Quinn's foetus reaches for liberation through constriction within the block as womb, working forwards from the state of the 'Slaves'. Where Michelangelo's figures struggle with their physical encumbrance and fade into the marble, Quinn's foetuses emerge from the block suspended and weightless, in direct inverse proportion to the mass of the 'Slaves'. Quinn's series brings Michelangelo's bodies full circle – the child is about to enter the world and be enslaved within culture, and continue the struggle in life that the 'Slaves' perform at the end of their existence. Moving from one piece to the next, Quinn asks us to identify at what point life enters the foetus. Is it there in the first piece, where the rudimentary formation of the brain stem and the spinal cord can be seen, or is it in one of the middle pieces, where

Untitled (Baby and Flower)
2007
Watercolour and pencil on paper
61 x 39 ¾ in. (155 x 101 cm)

3

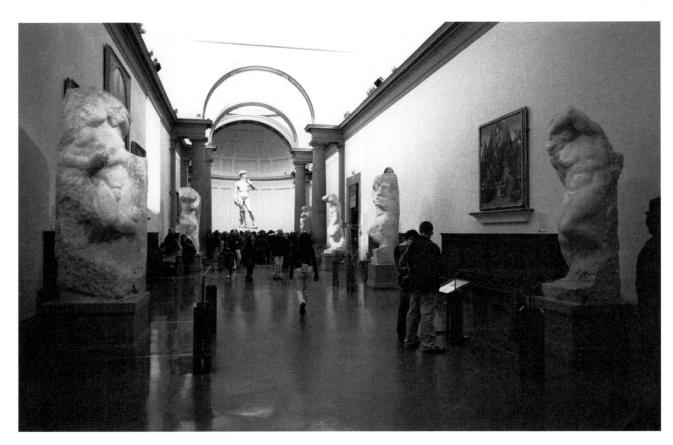

Michelangelo
Slaves
c.1520
Marble
Galleria dell' Accademia,
Florence

below left:
Awakening Slave
1519–20

below right:
Atlas Slave
c.1519–23

the foetus mutates from its unfamiliar, even monstrous appearance and takes on a recognisably human form? Or is it in the final piece, as the fully-formed foetus prepares to drop down through the birth canal like a ripe piece of fruit (or perhaps a flower) and enter the world? Where Michelangelo's 'Slaves' ask such questions as life drains from the body, Quinn asks them at the point of the creation and formation of the body, posing a very basic question about how we define what it means to be human. The womb is the ultimate repository of life, but as the first pieces in Quinn's series suggest, it houses a body that is unrecognisably human (or recognisably inhuman): the alien, almost monstrous creature from which we all develop. Where Quinn has previously undermined the notion of the ideal body in his series 'The Complete Marbles' and the fourth-plinth sculpture of Alison Lapper in Trafalgar Square, 'Evolution' takes this process a stage further by showing us the grotesque beauty from which we are all born, regardless of our shape or physical appearance.

Quinn's sculptural work has always been defined by using forms where the raw matter of the chosen material illuminates and reorients our understanding of the subject matter. In this he follows the best sculptural tradition, but he also adds his own absorption in *process*. Where Michelangelo's 'Slaves' rehearse various states of individual death and subjection, Quinn's statues follow an archetypal process of development, as the foetus emerges gradually from the marble, just as it develops within the womb. Each piece is more finished than the last, as the marble mimics the smooth skin and mottled veins of the foetus. Paradoxically, the more the foetus becomes recognisably human, the more it takes on the appearance of the cold, inert marble from which it is fashioned. For Quinn, this is a playfully formal process as much as a philosophical reflection on the idea of evolution in the biological sense of the term. The etymological source of the word 'evolution' is the Latin for 'unfold' or 'unroll'. Similarly, the ten pieces of 'Evolution' follow a similar artistic practice of unfolding. Like a piece of origami, Quinn's foetuses unfold as they develop – rather like the artist's paintings and sculptures of flowers – each subsequent marble turning in on itself, before unfurling again in the process of an increasingly complex design that is as much concerned with the basic process of artistic creativity as it is with offering a new conceptual perspective on the biology of evolution.

Nevertheless, Quinn's series does ask its viewer to reflect on the longer historical process of science's prurient examination and invasion of the body through history. Whilst 'Evolution' compellingly draws on the Renaissance tradition of Michelangelo and Leonardo's representation of the body, it

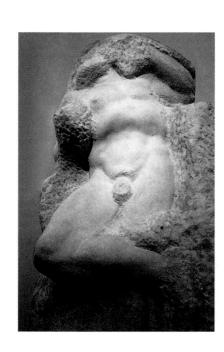

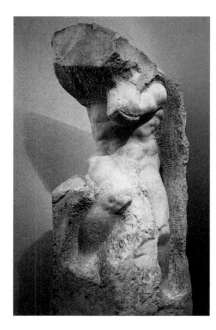

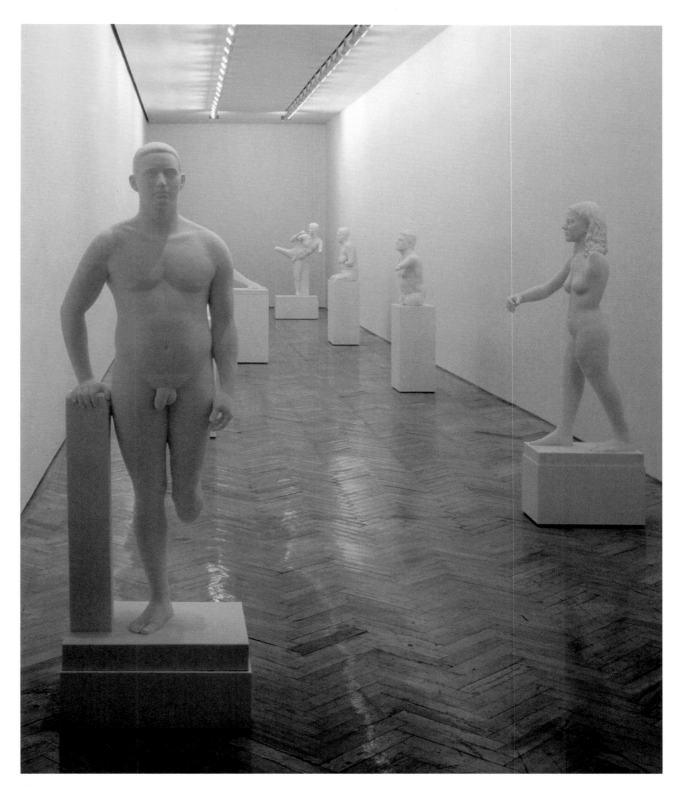

The Complete Marbles
1999–2000
Marble
Dimensions variable
Prada Foundation, Milan

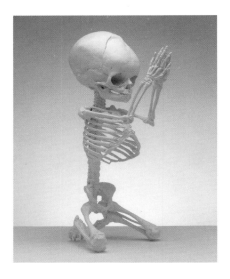

Angel
2006
Painted bronze
11 13/16 x 5 1/2 x 6 1/2 in.
(30 x 14 x 16.5 cm)

below:
Portrait of Marc Cazotte 1757–1801
2006
Lacquered bronze
35 1/5 x 18 1/8 x 12 1/2 in.
(89.5 x 46 x 31.8 cm)

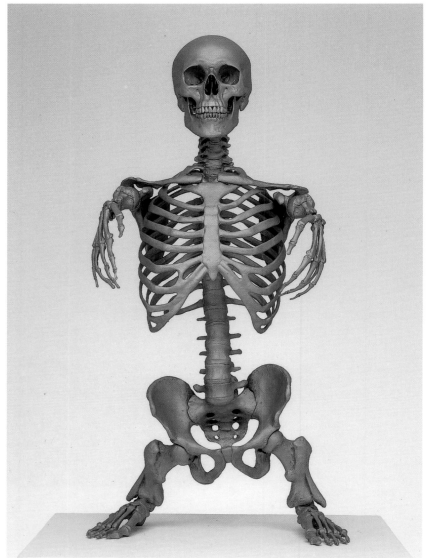

also evokes a later, Enlightenment moment when, freed from the prescription of religion, natural science voyeuristically laid bare the secrets of the cadaver. Quinn's cast baby skeleton, *Angel* (2006), has affinities with the late-17th-century tableaux of foetal skeletons preserved and then captured in engravings by the Dutch anatomist Frederik Ruysch. Like Quinn, Ruysch drew on scientific innovations in casting and embalming to reflect on the absurdity of life, adding proverbs to his ghoulish scenes of skeletons pressed into lace garments with lines such as, 'What is life? A transient smoke and a fragile bubble'. For Ruysch, the individual identity of the dead foetus or child is subsumed within the triumphant meeting of art and science, an Enlightenment moment that disregards the human in favour of digging ever deeper into the body to expose its secrets. Quinn's *Angel* and another work from the same year, the *Portrait of Marc Cazotte 1757–1801* (2006) suggest darker reservations about how science and art examine and dismantle the human body. If the skeleton is the basic structure that articulates the body, then to what extent does its artistic representation define the individual? Where Ruysch's Enlightenment scenes celebrate the triumph of art and science over the anonymous body, Quinn's late-modern skeletons look more like a melancholic eulogy for the loss of the individual. In the process they are less like portraits of an individual than anti-portraits of what a particularly corrosive tradition in art and science has done to the body and its sense of self.

'Evolution' approaches such matters from a different perspective. It puts the skin on the bones of such dilemmas, taking us into a different realm in which we are bound to ask how universal these foetuses will remain at a moment in history when the possibilities of genetic engineering and the surgical adaptation of the body in search of an ideal beauty may render this representation of the emerging human a distant curiosity to future generations. In this respect Quinn does directly address the thorny question of evolution, but with an eye as much on its possible future as on its history. The foetus marbles provocatively rehearse the 19th-century German zoologist Ernst Haeckel's evolutionary dictum that ontogeny (how the member of a particular species develops from fertilisation through to birth) recapitulates phylogeny (how a species evolves over time). Haeckel argued that the embryo developed through a series of stages that resembled the evolutionary phases of mankind's more 'primitive' ancestors. Most infamously Haeckel claimed (incorrectly), that the similarity between the pharyngeal arches in the neck of an embryo and fish gills was a reflection of the common ancestry of human beings and fish. In other words, he argued that the millennial process of human evolution from fish, through reptile to mammal effectively took place in miniature within the foetus in just nine months of gestation. Although most biologists now reject the universal claims of Haeckel's theory, they still concede a connection between ontogeny and phylogeny. Quinn's foetuses follow a similar journey. The earliest pieces flaunt their aquatic and reptilian features with their gills, tails and misshapen heads, but rather than pitching us into debates that set evolutionary theory against creationism, these foetuses ask us to reflect on how the future of evolution, and its manipulation by science, may change the way in which we see human development in the future.

In 2001 Quinn created *Lucas*, a portrait of his son made from liquefied placenta cast in a mould of the child's head. Quinn later said, 'This sculpture is like the bud of a flower. It's the beginning of individuality – the separation of the baby from the body of the mother.' The connection between Quinn's marble foetuses and his flower paintings and sculptures is unmistakable when seen within this context. The first foetal marble resembles the female sex organs; but it also looks like a flower. As the foetus develops, we are asked to identify individuality 'blossoming' or 'unfolding' within the figure: but at the same time we see it as archetypal, an ideal form, not one particular foetus but all foetuses, deliberately devoid of any visible markers of gender, race, class or physical ability. Similarly, the flower paintings and sculptures evoke then undermine the idea of individuality. Desire underpins both aspects of the White Cube exhibition: the human desire to consume the beautiful, perfect, blossoming flower, and the sexual desire that creates human life. But Quinn draws our attention to the fact that neither process is innocent or natural. With 'Evolution' we wonder if the foetus is the consequence of sex or scientific intervention in the shape of *in vitro* fertilisation. Both are driven by desire, but they can take very different forms. Similarly, the flowers appear to be the most elemental forms of nature. In Quinn's hands they are clearly artificial – lurid and overblown – but so they are in the world of biology. They are hybrid creations, unable to survive without our desire and ability to naturalise them as 'normal'. But thrown into relief by Quinn, they appear as monstrous and unnatural as the early stages of the foetus in 'Evolution', the products of man-made scientific intervention. Baby and flower: two of the purest icons in Western art, but now subject to modification and scientific intervention. For Quinn, there is no easy moral answer here: modification and intervention become part of the evolution of anatomy as well as biology – it is a risk, but also an opportunity.

Four weeks after the birth of my first child I found myself confronted by the ten pieces of 'Evolution'. It was an extraordinary and emotive moment, as I realised that they gave shape to that powerfully emotional ambivalence that many parents feel as they peer at grainy, spectral ultrasound scans of their babies, sheathed in the womb as Quinn's foetuses sit encased in their marble – the beautifully monstrous and monstrously beautiful process of creation, where you try and grasp the human, and are confronted by something that seems so inhuman. Quinn takes us on a journey of art – an ongoing process hewn out of marble – that gives us an opportunity to reflect on our own fragile lives as a process. Just like the ideal child they represent, this series of sculptures stands poised ready to enter the world, to embark on a journey of their own. Quinn's final conceit is that these pieces, formed in marble, have a potentially infinite life – unlike our own. This is perhaps their curse: they will never wither and die, just like Quinn's flowers. They remain in a state of endless becoming, where everything is possible, forever deferring their descent into the messy compromise of life: head down, resisting The Fall.

Lucas
2001
Human placenta and umbilical cord,
stainless steel, perspex, refrigeration
equipment
80 1/2 x 25 3/16 x 25 3/16 in.
(204.5 x 64 x 64 cm)

Jerry Brotton is Professor of Renaissance Studies at Queen Mary, University of London. His most recent book is *The Sale of the Late King's Goods: Charles I and his Art Collection* (Pan Macmillan, 2006).

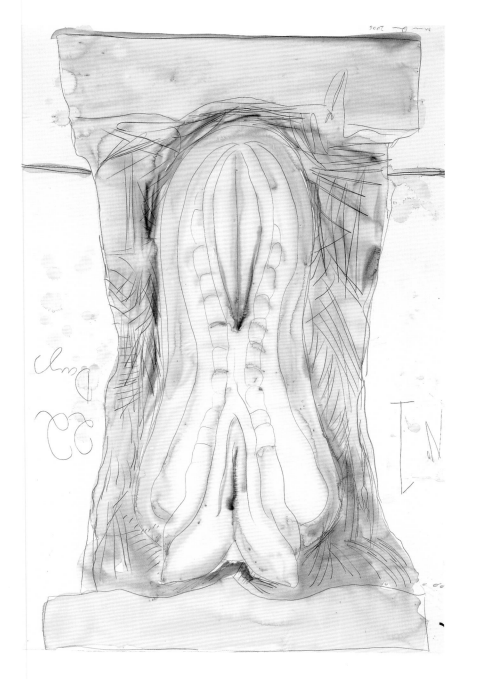

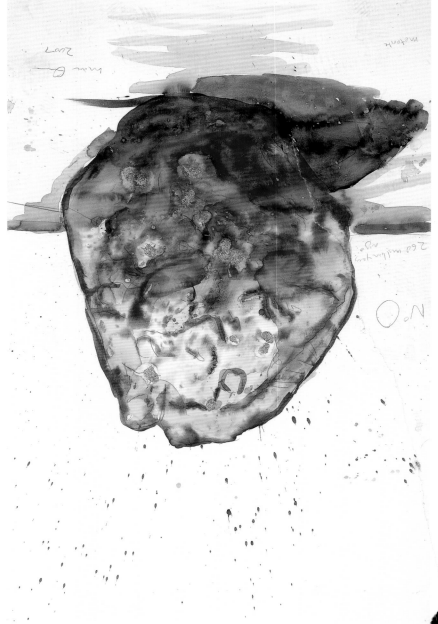

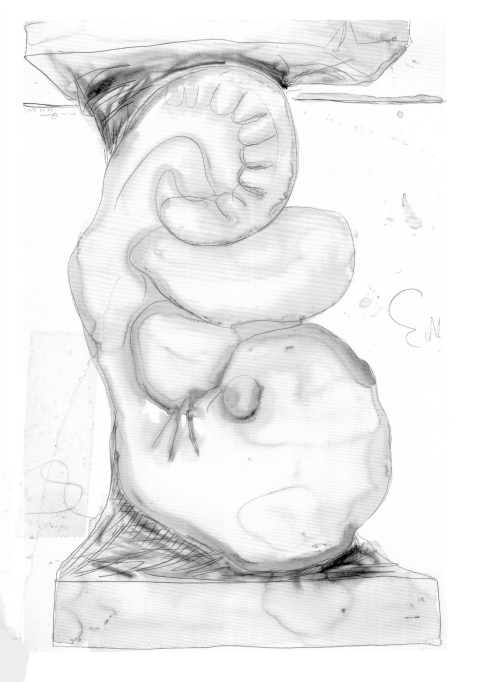
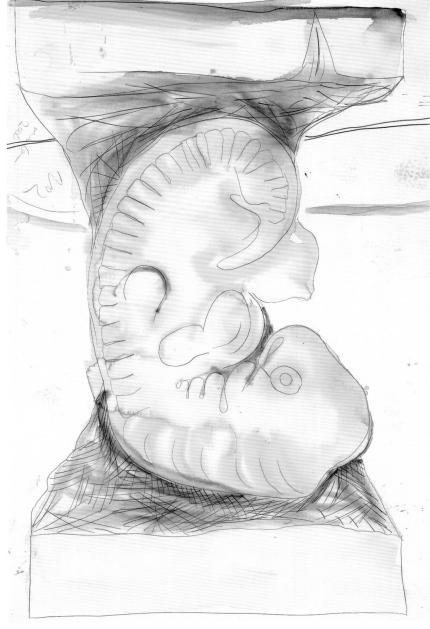

Studies for Evolution

page 10 (left):
Study for Evolution 0 (260 million years ago)
2007
Watercolour, acrylic, liquid glitter and pencil on paper.
60 x 40 in. (152.4 x 101.6 cm)

page 10 (right):
Study for Evolution I
2006
Watercolour and pencil on paper.
60 5/8 x 39 7/8 in. (154 x 101.3 cm)

page 11 (left):
Study for Evolution II
2006
Watercolour and pencil on paper.
60 5/8 x 39 13/16 in. (154 x 101.2 cm)

page 11 (right):
Study for Evolution III
2005
Watercolour and pencil on paper.
60 5/8 x 39 7/8 in. (154 x 101.3 cm)

page 12 (left):
Study for Evolution IV
2005
Watercolour and pencil on paper.
60 5/8 x 39 7/8 in. (154 x 101.3 cm)

page 12 (right):
Study for Evolution V
2005
Watercolour and pencil on paper.
60 5/8 x 39 15/16 in. (154 x 101.4 cm)

page 13 (left):
Study for Evolution VI
2006-07
Watercolour and pencil on paper.
60 5/8 x 39 7/8 in. (154 x 101.3 cm)

page 13 (right):
Study for Evolution VII
2006
Watercolour and pencil on paper.
60 9/16 x 39 15/16 in. (153.8 x 101.4 cm)

page 14 (left):
Study for Evolution VIII
2006
Watercolour and pencil on paper.
60 5/8 x 39 15/16 in. (154 x 101.5 cm)

page 14 (right):
Study for Evolution IX
2006
Watercolour and pencil on paper.
60 1/8 x 39 13/16 in. (152.7 x 101.2 cm)

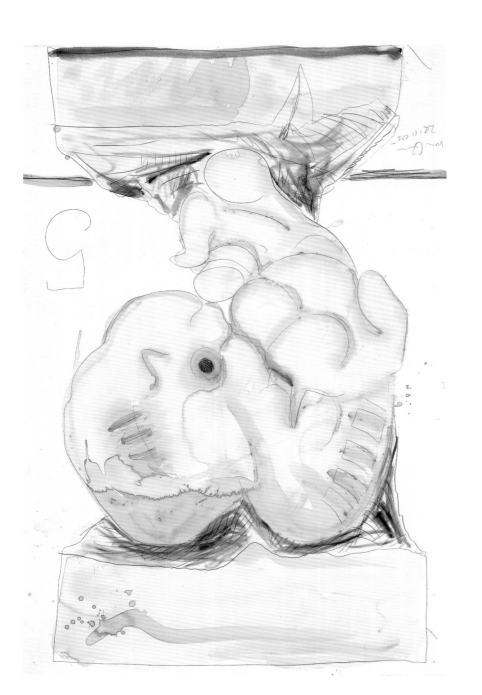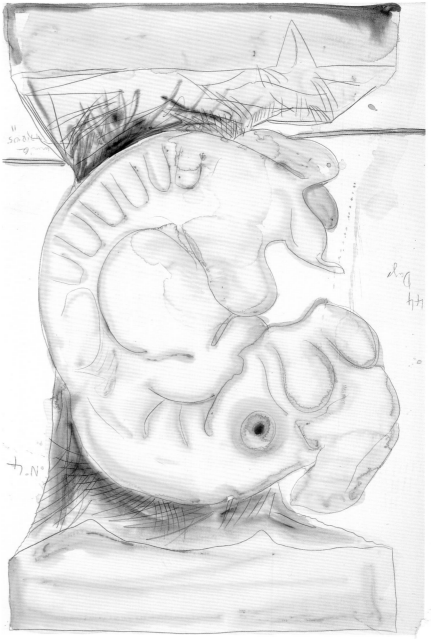

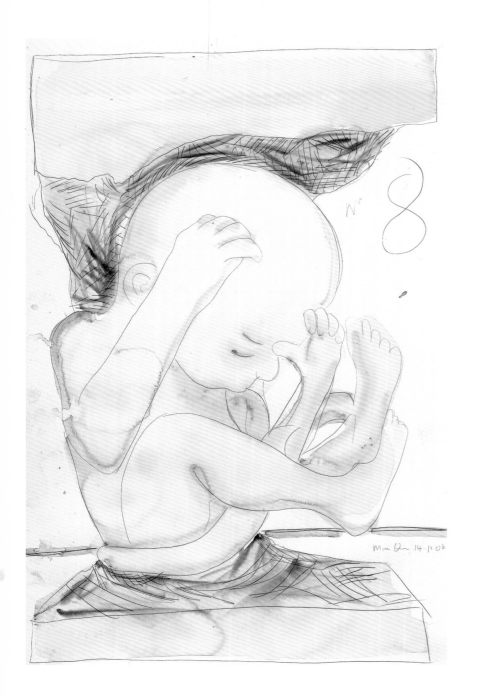

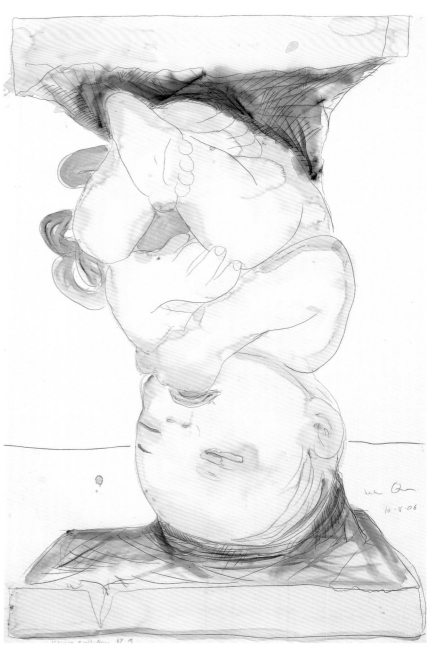

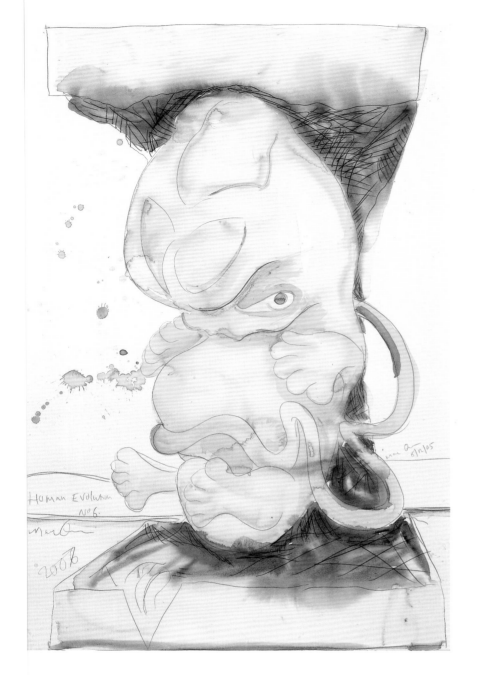

Human Evolution
No 6.

2006

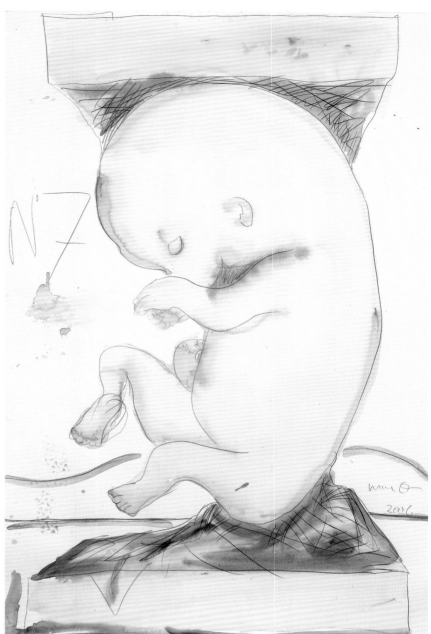

No 7

2006

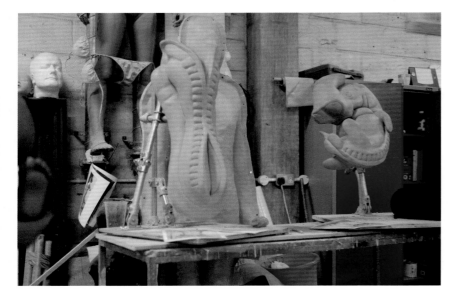
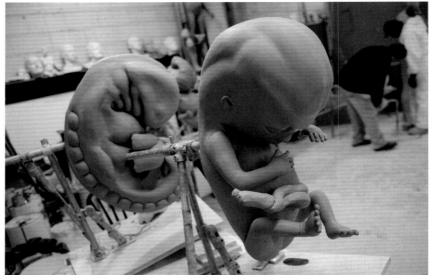
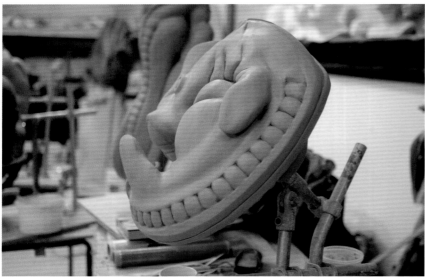
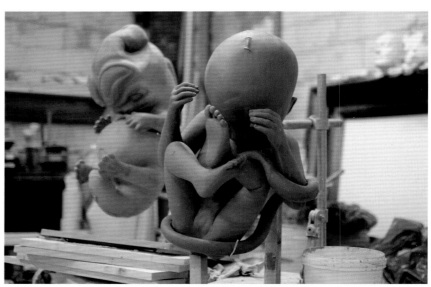
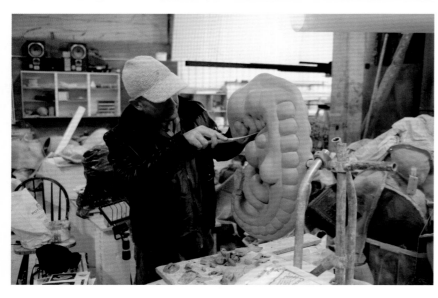
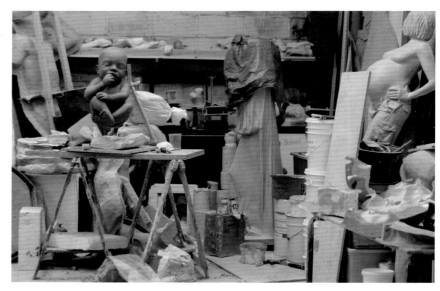

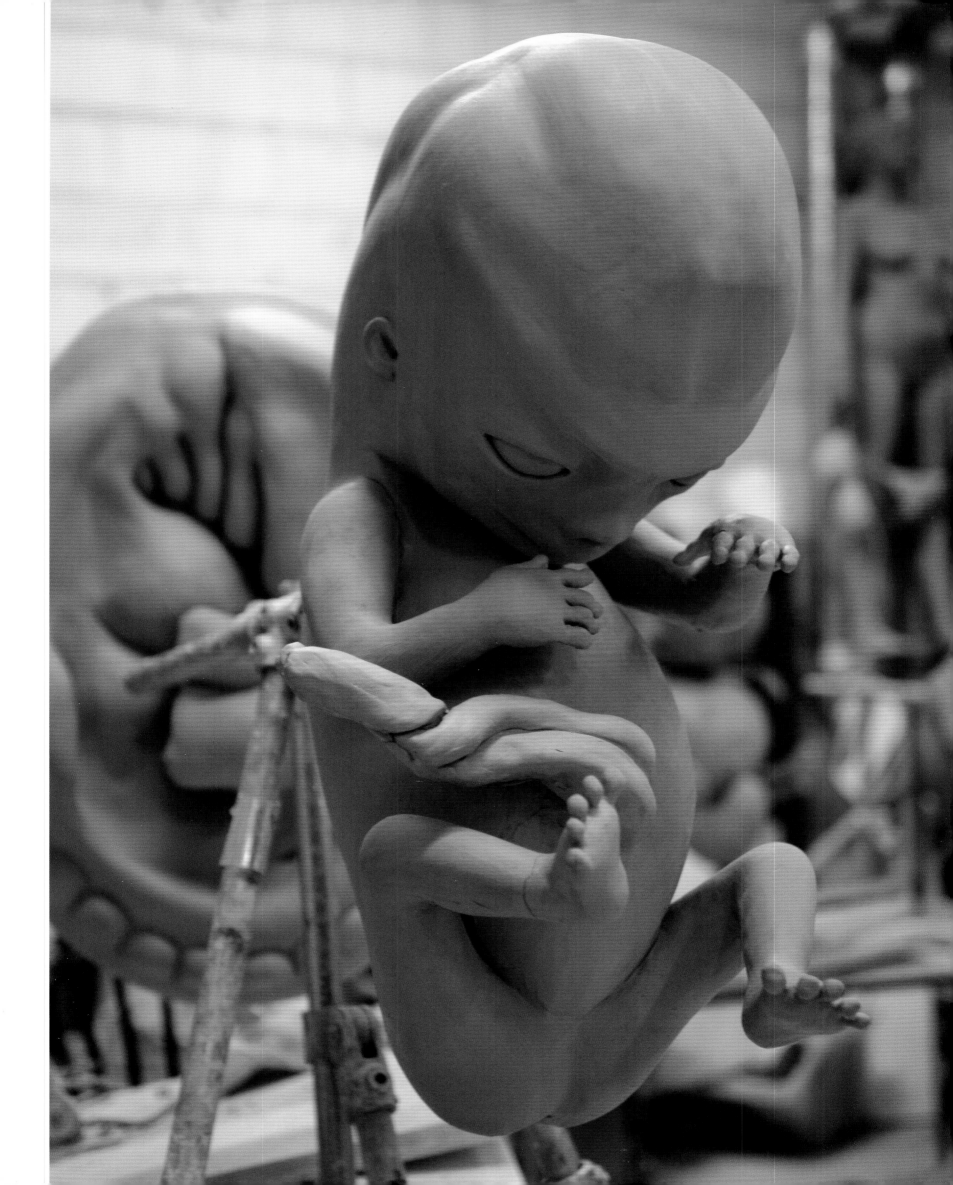

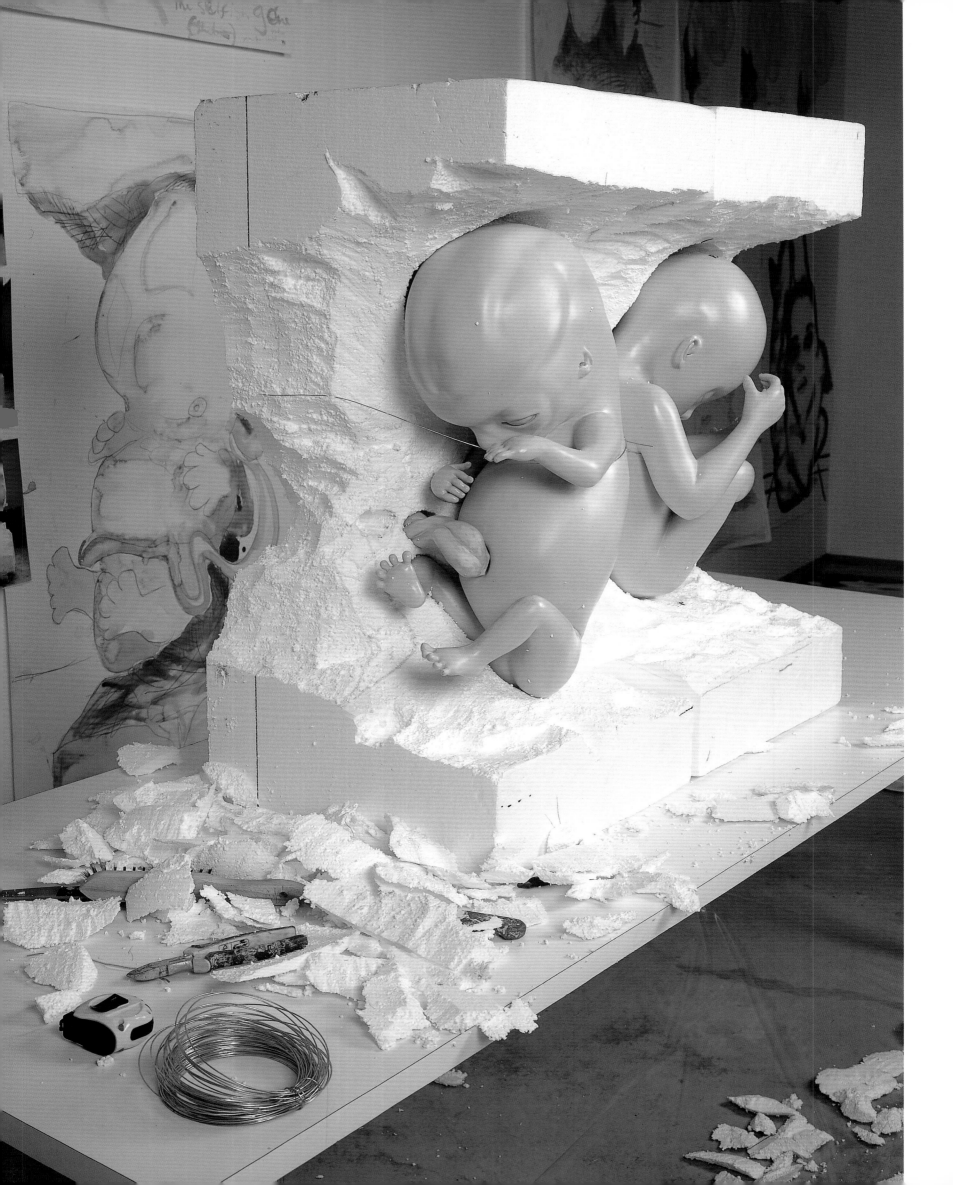

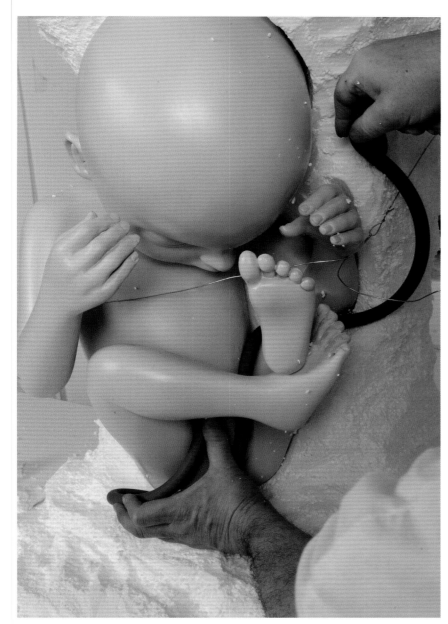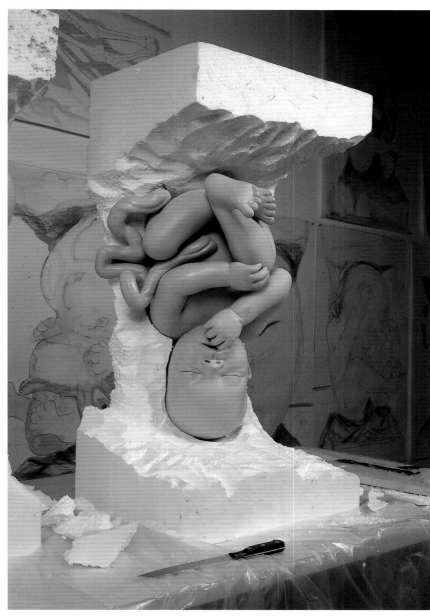

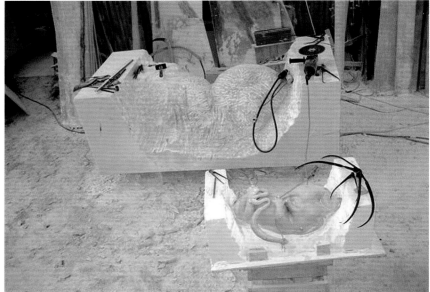

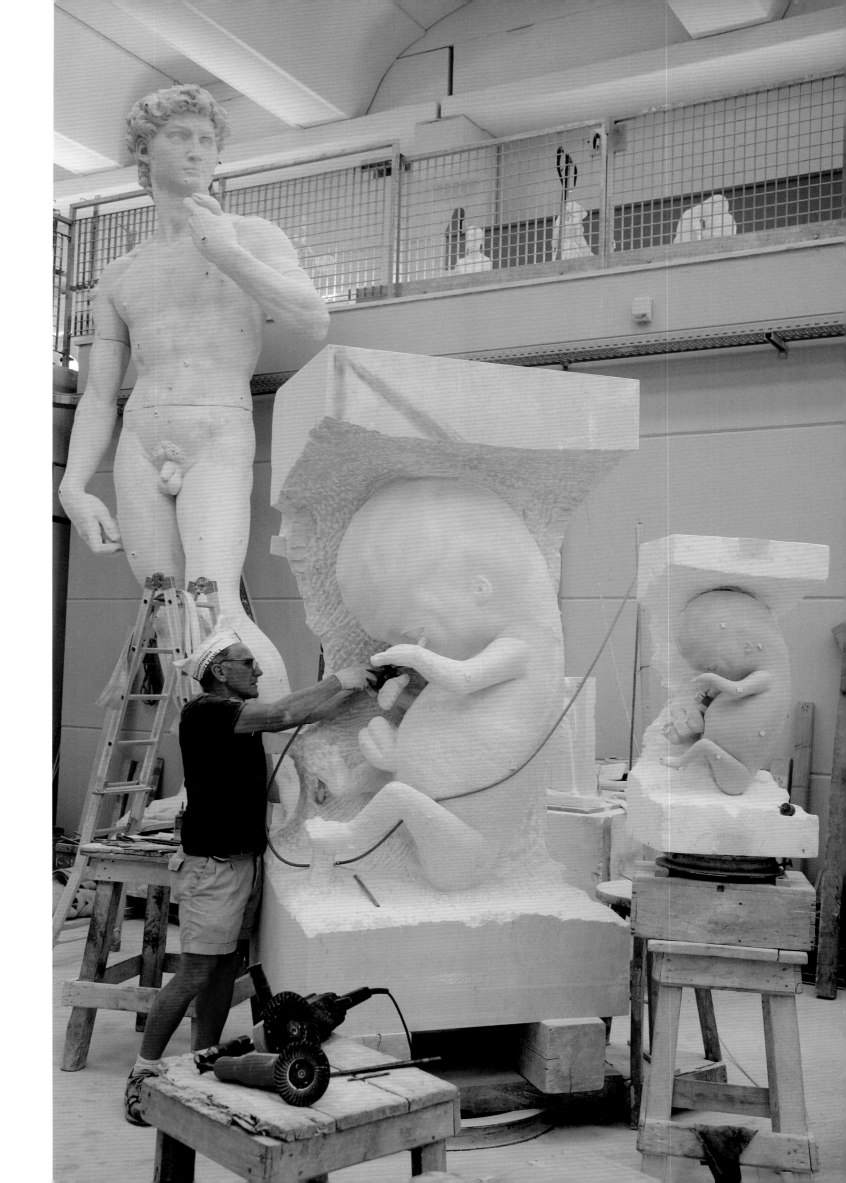

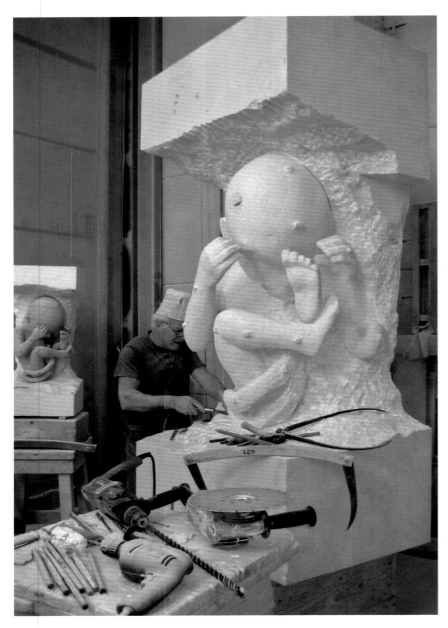
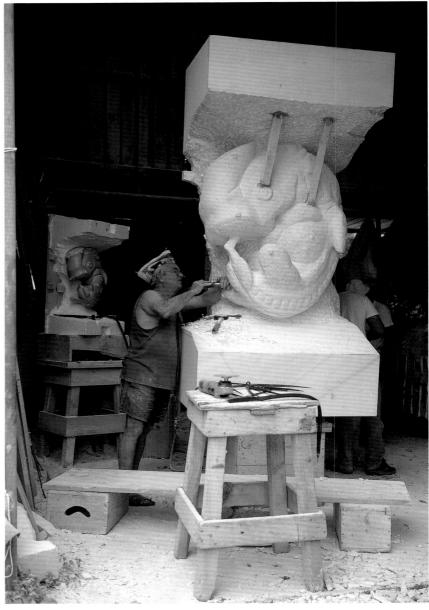

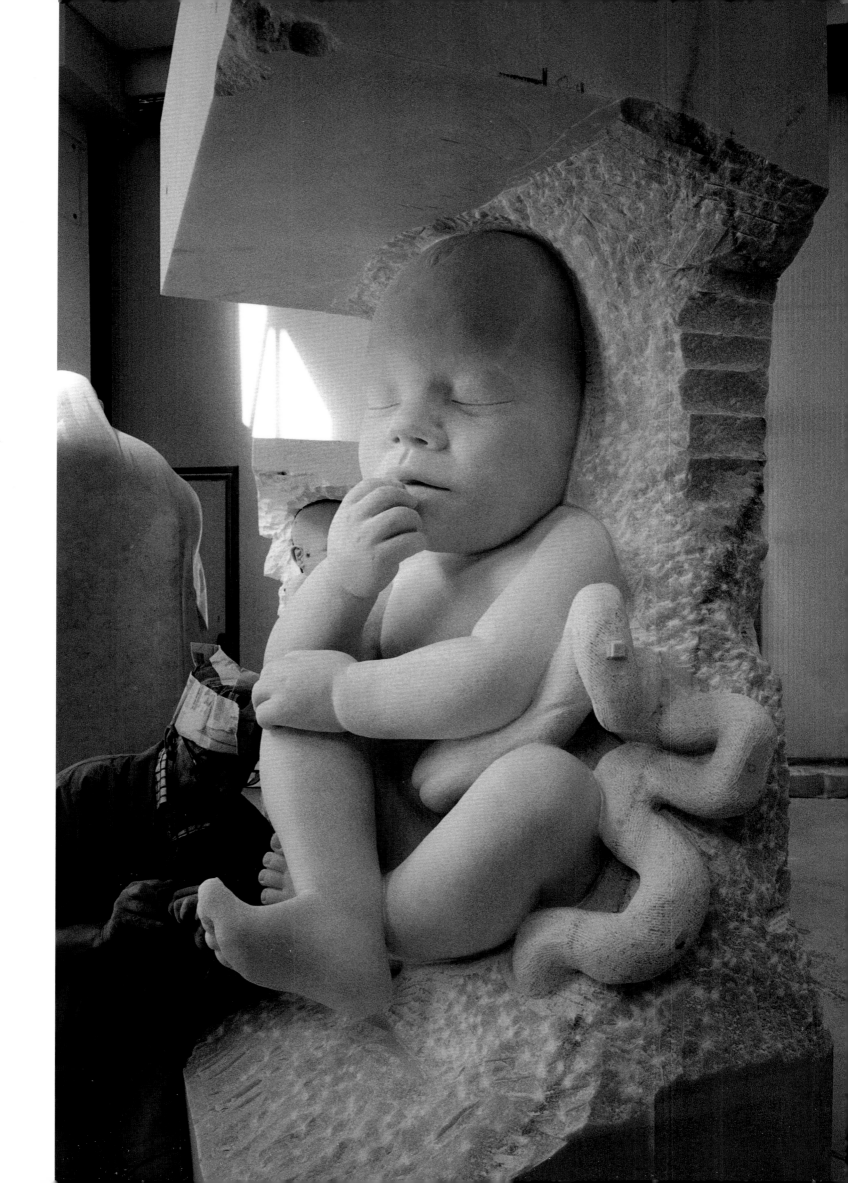

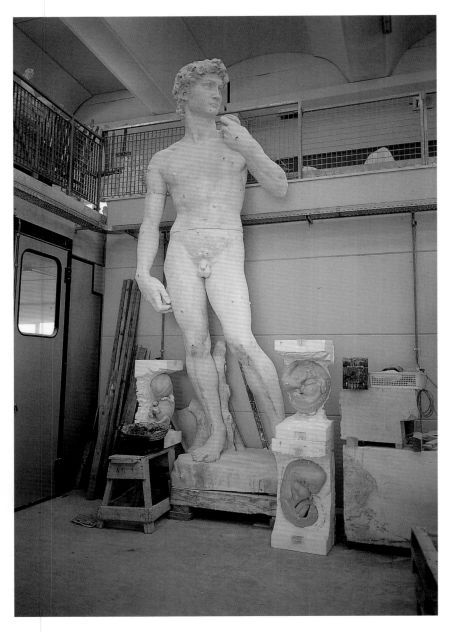
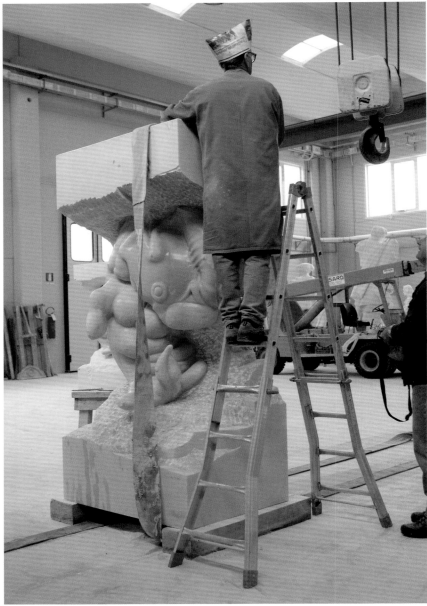

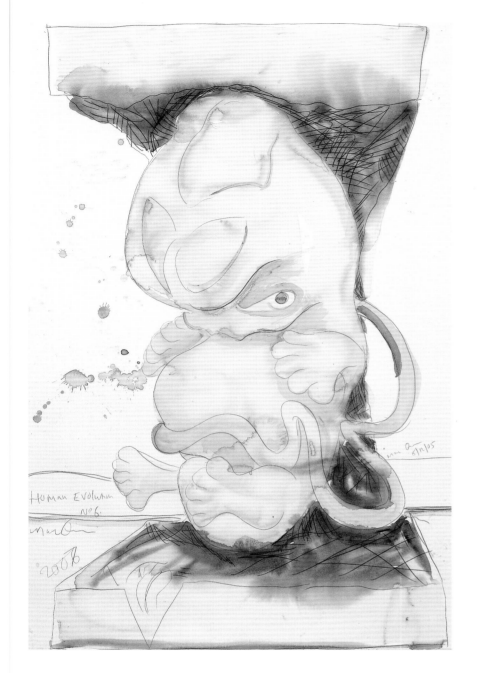

Human Evolution
No.6.

2006

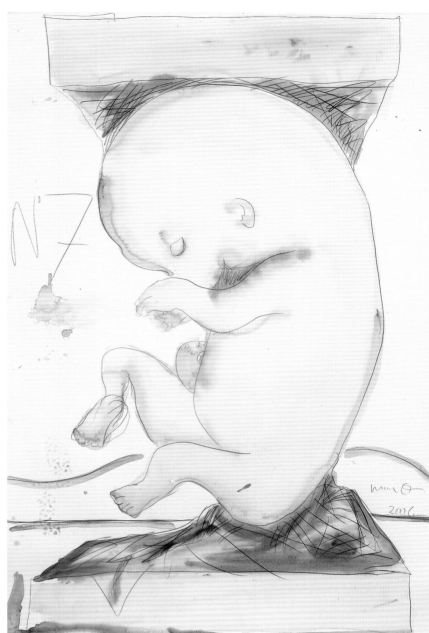

2006.

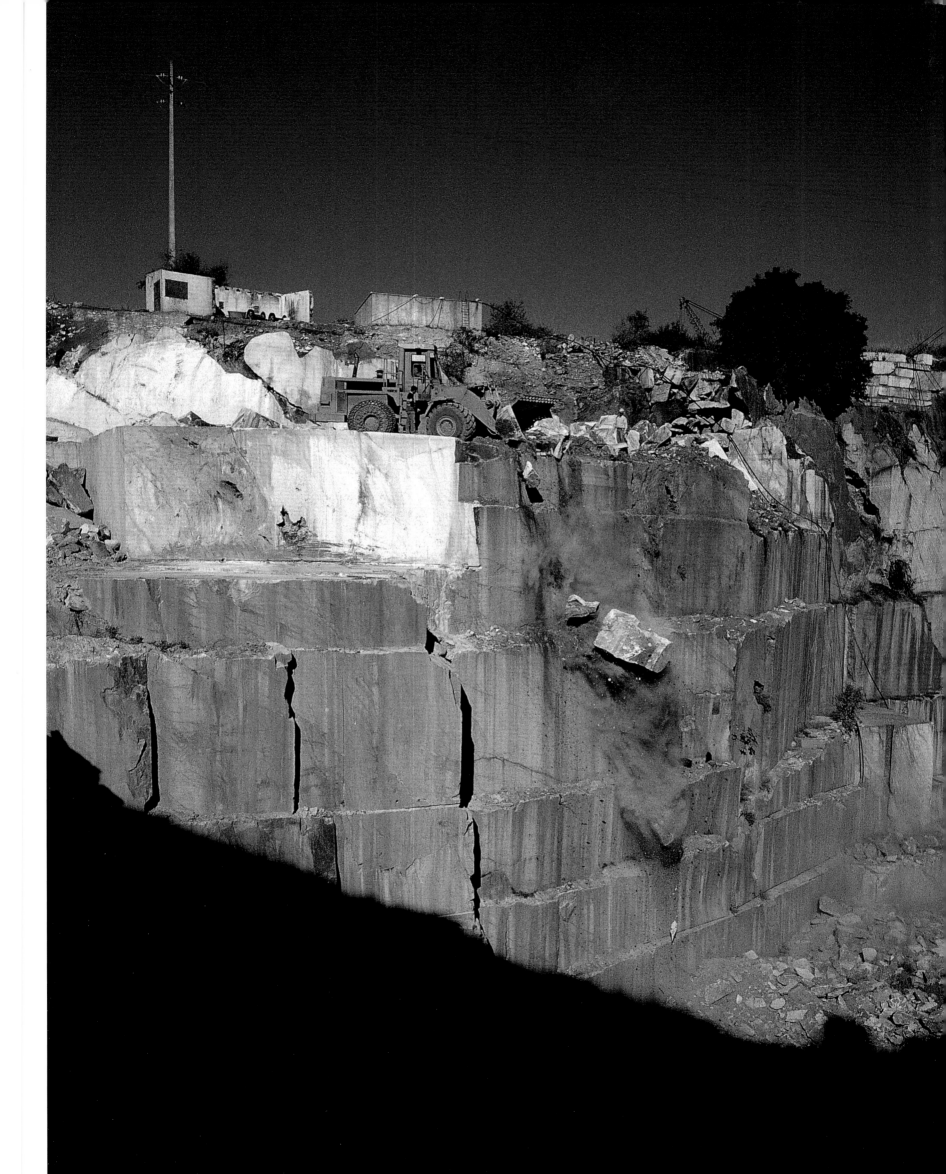

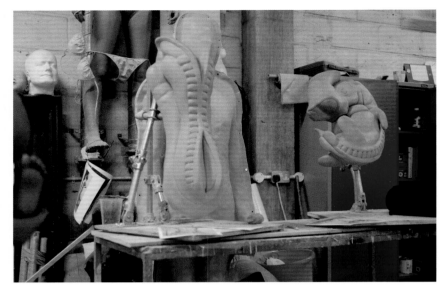
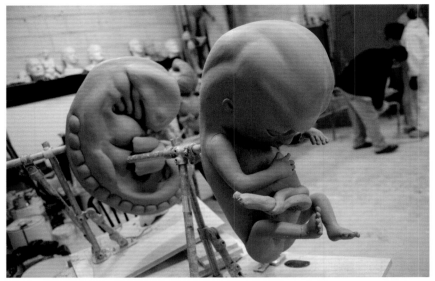
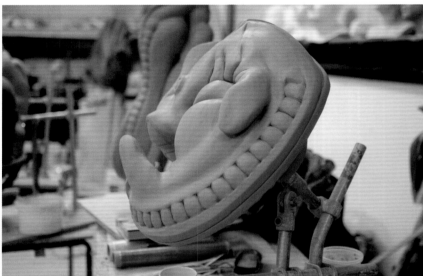
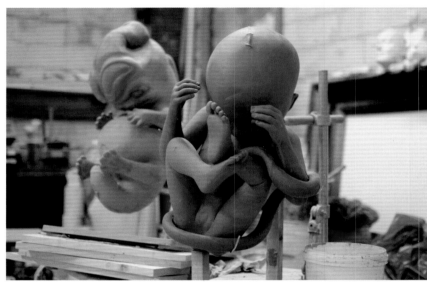
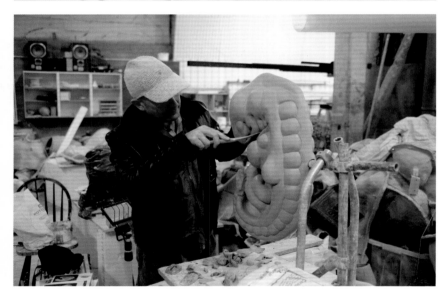
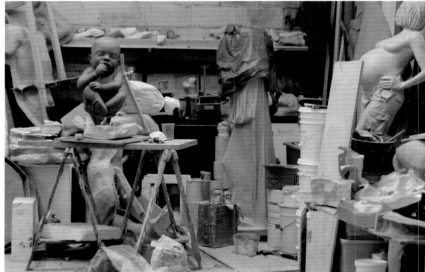

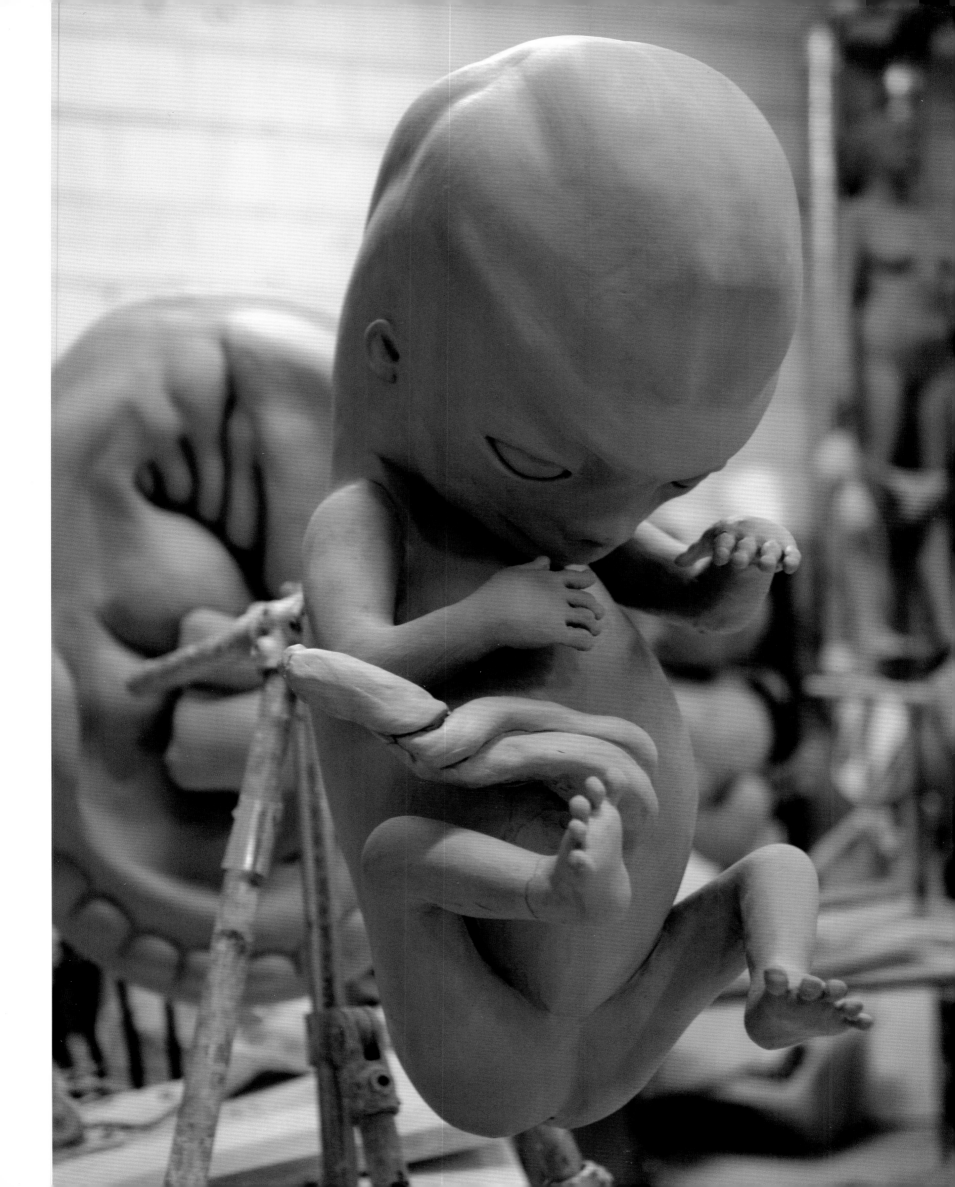

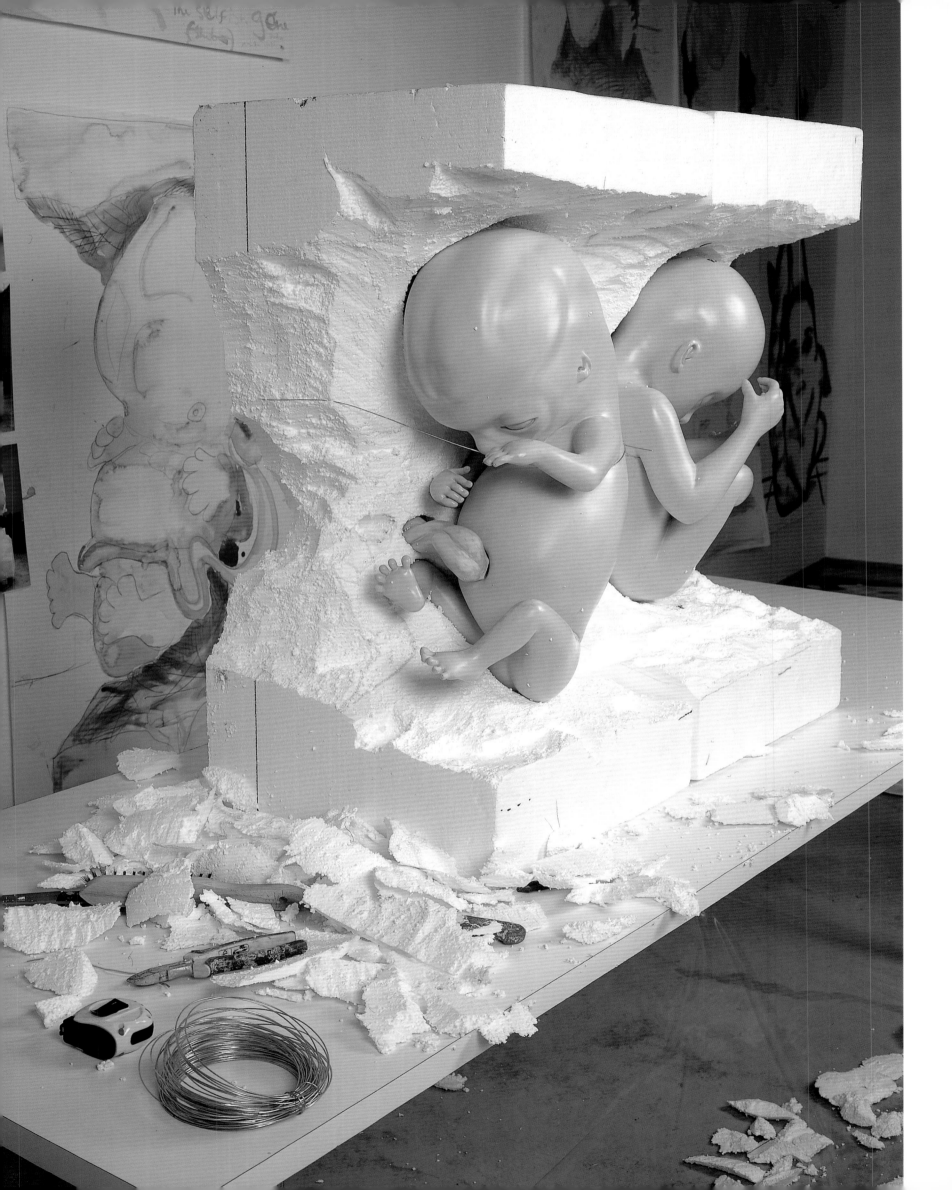

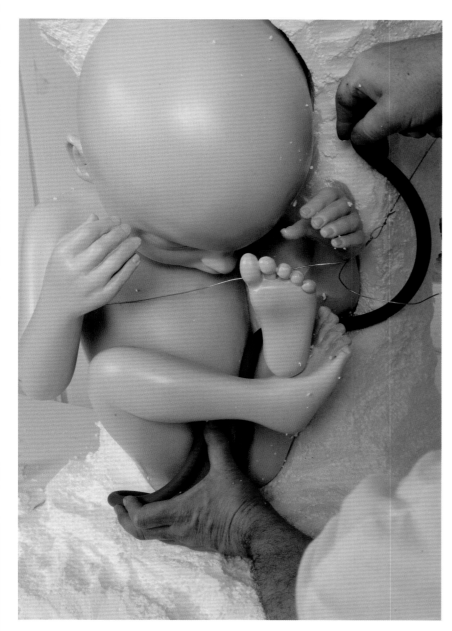
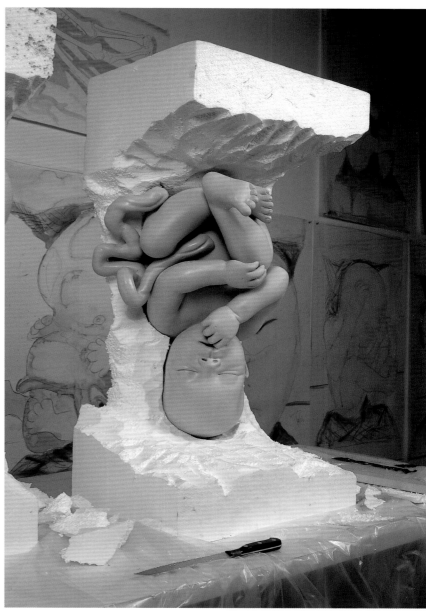

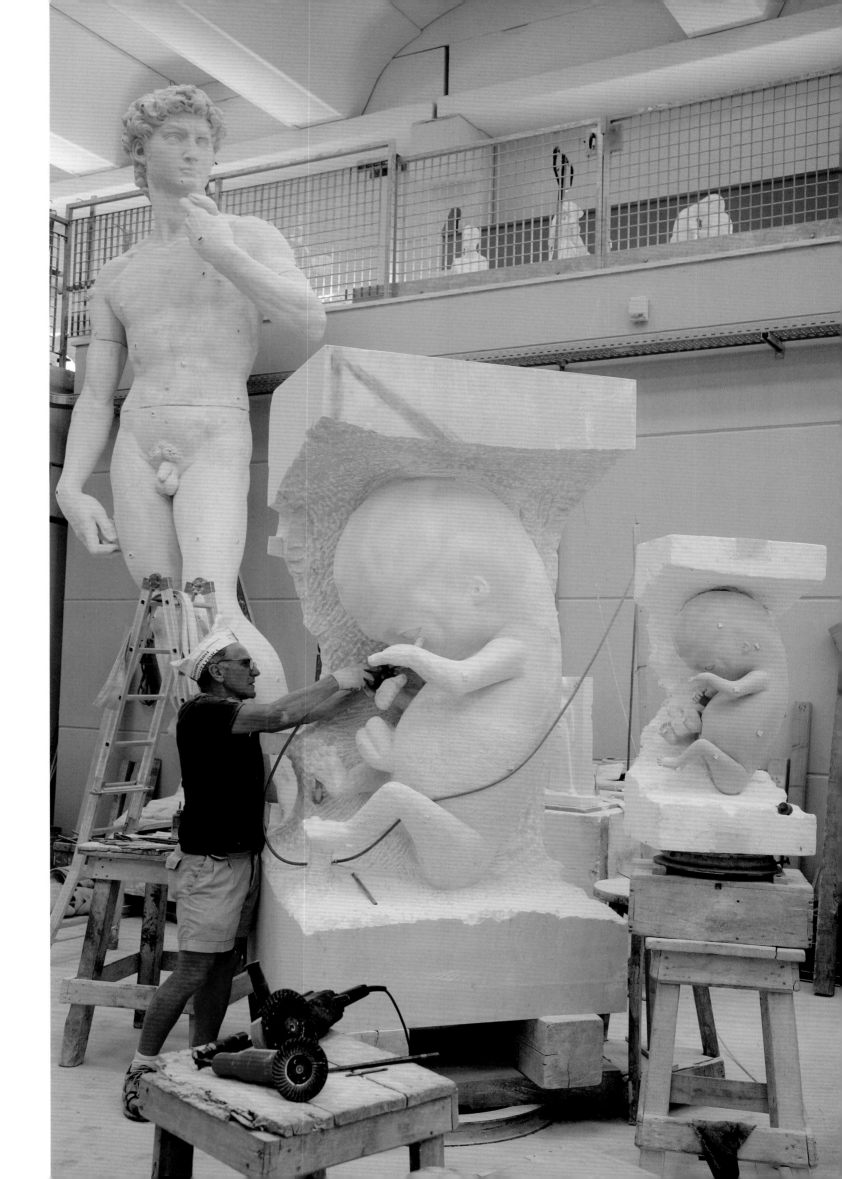

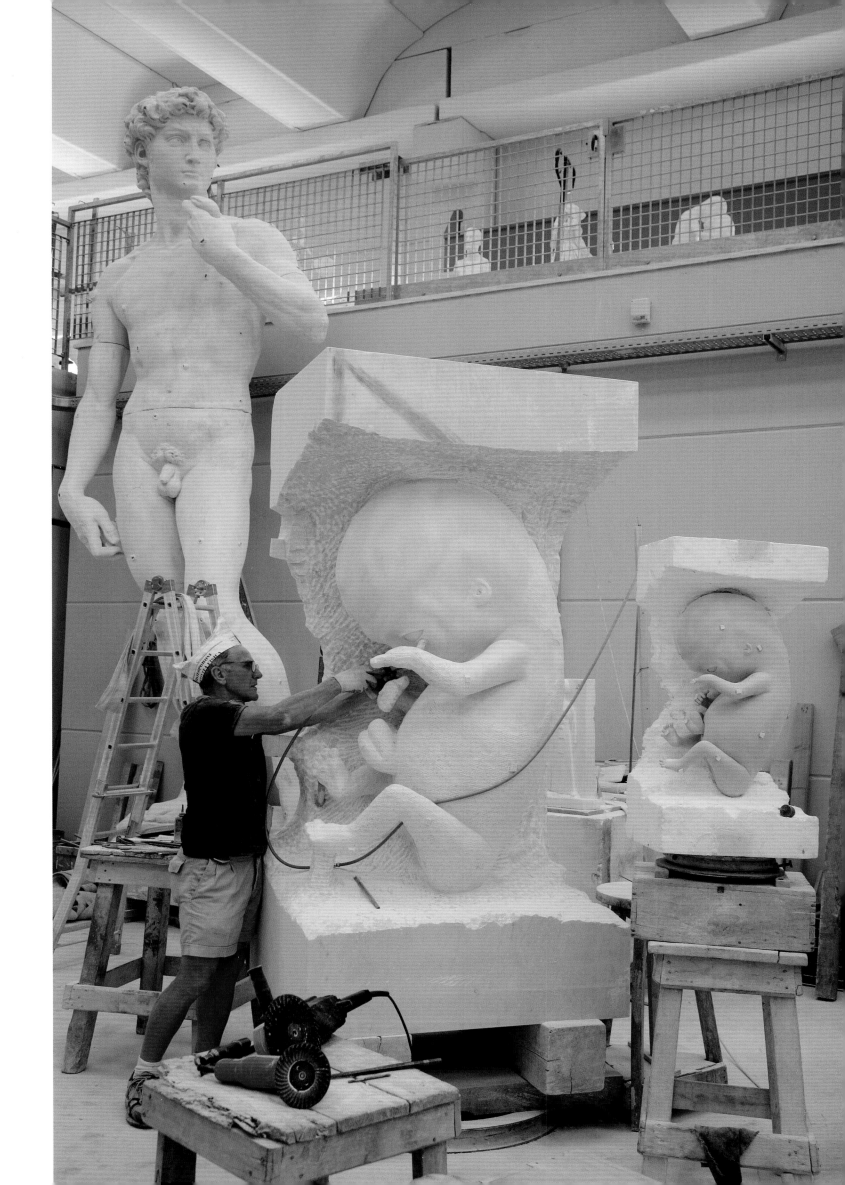

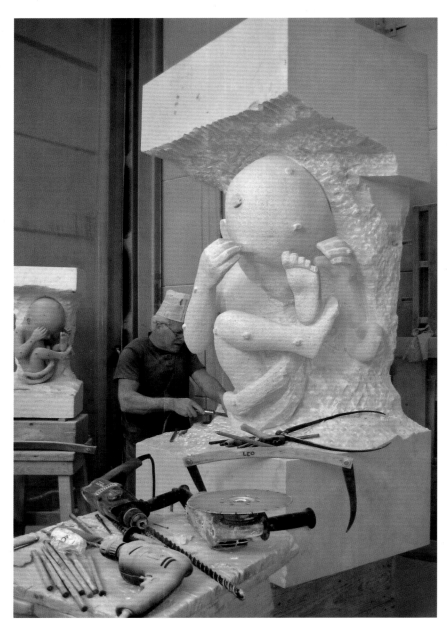
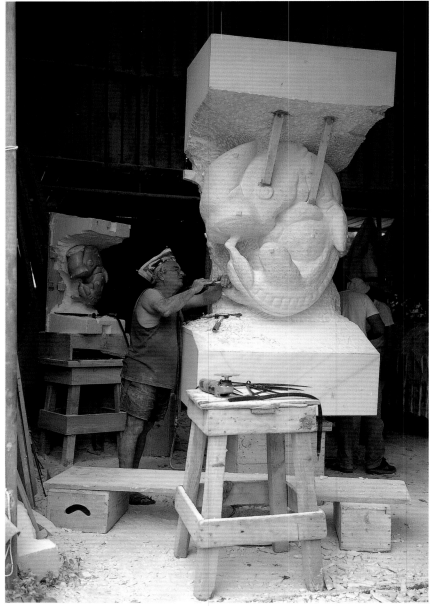

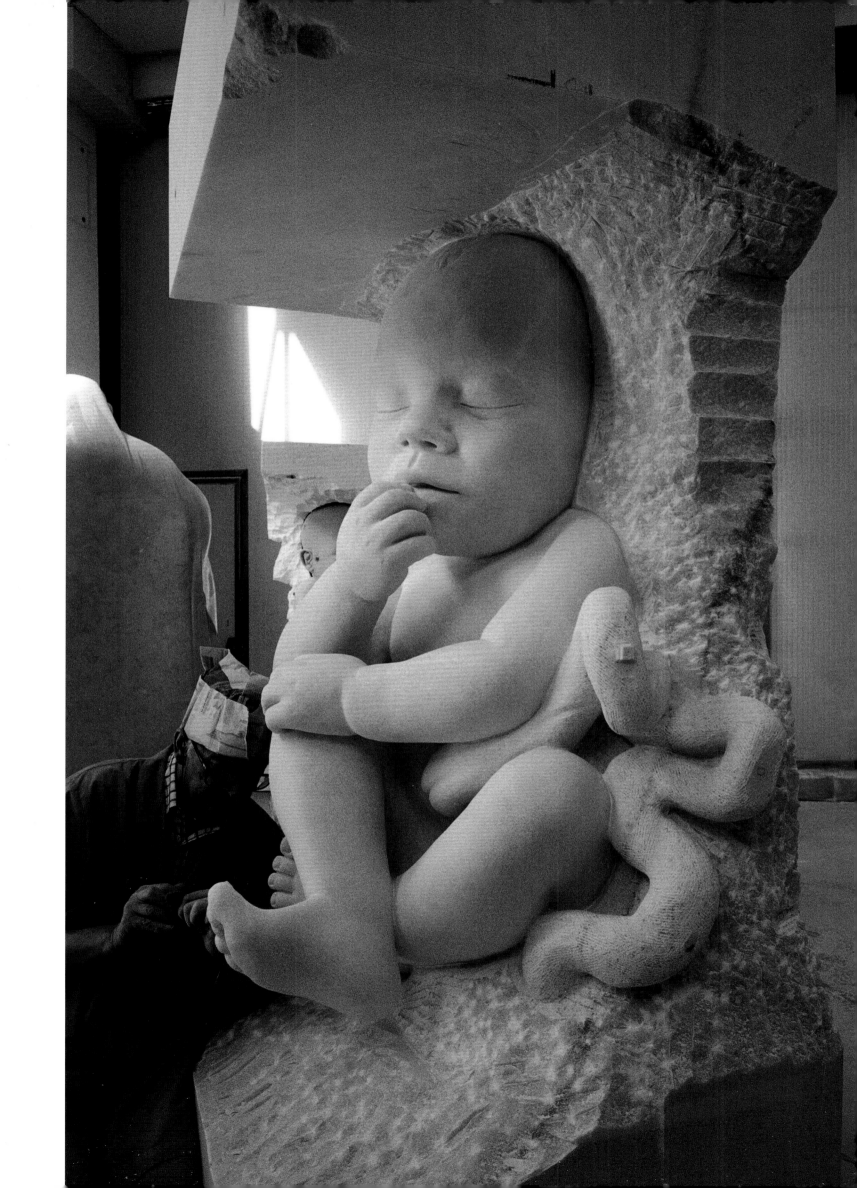

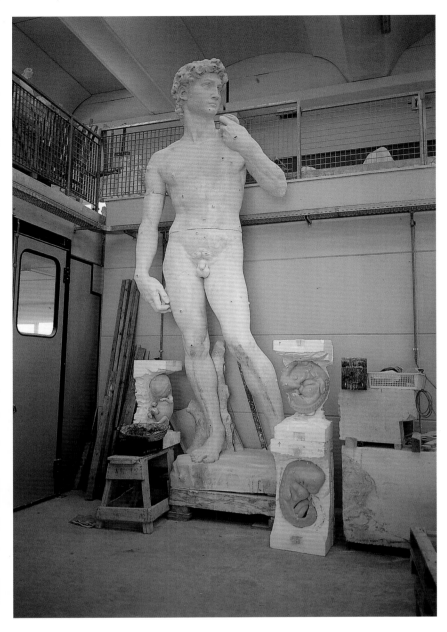
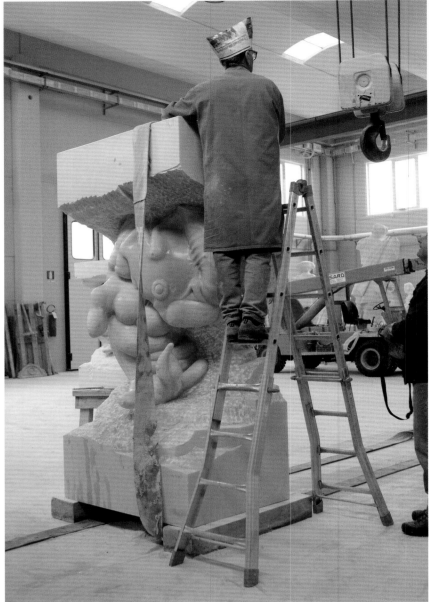

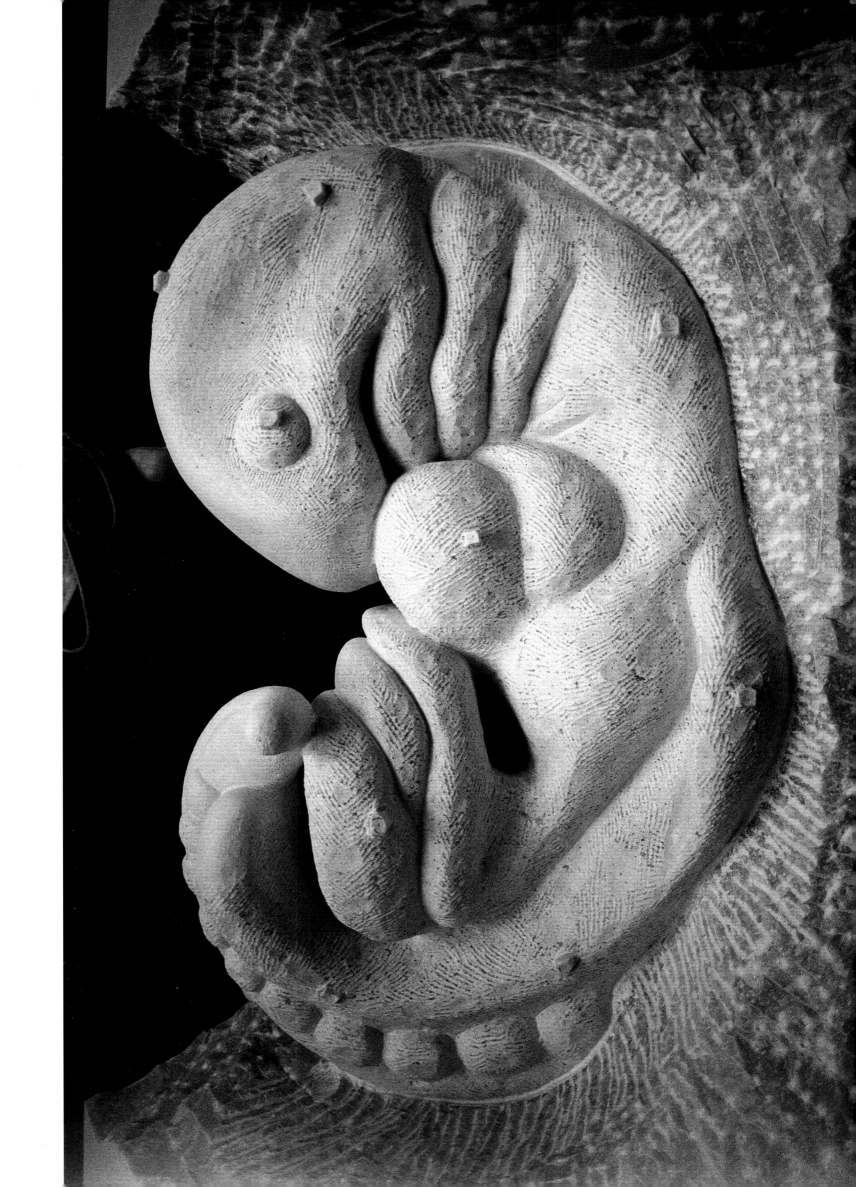

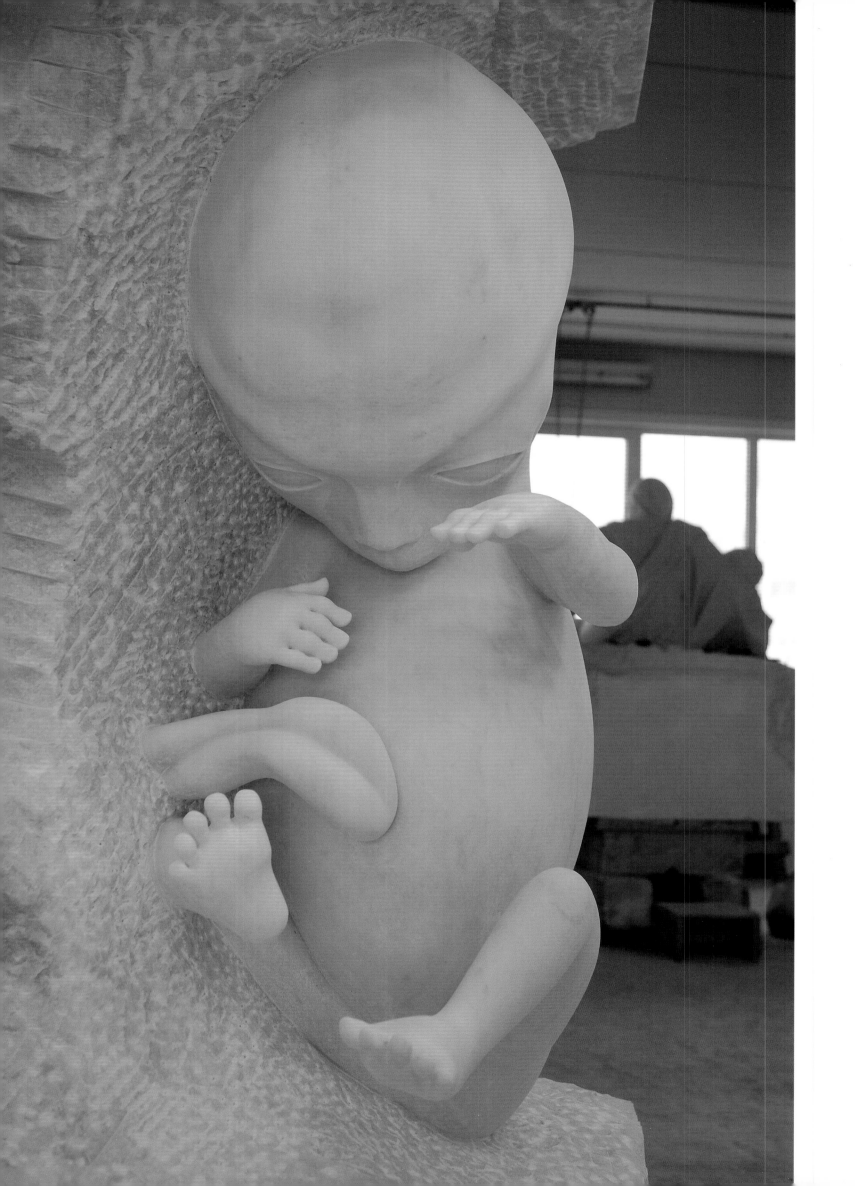

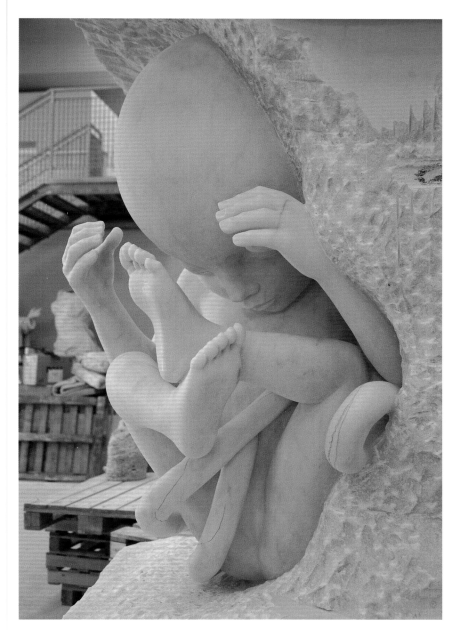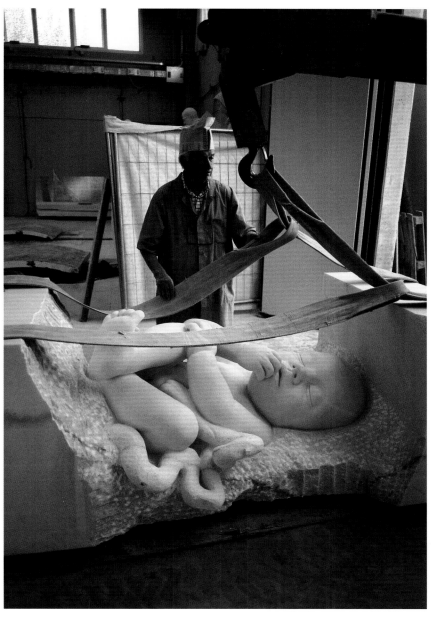

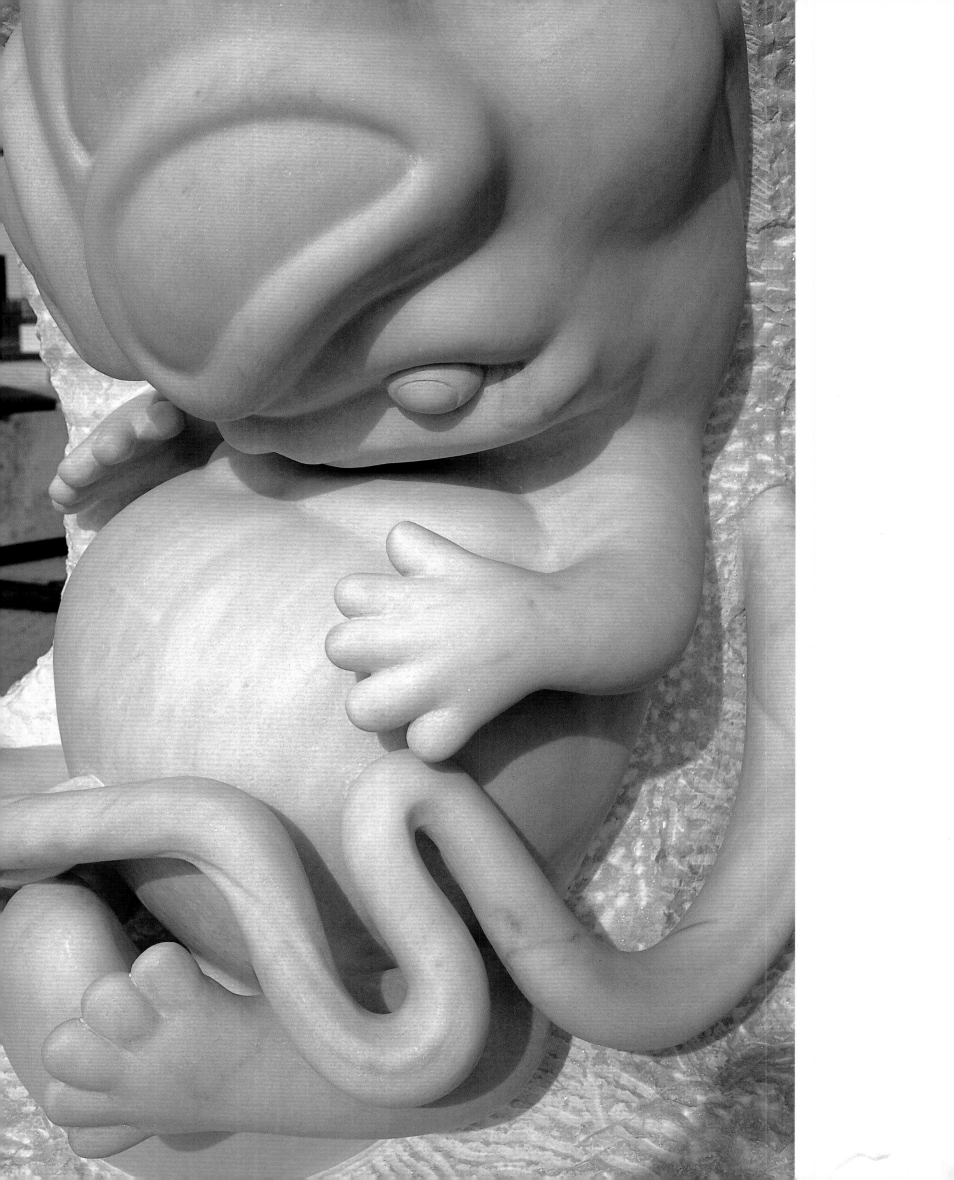

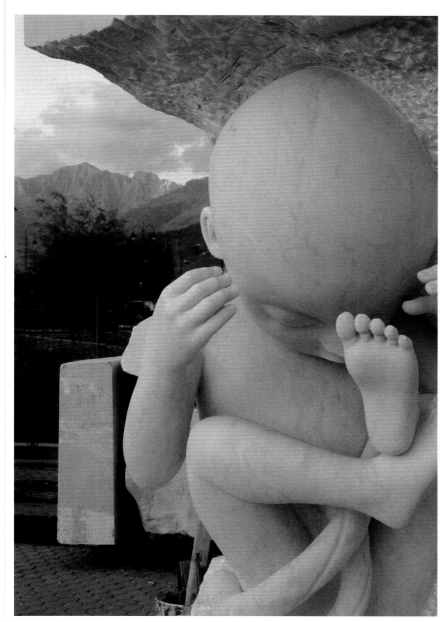
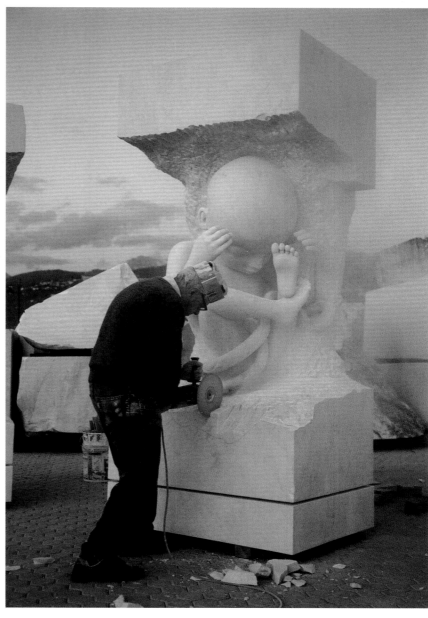

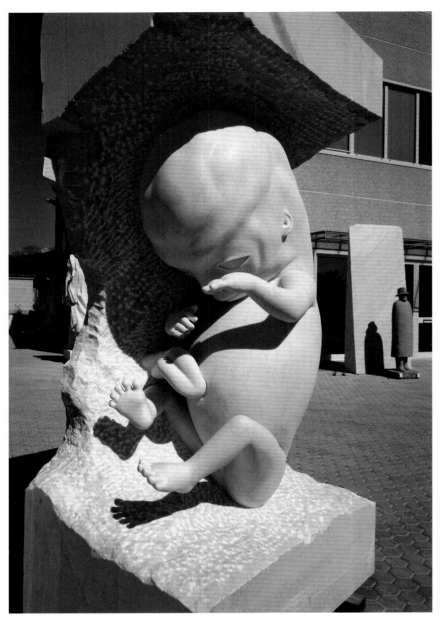

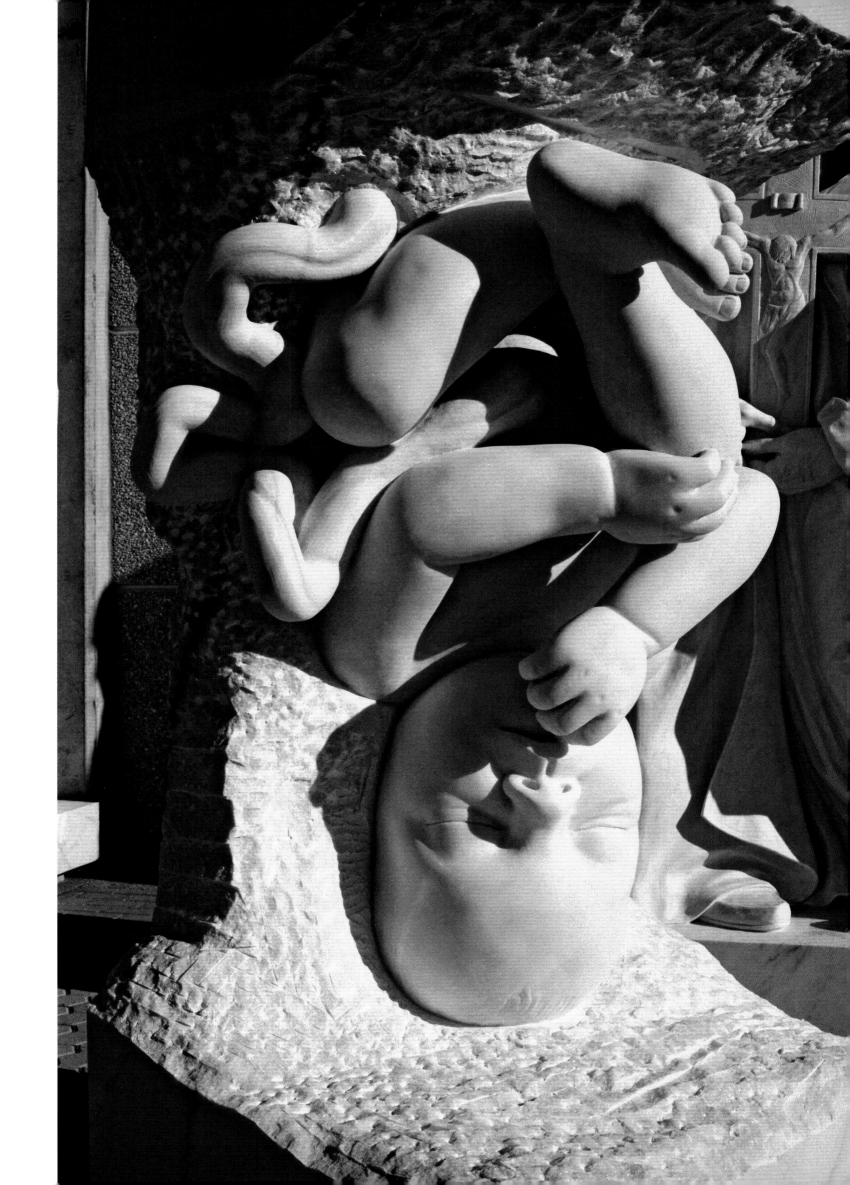

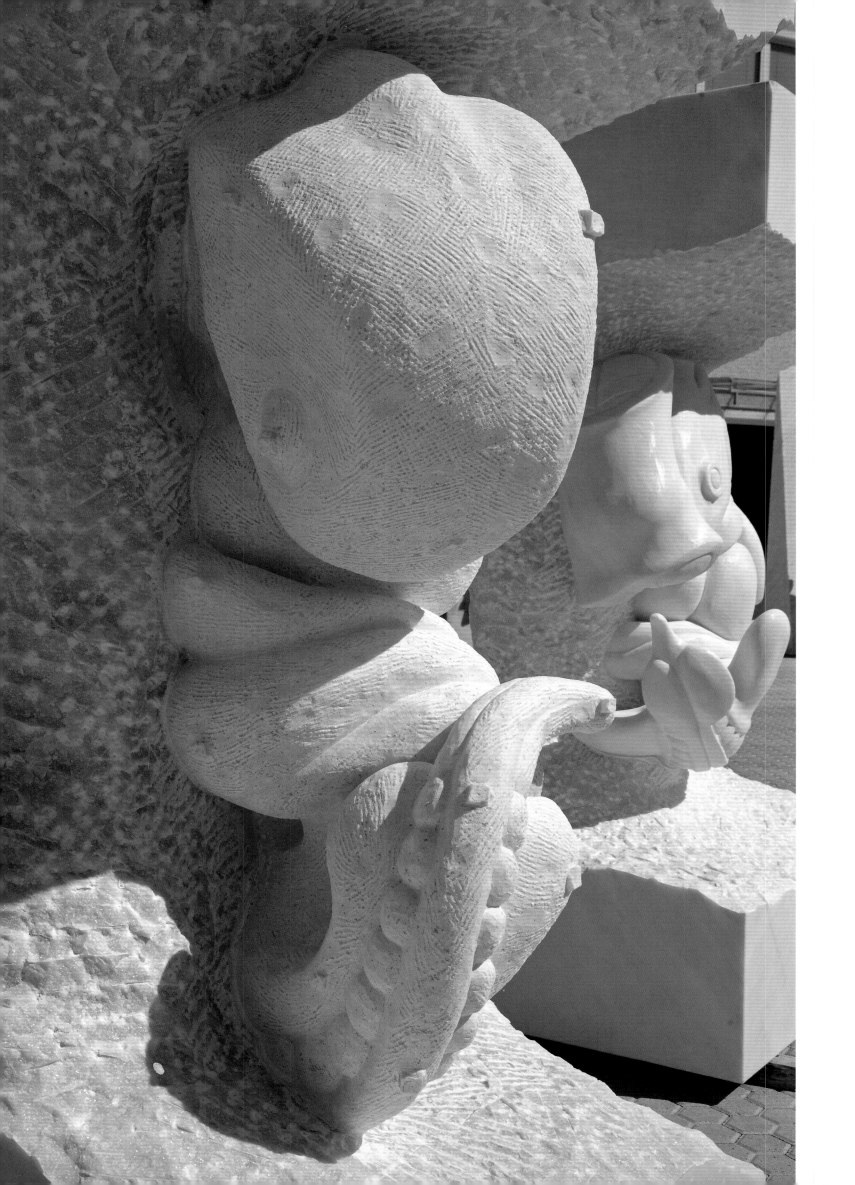

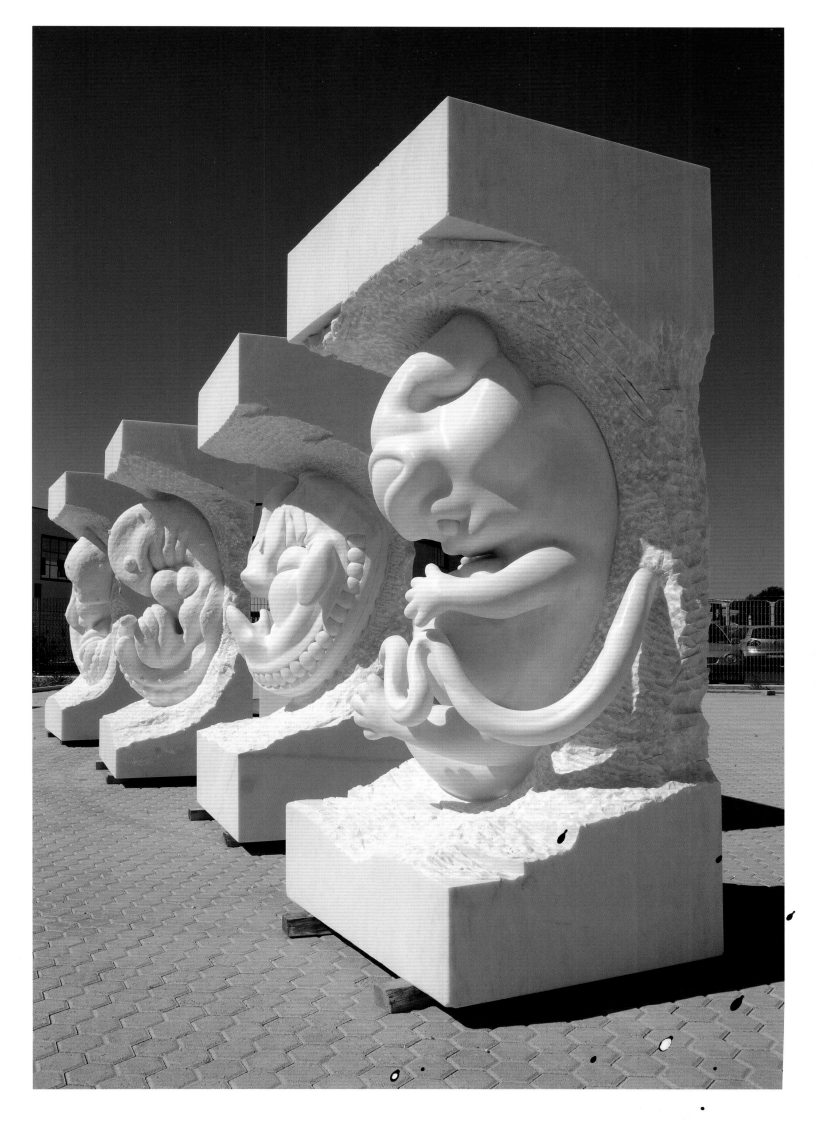

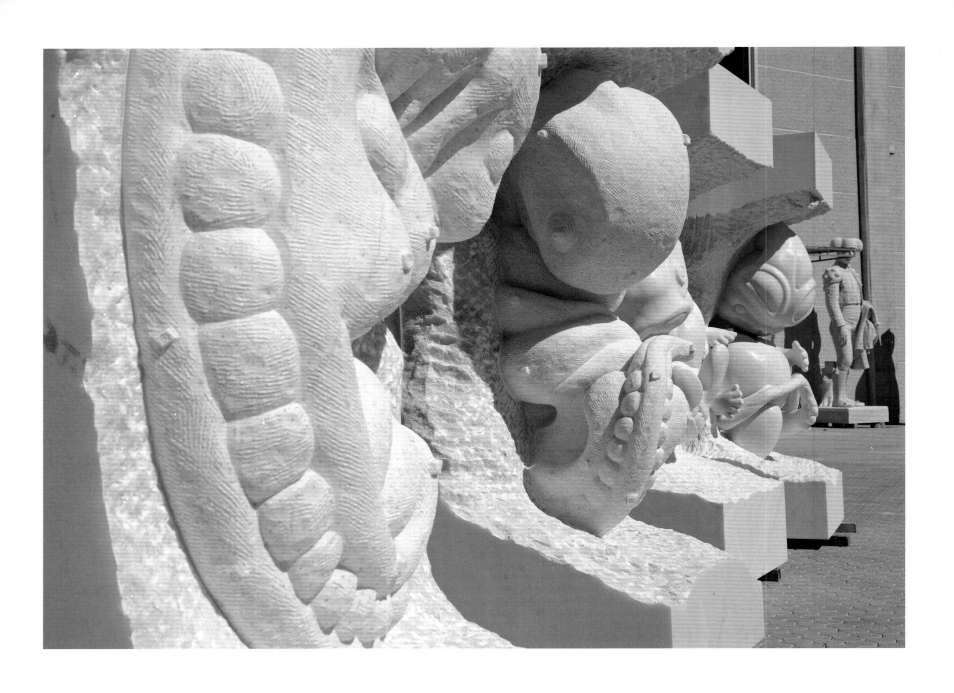

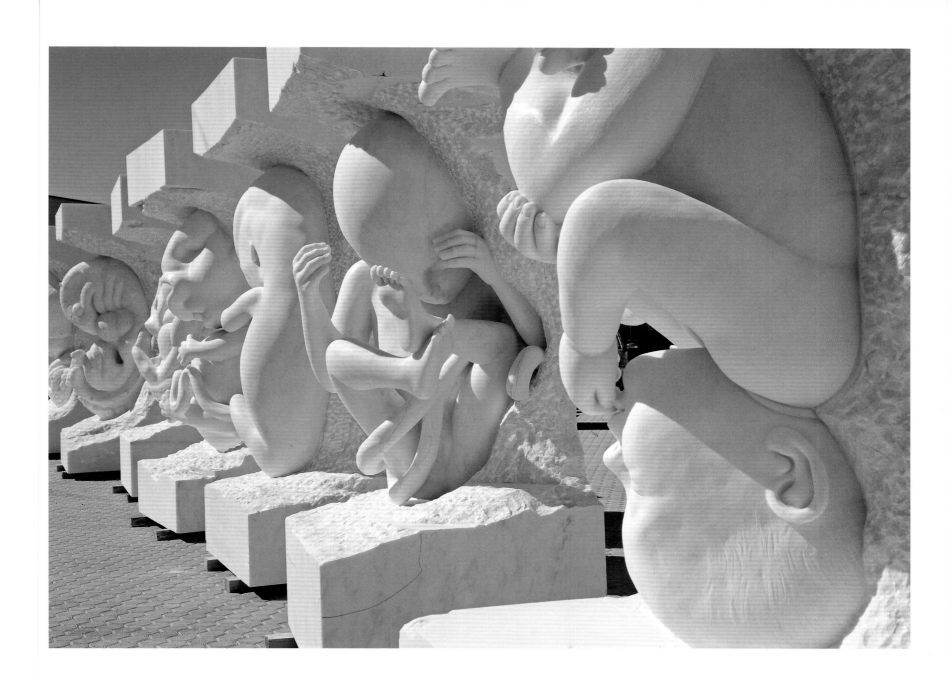

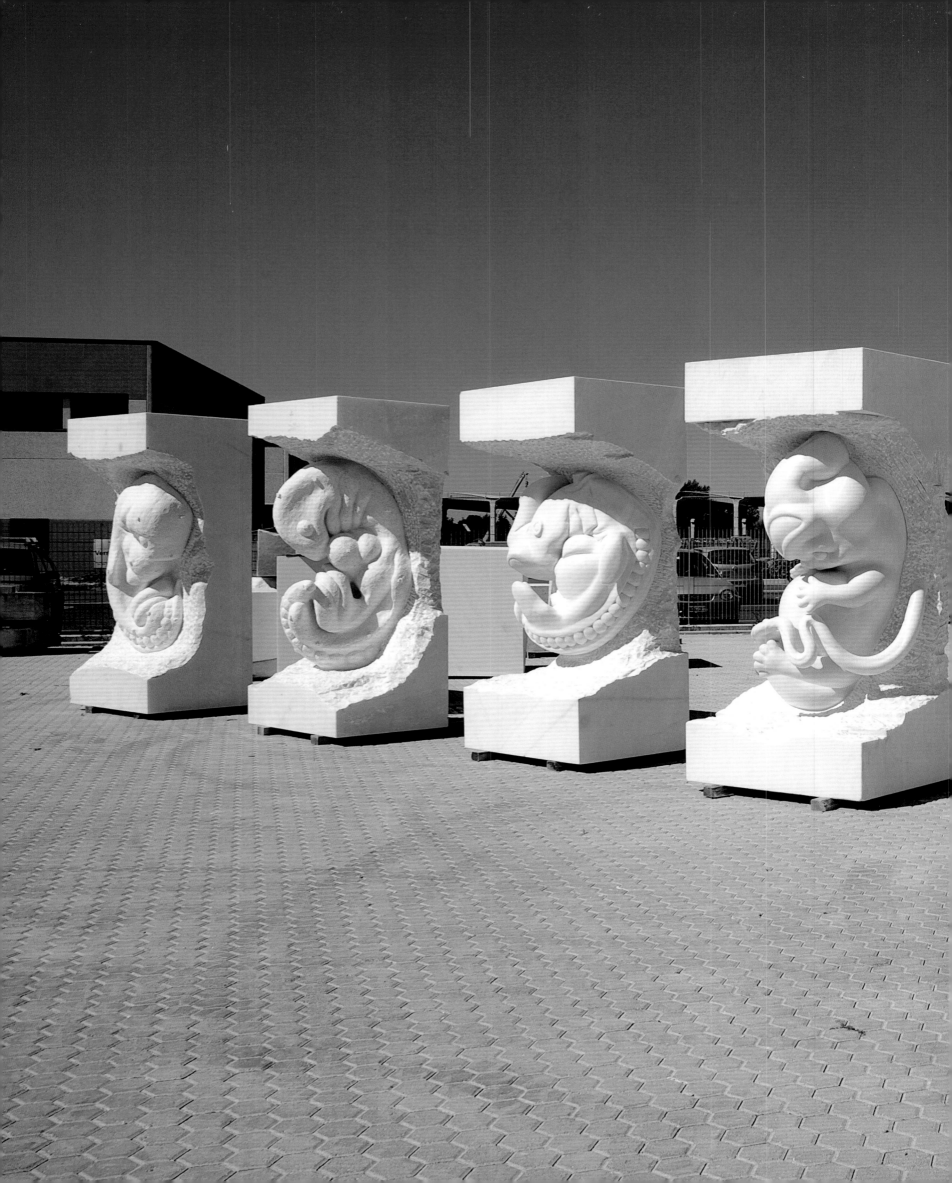

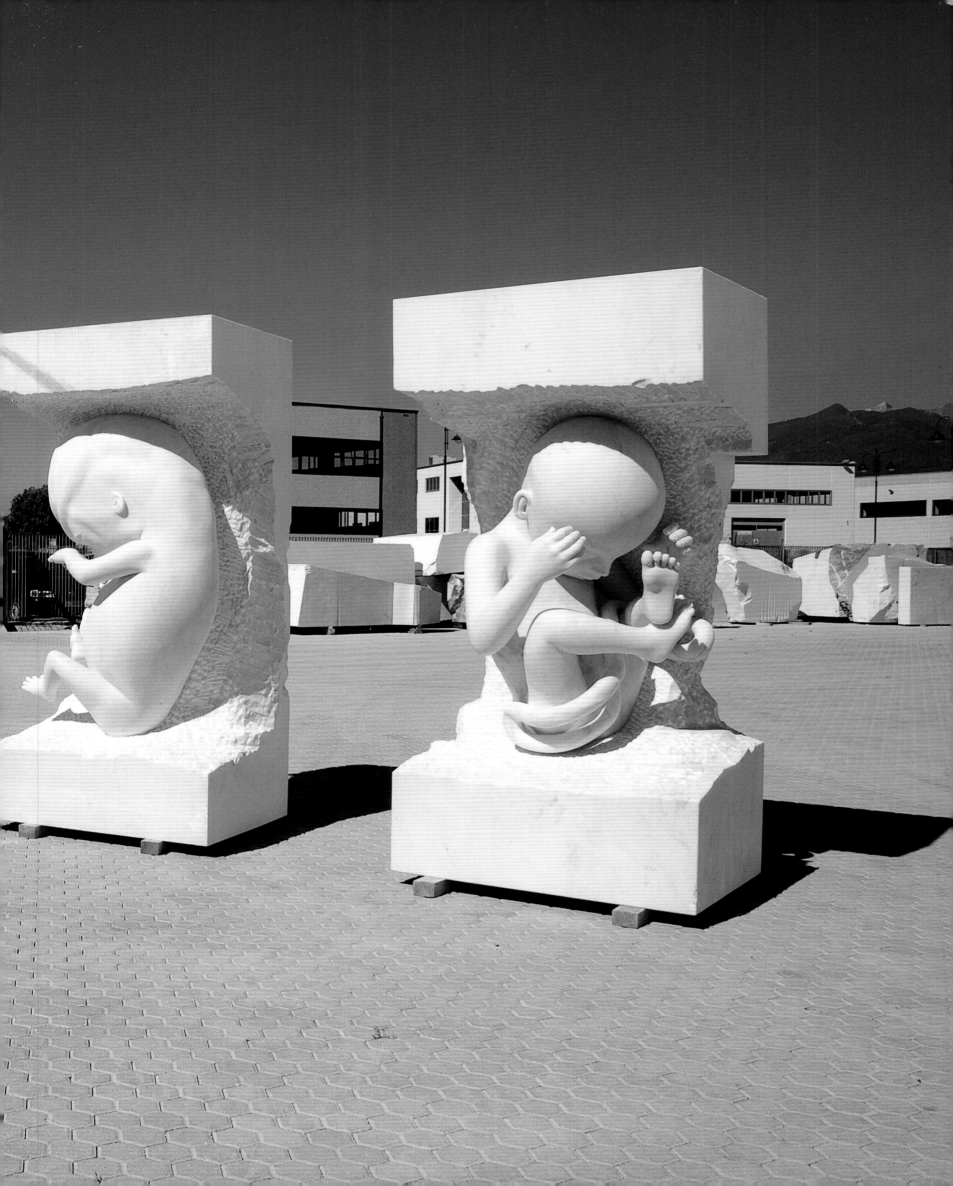

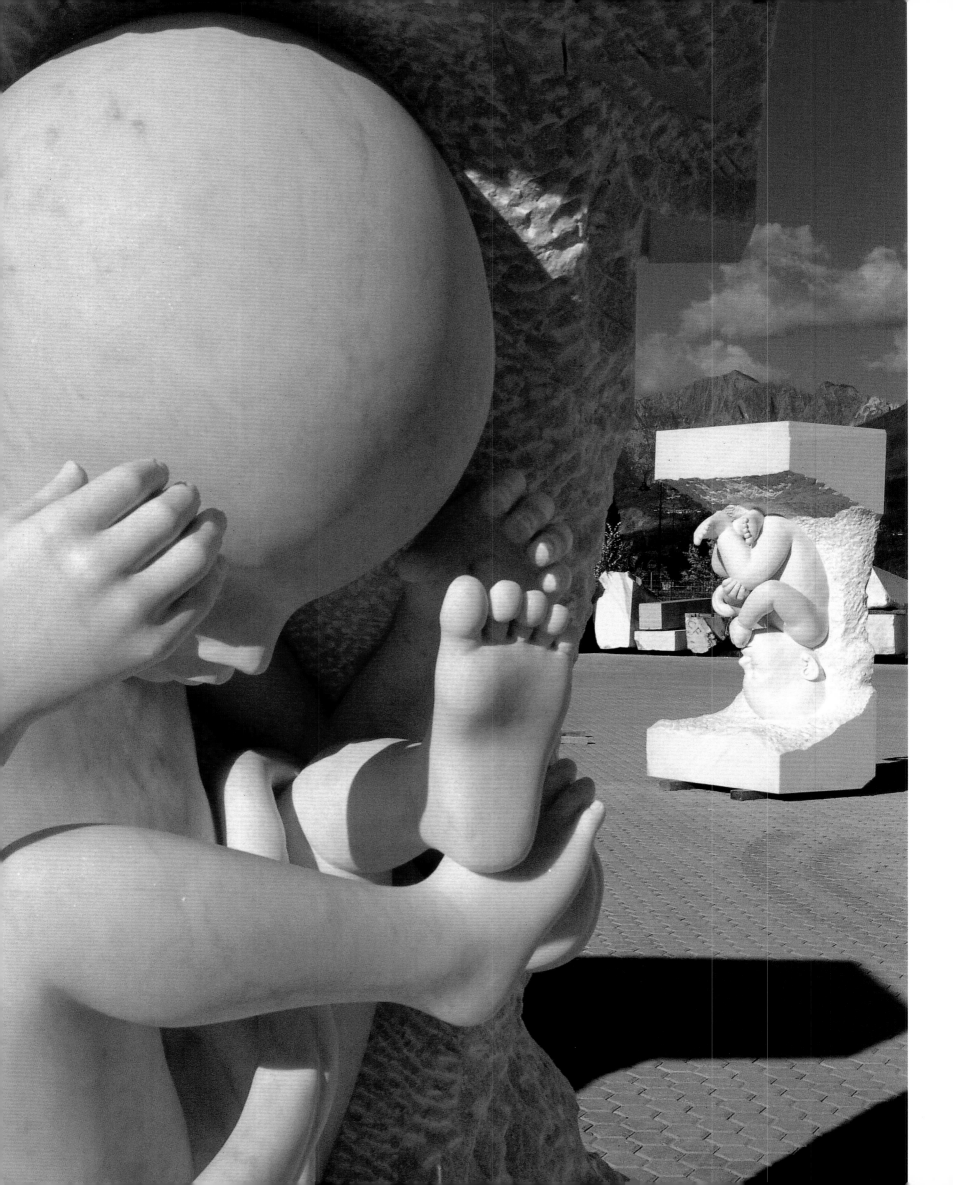

A Martian Anthropologist on Earth

**Will Self in conversation
with Marc Quinn**

Artist's studio, November 2007

Marc Quinn's studio is to the north of Clerkenwell district in central London. Clerkenwell, with its history of precision engineering and cutlery manufacture, and its proximity to the meat market of Smithfield, seems to possess exactly the right historical geography – and psychogeography – for the Quinn project. And, of course, it was the Fleet Valley that William Blake had gazed upon, when, in 'Jerusalem', he recoiled from its 'dark satanic mills'.

The premises themselves are inconspicuous: a purpose-built atelier, perhaps 1980s, its exterior rendered with stock London brick. Once inside, you could be forgiven for thinking you were in an upmarket design studio, or a cutting-edge architectural practice. Forgiven, that is, until you see the work. Right inside the translucent-glass front door kneels *Angel*, the foetal skeleton that Quinn recently exhibited in Winchester Cathedral, while straight ahead there are the enigmatic, gold-leafed features of an ascetic, 19th-century Thai Buddha bronze.

Upstairs, on the walls, there are the enormous canvases that make up the new series '5th Season', their mutant Rousseau greenery effulgent in the artificial light, while placed here and there are other Quinn works: the marble torso of a physically disabled man, the contorted yoga position created – by the artist himself – for the world's most famous supermodel. Downstairs there are more Quinns and more votive objects: a grey stone sculpture is a 2nd-century Gandharan depiction of Padmapani; the emanation of Bodhisattva Avalokiteshvara holds a lotus flower in a levitated meditation. There's a 3rd-century Roman marble bust of the Emperor Alexander Severus as a boy, and – perhaps most intimidating of all – a fragment of an Egyptian cartonage mummy case from the Ptolemaic period, its thin plaster shell hand-painted with features at once guileless – and monstrously indifferent.

Some artists might, perhaps, feel intimidated by displaying their own work in such an association of deep time, but Quinn's gamble – if that's what it is – pays off triumphantly. His own pure forms and severe depictions have the presence – the gravitas, even – to more than hold their own. As for the artist himself, in conversation he has a diffident, detached manner, that while in no ways contrived, nonetheless serves as a mask to hide his own fervid commitment.

ws: I want to talk a bit about process. Do you conceive of your pieces as being discreet or do they follow on from one another? For example, with the new series of large marble works, 'Evolution', can you identify the moment that you started thinking about that as opposed to thinking about something else?

MQ: Well, I think everything is both a reaction to everything else and connected to it. In a way, the 'Evolution' pieces come from the marble sculptures – like the one of Alison Lapper – and the idea that they're a celebration of a different kind of body shape, while we are obsessed with notions of normalcy. Then I was flicking through a medical book and realised that actually every single person who had those reactions has looked, at one time, much stranger and far more different.

I think another source were the DNA sculptures I'd done – like the DNA garden. A DNA portrait is great because it works not only in three dimensions but the fourth: time. It's also great because it's the ultimate ancestral portrait: all your predecessors – human and otherwise – are somewhere in that strand of DNA. Then I was talking to a doctor who reminded me that the morphology of a foetus also recapitulates evolution: every life form is articulated by its

A Martian Anthropologist on Earth

**Will Self in conversation
with Marc Quinn**

Artist's studio, November 2007

Marc Quinn's studio is to the north of Clerkenwell district in central London. Clerkenwell, with its history of precision engineering and cutlery manufacture, and its proximity to the meat market of Smithfield, seems to possess exactly the right historical geography – and psychogeography – for the Quinn project. And, of course, it was the Fleet Valley that William Blake had gazed upon, when, in 'Jerusalem', he recoiled from its 'dark satanic mills'.

The premises themselves are inconspicuous: a purpose-built atelier, perhaps 1980s, its exterior rendered with stock London brick. Once inside, you could be forgiven for thinking you were in an upmarket design studio, or a cutting-edge architectural practice. Forgiven, that is, until you see the work. Right inside the translucent-glass front door kneels *Angel*, the foetal skeleton that Quinn recently exhibited in Winchester Cathedral, while straight ahead there are the enigmatic, gold-leafed features of an ascetic, 19th-century Thai Buddha bronze.

Upstairs, on the walls, there are the enormous canvases that make up the new series '5th Season', their mutant Rousseau greenery effulgent in the artificial light, while placed here and there are other Quinn works: the marble torso of a physically disabled man, the contorted yoga position created – by the artist himself – for the world's most famous supermodel. Downstairs there are more Quinns and more votive objects: a grey stone sculpture is a 2nd-century Gandharan depiction of Padmapani; the emanation of Bodhisattva Avalokiteshvara holds a lotus flower in a levitated meditation. There's a 3rd-century Roman marble bust of the Emperor Alexander Severus as a boy, and – perhaps most intimidating of all – a fragment of an Egyptian cartonage mummy case from the Ptolemaic period, its thin plaster shell hand-painted with features at once guileless – and monstrously indifferent.

Some artists might, perhaps, feel intimidated by displaying their own work in such an association of deep time, but Quinn's gamble – if that's what it is – pays off triumphantly. His own pure forms and severe depictions have the presence – the gravitas, even – to more than hold their own. As for the artist himself, in conversation he has a diffident, detached manner, that while in no ways contrived, nonetheless serves as a mask to hide his own fervid commitment.

ws: I want to talk a bit about process. Do you conceive of your pieces as being discreet or do they follow on from one another? For example, with the new series of large marble works, 'Evolution', can you identify the moment that you started thinking about that as opposed to thinking about something else?
MQ: Well, I think everything is both a reaction to everything else and connected to it. In a way, the 'Evolution' pieces come from the marble sculptures – like the one of Alison Lapper – and the idea that they're a celebration of a different kind of body shape, while we are obsessed with notions of normalcy. Then I was flicking through a medical book and realised that actually every single person who had those reactions has looked, at one time, much stranger and far more different.

I think another source were the DNA sculptures I'd done – like the DNA garden. A DNA portrait is great because it works not only in three dimensions but the fourth: time. It's also great because it's the ultimate ancestral portrait: all your predecessors – human and otherwise – are somewhere in that strand of DNA. Then I was talking to a doctor who reminded me that the morphology of a foetus also recapitulates evolution: every life form is articulated by its

41

development. It's analogous to starlight being 100 million-years old. I like the idea that 'Evolution' is looking back in time, and that the rock the pieces are made from is approximately 3.4 billion-years old. So, overall, the series connects many different kinds of origination: we, ourselves, are sculptures *of* a body, sculpted *by* a body; my sculptures are thus sculptures of a sculpture. And, as the body-as-a-sculpture's qualities are generated by the embryo's DNA, so these sculptures are generated by the marble.

ws: What attracts you to working in marble? Is it a type of pictorial frame – created, in this case, by the plangency of classical allusion?

MQ: I suppose there is a reference here to Michelangelo's 'Slaves', although the allusion is more to Michelangelo than his sculptures. They're termed 'unfinished', although some of them, I think, have been left that way on purpose. Whichever the case, you have this sense of the image being born from the marble. It was also Michelangelo's idea that, whenever you work a piece of marble. Now, for him this may have been metaphorical – but he was right: sculpture really is the emergence of life from matter. What I find fascinating is why is this table inert while the atoms in you have somehow come together to make a Will Self. But what utterly intrigues me with this pink marble is that the material itself mimics the micro-veins and blood vessels under the skin. You don't get that with white marble.

ws: It's almost as if the DNA portraits merge with the marble.

MQ: Yes, but even more fundamentally, it is like the rainbow sculpture I made where a fountain of water had light hitting it and – so long as the angle of instance is correct and the light is the right kind – it creates the third, emergent property: a rainbow. Life is an emergent property in precisely this sense. To propose the same question another way: when does something become another thing? The pieces in the 'Evolution' series are illustrations of that conundrum. And it begins with an uncut rock: so a rock with either – you could say – with all of them in it, or none of them.

ws: So there is a modification of Michelangelo's dictum?

MQ: Yes, because in his view the atoms in you could only ever have been Will Self. Also, in those days, you started with a block and then you had an idea to fit the block whereas, nowadays, people can make art out of anything and they don't usually make it out of blocks of marble and, if they do, they find the block to fit what they want. Even so, I love the idea that the Alison Lapper sculpture was sitting in a mountain in Italy for billions of years.

ws: So, to what extent is 'Evolution' a series of works of art about the genesis of an idea rather than the genesis of a body?

MQ: Hopefully both – and more: all levels of evolution, including the making of the work. It's not just about human evolution. And with the paintings for this show, the series '5th Season', it's about desire and evolution. Here we have all these different plants that couldn't exist in nature at the same time, but purely because of human desire, you can buy them all in the market on the same day.

ws: What you say reminds me of your giant freestanding orchid piece, entitled *The Overwhelming World of Desire*. I wonder whether that was a conscious allusion to the Schopenhauerian idea that all organisms are ceaselessly striving – desiring – in that way.

MQ: No, I think I just had the same idea as Schopenhauer [laughs], independently.

ws: But that *is* your kind of world view, to some extent, isn't it? I get a sense, looking at your work, that you have an enormous awareness of the standing-into-being of things; they're struggling *to be*.

MQ: Well they're struggling to *become*, yet chance has also determined what they actually *are*. What I loved about *Self* was that it was a sculpture completely dependent on infrastructure: if there was no electricity, the sculpture would split. If it melted and someone asked you: 'Where's the form gone?', you could only say that it hadn't gone anywhere: it *was* there and now it isn't. That struck me as a great metaphor for something that's alive. Where do people go when they die? They don't go anywhere: they just *were* and now they're not.

ws: It's like a Zen kÿan. Are the paintings only collectively named?

MQ: No, they also have individual titles. There are four in the show: one's called *Opening of the Northwest Passage*; another's called *Evacuation of Bewdley in Worcestershire*. They're all titles that evoke the change in things due to our new, mediated relationship with nature. I like the Ballardian concept of bringing the macro into the very British micro, hence: *The Flood Plain of the Thames*.

ws: In another artist this would be ludic; it would be game-playing. But I never get the sense from you that you're playing games at all – I think you're deadly serious.

MQ: For me, the work is the entire oeuvre and its connections. It's like a brain and there are synaptic connections between all the works. That's how a new work arrives: the other works spark a synaptic connection and create a new work which I then make.

ws: So the aim is to produce works that themselves are capable of generating other works.

MQ: Exactly: the work itself has to then tell you something you didn't know that it was about, otherwise it becomes boring illustration.

ws: I remember when we worked together back in 2000, when you were making *Garden*, the ideas we were kicking around at that time were of the work being contemplated in a radically different and evolved form of human culture. I wrote this piece to accompany *Garden* that was a bizarre picture of how the work might end up being seen in some distant future. And I always find that implication in your work: that the *viewer* either has evolved, or is in a state of evolution.

MQ: Yes, because hopefully, they create an evolution within the viewer. When you see an art work it *should* change something in you.

ws: Was that there from the beginning for you? Did you approach making art, when you came to it in the early '80s, with an idea of disrupting these categories: how viewers are expected to behave in galleries, how they are expected to react?

MQ: Yeah. I mean I always liked things that weren't what they seemed to be. I made the bread sculptures – heads in bread – and then they were moulded and cast in bronze so they appeared to be expressionistic bronze sculptures, while, in fact, they were formed purely by the random effects of cooking the bread. So... I like to subvert... I like things that appear at the junction of one thing and another.

ws: I was also thinking about the formal constraints of what artists do, and the way people approach gallery art with certain preconceptions about who

Alison Lapper Pregnant
2005
Marble
139 ³/₄ x 71 ¹/₁₆ x 102 ³/₈ in.
(355 x 180.5 x 260 cm)

they should be. It's like when a theatre audience goes to the theatre, they don't stand up on the seats, pull their trousers down and fart at the stage – or riot – as a rule. Your art seems to me to also disrupt. I never think you want your gallery viewers to behave like gallery viewers.

MQ: No. I think one of the great things about doing the sculpture in Trafalgar Square was that it took art out of the gallery and into the world, and people behaved how they wanted to behave. Every single reaction to that sculpture was brilliant, in my view, whether positive or negative, because it was part of an authentic encounter between the workaday world and art. I think that's something that's changed a lot in Britain in the last ten or fifteen years: contemporary art has become part of the central discourse in a way it wasn't before.

WS: Do you think that it was necessary, for this change, that conceptual artists became more – mainstream's the wrong word – more integral to society? And were you the right people – or the right artists – in the right place and time to do it?

MQ: I don't know. I mean, how can you compare? What I do know is that it was always vital, to me, from the beginning, to not merely be making decorative objects for bourgeois collectors – the work had to resonate with anyone.

WS: To what extent do you expect a viewer of the '5th Season' paintings, the 'Evolution' series, and these very strange, bronzed, chimerical plants that you've created and entitled 'The Nurseries of El Dorado', to have an intellectual reaction as opposed to an aesthetic one?

MQ: Well, I think it always has to be primarily aesthetic and emotional, then the intellectual unfolds afterwards, because otherwise people don't bother thinking about something *or* feeling it. When I make it, I feel first and then I think about what I've made and what it means in context of the other things I've made. You have to start with something visceral, whether it's beauty or shock, and then, once that's got under the skin, then you can begin deciding what it is you're looking at. It's like falling in love: you have to fall in love or hate with the work and then you think about why you did it afterwards.

WS: Do you fall in love with your own work?

MQ: I do, yeah. You know that you've finished a piece when you can look *at* it... when you separate.

WS: Proust says in *Remembrance of Things Past* that once you've fallen out of love with somebody, it's impossible to fall in love with them again because, by that fact alone, they've changed...

MQ: And you've changed.

WS: Exactly: you're no longer the kind of person who would fall in love with that object. Does that resonate with you? Is that what it's like making works and then giving them to the world?

MQ: Yeah, although I can still enjoy works that I made before; I don't hate something as soon as it's finished, because I'm interested in them all as a totality: how they connect. Still, the next work is obviously always the most exciting one.

WS: With a series like the meat sculptures you exhibited in Ireland, what did you think you were doing when you adopted a classical typology for them? You're not game-playing, are you?

MQ: No, it's more simple: they were just about different kinds of bodies and, by taking the idiom used for the idealised human body, and applying it to the abject and despised animal body, you get an interesting clash.

WS: But you're never tempted by pastiche, are you? Some artists would reference advertising or popular culture, but you don't do that – do you know why?

MQ: To do pastiche, to reference – this is to suggest an intellectual position; and when I start to make art, I have none. I'm not exactly naïve – but I am enthusiastic. I always think that whatever I do will somehow fit in, in some way, so this keeps the individual works simple: they are new departures. To be a pasticheur... well, that would be like having a great wallchart that gives exhaustive examples of what Marc Quinn artworks *can* be, together with things that they *can't* be. Whereas I'm just interested in what it is to be a person in the world: the direct and unmediated experience.

WS: Some works, like the 'Shit Paintings', do assault the viewer, don't they? But, again, I don't think of you as a provocateur.

MQ: Well, whenever people say that I'm a shock artist I think it's a complete misunderstanding. I want to find something new and surprising, and to broker a different relationship between this and a viewer; but to shock just for the sake of it – that I don't understand. It's not my motivation. My conception of it – and this is how I see the 'Shit Paintings' – is that I think people are shocked when an artist expresses something fresh in terms that they think of as deeply, in this case intimately, familiar.

WS: Bearing this in mind, I imagine people might well wonder *how* you work; by which I mean: what is your initial medium?

MQ: I like to do lots of different things at the same time. I've got a very low attention span, but also, they take different amounts of time. A marble statue of an embryo takes roughly eight months to carve, but I'm not sitting there for eight months waiting for it to be finished. I made clay originals of all of these sculptures, which were then cast in fibreglass and embedded in polystyrene rock. Then I cut this away to make it exactly like I wanted the finished work. Then that's taken to Italy where stonemasons transpose it into a block of marble. Obviously, I go there quite often to make sure that things are happening and say, 'Oh, stop now, this is enough', or 'Leave that bit like that', or 'Let's add that bit there', but, essentially, it's a transformative medium – like going to a bronze foundry – so there's no point in sitting there all the time.

WS: Did you know how many pieces there would be in 'Evolution' – and the relevant stages in gestation – from the beginning?

MQ: I chose the stages for their morphology, there isn't one from each month: they're much more concentrated at the beginning and the end because there's a period of growth without change that isn't so interesting.

WS: I was struck by the way in which they're going to be arranged, which seems almost sacerdotal.

MQ: Yes, like a burial chamber, or a tomb, but I'm not sure how strictly geometric it will be. I want to go to Italy next week and play around again in the yard. And, finally, in the gallery.

WS: Is that the moment when things are finished for you?

MQ: Certainly, with a series like this one, it's when you see them all together,

out of the context in which they're made – that's when you can detach and start thinking about new things.

WS: I get the sense that, in recent years, you've been feeding off the past and off classical sculpture, not looking for ideas but looking for formal properties, typologies. Would that be fair?

MQ: Obviously, that's the case with the marble statues; I wouldn't say it's true of the flower sculptures. With the Kate Moss sculptures, maybe, a little bit. They seem to be more contemporary in their language – but they do have references.

WS: We took a trip to Easter Island earlier this year to look at the Moai and I wondered if that had shaken down.

MQ: I think it *is* shaking down: the huge Kate Moss I did in September for the show at Chatsworth was quite Moai-like to me; and I did the Darth Vader head in concrete that was also quite Moai-like. But you never know when an influence will assert itself. I think it's a question of filling yourself with as many influences and experiences as possible, then your subconscious does the rest.

WS: Do you feel a conscious hunger?

MQ: Yeah, I always want to absorb things.

WS: You never feel full up?

MQ: No.

WS: I feel myself trapped often in language, as a medium, and quite full up with literary representations of the world.

MQ: It's like a food addict compared to a drug addict: a drug addict can give up their drug and live a normal life without having to encounter it again; whereas a food addict has continually to deal with their drug of choice even when they're in recovery.

WS: So, you're the food addict.

MQ: No *you* are because words are everywhere.

WS: But aren't images everywhere as well?

MQ: They are, yeah, but I'm not in recovery yet. I'm still bang out there!

WS: You're still in full-blown addiction, and that's how you describe it. This is very interesting. Is it obsessive for you, then?

MQ: There is a certain obsessive quality to work for me, yeah, definitely.

WS: Do you find it hard to stop thinking about it?

MQ: I often wake at night thinking about it. But then I can go away on holiday. I used to live where I worked and then it was incredibly difficult to stop. My natural state is to be completely obsessed, all the time, so I build in these controls that make me do other things, otherwise I would go mad.

WS: Do you think that working with other craftspeople and technicians is also a check and a provider of balance?

MQ: It is, and it's also a way of interacting with the world – and with other people. I'm interested more and more in the relationships between people and articulating that in the work. The paintings are executed with assistants who have been trained up to paint with me, so part of the pleasure of doing them is collaborative. Talking about the work, discussing it, working together – I love those aspects.

WS: But you don't actually want them in the studio, do you?

MQ: They're never in the studio, no.

WS: You like to visit them, which is a hierophantic and magical role.

MQ: Yeah, I like to visit them: I don't like having 30 people here. Some people like having hundreds of people in their studio; I can't stand that.

WS: You've entitled these strange, chimerical plants 'The Nurseries of El Dorado'. It's an allusion to a failed civilisation.

MQ: Yes, each one will also be titled by the Latin names of every single flower in that hybrid: so, incredibly long, Latin names.

WS: Which suggests scrambled DNA.

MQ: Exactly, like the long train of DNA.

WS: This isn't ludic, you're not playing games here?

MQ: Well, it depends what you mean by a game, because it's all a game, really, and it's making the game a game about important things rather than superficial ones.

WS: But for something to *really* be a game, it has to be distinct from what's really serious, whereas, for you, a game *is* serious.

MQ: Certainly, because there's a ludic quality to Beckett, for instance, or Jarry, or Duchamp, that doesn't in any way detract from their seriousness.

WS: By analogy, with your environmental work, I don't get the sense that it's agitprop for the green cause.

MQ: Well, I think climate change is a very human problem; or, at any rate, we're only capable of seeing it anthropocentrically. I don't think that it will be the end of life on Earth, I don't think it's the end of the planet. There have been ice ages before – whatever. It's the end of the human race, perhaps, but to think that it's the end of the world is very arrogant and self-centred, I think. And what I'm interested in... you know, the world will hybridise into something else, while humans themselves are continually evolving. In fact, in ten million years, this series of marble sculptures might only be half of the story. There might be ten other ones continuing the series, and people will look at the ones depicting our ontogeny, and say: what a primitive life form.

WS: Of course, because of the impact of our own technology, our physical evolution may be curiously maladaptive.

MQ: Absolutely. We may evolve towards being non-moving, super-intelligent blobs. Perhaps the more active of the blobs will learn to walk a few steps: you know, there'll be an Olympics for walking eight steps... [laughs] ...something like that. But that would have to be a slave society, whether the slaves were machines or another species. Of course, none of this implies that we should, therefore, do nothing about global warming – that's not the case. I think we should do everything we can, but I do think that it's a problem for the human species. And maybe not even a problem: we'll be adaptive. But it's a human thing – it's not the end of the world.

WS: All of this has been present in your work for a while now, going back to *Garden*, in 2000 – the preoccupation with mutable environment and human impact.

MQ: In fact, with *Garden* – and this is in retrospect – it's an environment held in suspension by our infrastructure, but there's no moral judgement implied, because I think the more you present a work as metaphor, the richer it becomes to people viewing it. Once it has a very defined view you can only agree or disagree with it, which are merely two reductive reactions in place of a multiplicity.

For myself, some of the works verge on being objects of philosophic

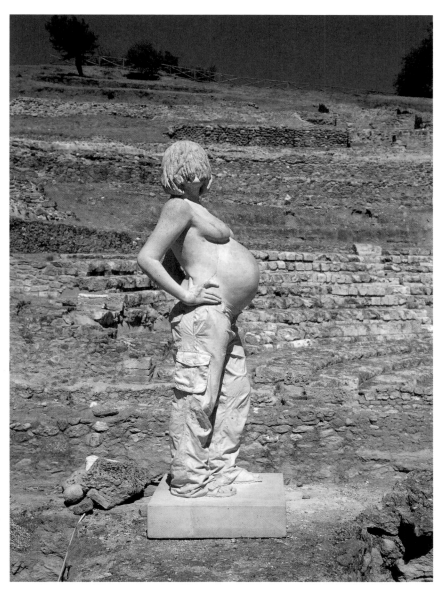

Hoxton Venus
2006
Concrete
70 $^1/_2$ x 23 $^7/_8$ x 23 $^7/_8$ in.
(179 x 60.7 x 60.7 cm)

contemplation – especially given that they're concerned with time, the different levels of time: human time, geological time, the timeframe of the universe. Our time isn't the only one, so, there's this aspect of the work that involves freezing flowers, and there's also this other disambiguation, because when you take a flower and you freeze it, you get this magic trick happening before your very eyes: the flower is now dead but it's an image of itself as it was alive, at exactly the same scale, taking up exactly the same position in space. 'The Nurseries of El Dorado' series both complements this and contrasts with it, since however many completely dissonant and wrong flowers and plants are put together, you always accept it immediately as a real plant and, to me, that suggests that we're programmed, in a way, to accept evolution.

WS: Or we're programmed to try and accept it. We want to fit it in and maybe that very ancient part of us that is concerned with recognising and using the environment more than anything else is determined to assimilate these mutants nouveaux.

MQ: That's, I think, a very interesting element of it. We've put ourselves in the condition of insects: an orchid that mimics another insect, and an insect goes to it, and tries to mate with the plant. These sculptures mimic a natural object – we know they're not, but we think they are.

WS: So, is that what's going on here? You're creating, as it were, the mutated flowers for human bees who lust for art to rub up against...

MQ: Exactly.

WS: ... and collect the pollen of meaning.

MQ: Correct.

WS: I don't know how well your audience – let alone your collectors – will take that. Tell me, do you feel isolated in what you do, or do you feel a kinship with other artists?

MQ: I think everyone's different, but with the people who are making art at the same time as you there has to be some kind of a relationship because you're all open to the same influences and environments.

WS: There are those artists who have a preoccupation with people who have made things before, but I don't feel that about you – you're not like Bacon repainting Velasquez over and over and over again.

MQ: No. I'm interested in the future, not the past, even though a lot of the things I do reference the past: I don't want to recreate, I want to create.

WS: Do you feel yourself to be part of a movement in contemporary art?

MQ: Only as far as I *am*, in that I'm here in London making work and being labelled that way... but, no, I think every artist is on their own. To be honest, Will, I don't think about it very much, those questions. I'm not a person who likes to be a member of groups, and I find it easier to speak to artists in other mediums, like you, than artists who work in the same one, although I do have friends who are artists as well.

WS: You have a very literary turn of mind. I was very struck when we were travelling together, that I was able, sounding off you, to come up with a whole collection of stories. I came back and told people: I don't think there's anybody, in any medium, with whom I've had that kind of rapport.

MQ: But I think we're both fascinated by ideas and we express our ideas in different mediums, don't we, but, essentially, we could almost swap positions.

WS: Possibly – but I'm struggling to understand how it is that you translate your language of thought into imagery and objects.

MQ: You have to have at least two elements: one is the idea and the other is the medium, then you have to let it happen. That's the most important thing: to let the thing happen and to follow it and not to stifle it by trying to make it what you originally wanted it to be.

WS: So, to take an example, the year before last, you were sitting in on operations, and were starting to think about the medium – if we can call it that – of surgery, and that's, presumably, something that's still running on in the substratum of your mind.

MQ: Exactly. And, who knows, maybe it will pop up after these works are complete. You could argue there's a connection, after all 'Evolution' is a series of depictions of the inside of the body. I went to some plastic surgery operations and some heart transplants and other heart operations. They were incredibly strong experiences and I'm sure they will surface in some way. At the moment, I wouldn't like to even say *what* they were because that would tie it down.

WS: But is it possible to think of surgery as a medium?

MQ: Well, not as a medium. That would only be true if I was actually making the art works in living human flesh.

WS: You're tempted, aren't you?

MQ: [Laughs] It would be interesting.

WS: You're a voracious photographer, aren't you?

MQ: I'm obsessed by images, but also, what I love about photography – the thing that obsesses me most – is its relationship to the continuum of time. Photographs are like moments... I've always thought that it would be great to do a book called *Three Seconds of My Life*, and then take all the pictures at $1/500^{th}$ of a second so you could produce 1,500 pictures within that three seconds, but they would be 1,500 different moments. So, I like the idea of that compression. And, in a way, a frozen sculpture is like a photograph, because it, too, is a moment out of time.

WS: How much do you think your experience of addiction informs that preoccupation with time?

MQ: I hadn't really thought about it until afterwards but, in a way, all those frozen sculptures are dependent objects: they're all about dependence. Of course, in as much as we're all living, we're all dependent. But I think many people view this as an addictive society – so my concerns reflected wider ones as well.

WS: Myth is a kind of access to deep time, isn't it?

MQ: Well, myth is like the dream of society, isn't it? And dream is the myth of the individual. That's what I was interested in with the Kate Moss sculptures: trying to make a mythic image; an image that was part of our dream, yet was also intangible, invisible, floating. It goes back to that idea of the flower sculpture: when you freeze a frozen flower, it becomes an image detached from an object. And what we know as 'Kate Moss' is her image detached from Kate Moss as a person. The image has become this gargantuan and demanding *thing* that sucks up psychic energy like a black hole. Yet in the human mind there seems to be an instinct to create the images that, in fact, form us. So, do we form images or do images form us?

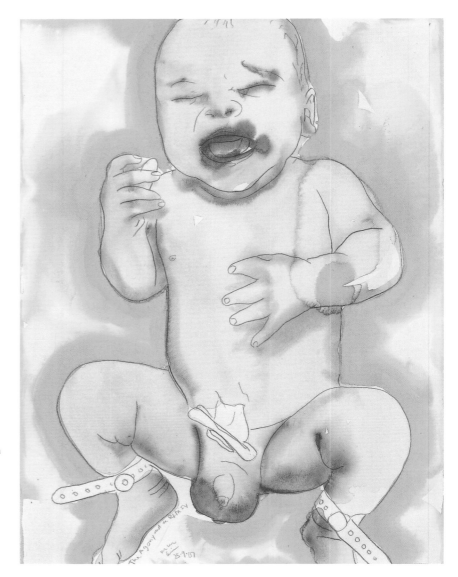

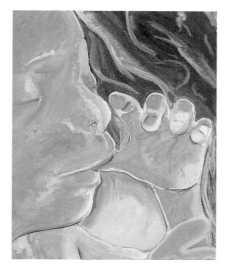

Portrait of Lucas on 04/06/01
2007
Oil on canvas
20 ¹/₁₆ x 16 ¹/₁₆ in. (51 x 40.8 cm)

opposite:
The Agony and Ecstasy
2007
Watercolour and pencil on paper
29 ¹⁵/₁₆ x 22 ¹/₁₆ in. (76 x 56 cm)

ws: Part of what you seem to be doing with the Moss sculptures, or the piece you exhibited in Winchester Cathedral recently, is to supply an image deficiency. Would that be true?

MQ: Yes, and I think these pieces are quite as real as a sculpture of Aphrodite or the Virgin Mary, as real and as serious as those images.

ws: So are you fulfilling the same role as somebody who created a work of devotional sculpture would have been?

MQ: Well, with the Kate Moss sculptures, very much so – that's why I link them to the Easter Island sculptures, because they, too, are devotional images of real people.

ws: To what extent do you stand in the same relation to those works, as Michelangelo would've done to the roof of the Sistine Chapel? Where's the religion here?

MQ: I suppose the difference is that there's a distance, although not an ironic one. I'm proposing them rather than believing in them.

ws: So, are they, in fact, suggestions of the absence of religion rather than its presence?

MQ: Well, they're things that mimic the functionality of those images without being done in order to propagandise a religion. Possibly, through such mimicry, these images are proposing that celebrity is the new religion, and if you took one of them somewhere, and someone found it, and they began to worship it, that would be fine because it would have become what it's proposing.

ws: So, it's a cargo cult for a culture that's materially superabundant?

MQ: Well, exactly, it could be. But, at the same time, I concede that this is quite a hard-headed analysis of what our relationship is to images and why we need to have these uber or supra images that can shape our lives.

ws: Are you satisfied? It seems an odd question to ask when you're about to show in a very prestigious gallery with a gallerist who you've been friends with for many years – but are you satisfied with this particular way of presenting your art?

MQ: There are lots of different ways of presenting art. This is one important way, but doing Trafalgar Square was interesting; doing things outdoors, doing differently, that can be very stimulating. However, ultimately, I think it depends on the work and how it demands to be seen.

ws: Some people who produce things that are commonly termed 'sculpture' feel very drawn to architectural space, but you seem more drawn to public spaces...

MQ: I'm more drawn to natural space. I mean, the idea of taking the Alison Lapper sculpture to Easter Island, to me, is much more exciting than putting it in a museum. The thing that you have to always remember is that all culture is a human construct: there's no natural culture, no rock that you're going to bump your head into that isn't put there by people – and therefore can be taken away again. That's one of the things about the art world that I find so ridiculous. There are no rules as to what art is, and yet people become obsessed with one way of doing things.

ws: Isn't that because people think of art as being a kind of DNA from which you can read other human cultural attributes?

MQ: That is a good way of looking at it, but I don't think that should prevent genetic manipulation. That's something people don't like to think about... I mean, obviously, society's invented to stop people thinking, isn't it, like religion – and that's why some of the things that are difficult, have difficulty finding homes. That's why the Alison Lapper sculpture didn't sell.

ws: I do find this astonishing and depressing, slightly – or not?

MQ: Well, not depressing because the work hasn't disappeared, and it will find a home. But it's baffling, I think, more than anything.

ws: What's your hunch about it in the last analysis?

MQ: I don't think people like to be confronted by things on that scale. But it's interesting because the large Kate Moss sculptures sold very easily, and they were the same scale. And, you know, in a way, that's your answer.

ws: Maybe that's the problem with *Alison Lapper Pregnant*: that it cries out for understanding of Alison Lapper's predicament – you can't get away from that.

ws: You've worked quite a lot with the bodies of those that are close to you: your children, your partner – is that a different sort of medium for you: the family?

MQ: It's not a medium, as such: it's not about having a family, it's just that I work with what I know, I suppose, and what comes to hand. If I didn't have a family, I'd work with other images.

ws: The bodies you've used that don't belong to your family, you've ended up forming relationships with, so there's something about working with other bodies that means you have to make that connection.

MQ: I think so. It's what we were saying before about the difference between the artist working alone in a studio and then collaborating with other people. It does seem that I'm interested in people even though I wouldn't have thought I was the kind of person who was. However, looking at the work *in toto* – a lot of it is about people.

ws: Your relationships with your models aren't like those between Picasso and his models: straightforward sexual interaction and appropriation.

MQ: No, it's more like blocking actors on a theatre stage. I've always thought it must be quite satisfying to be a director in theatre or films. And maybe I use actors in my art but in a different way.

ws: I wonder if there's not something almost science fiction about this practise, given what you say concerning human culture. It occurs to me that it's quite a Martian perspective.

MQ: What, like an anthropologist?

ws: On Mars.

MQ: Or on Earth?

ws: Or on Earth.

MQ: A Martian anthropologist on Earth?

ws: Yes.

MQ: That's exactly how I'd like to see myself.

Will Self was born in London in 1961. He is a fiction writer as well as a regular broadcaster on television and radio and contributor to numerous newspapers and magazines. He currently lives and works in London.

Evolution 0-IX

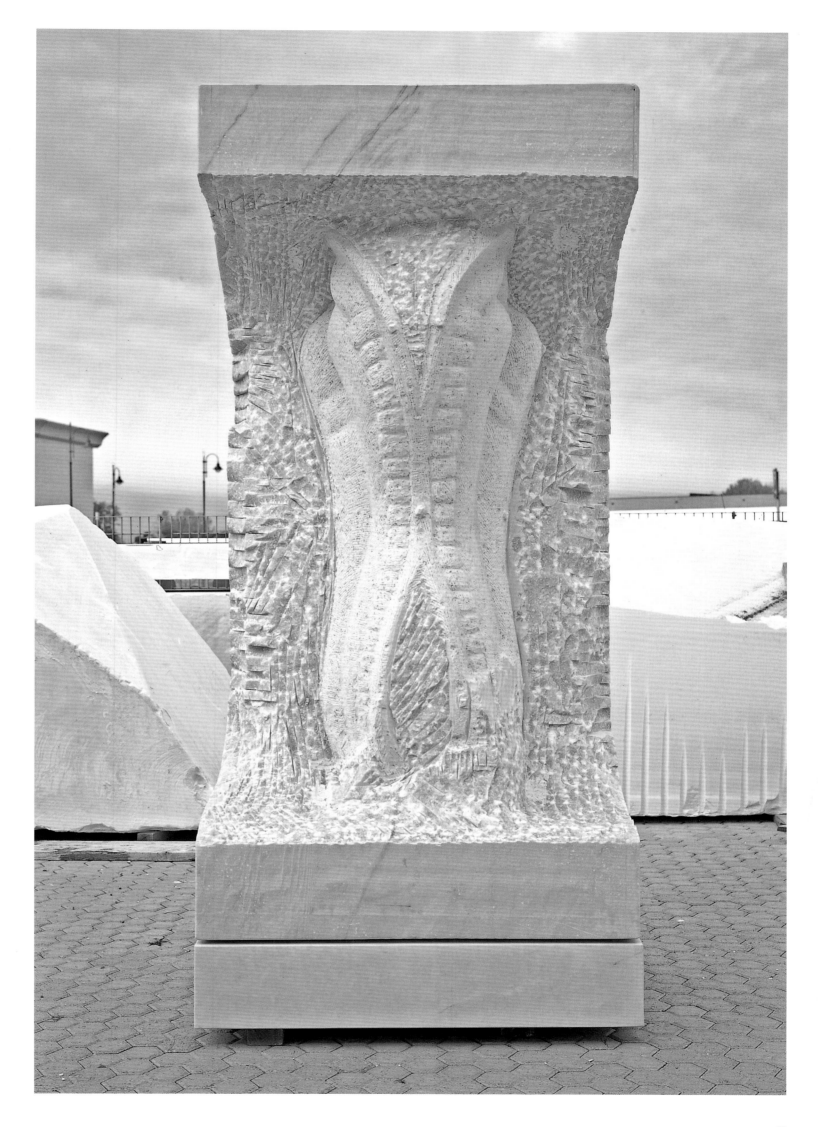

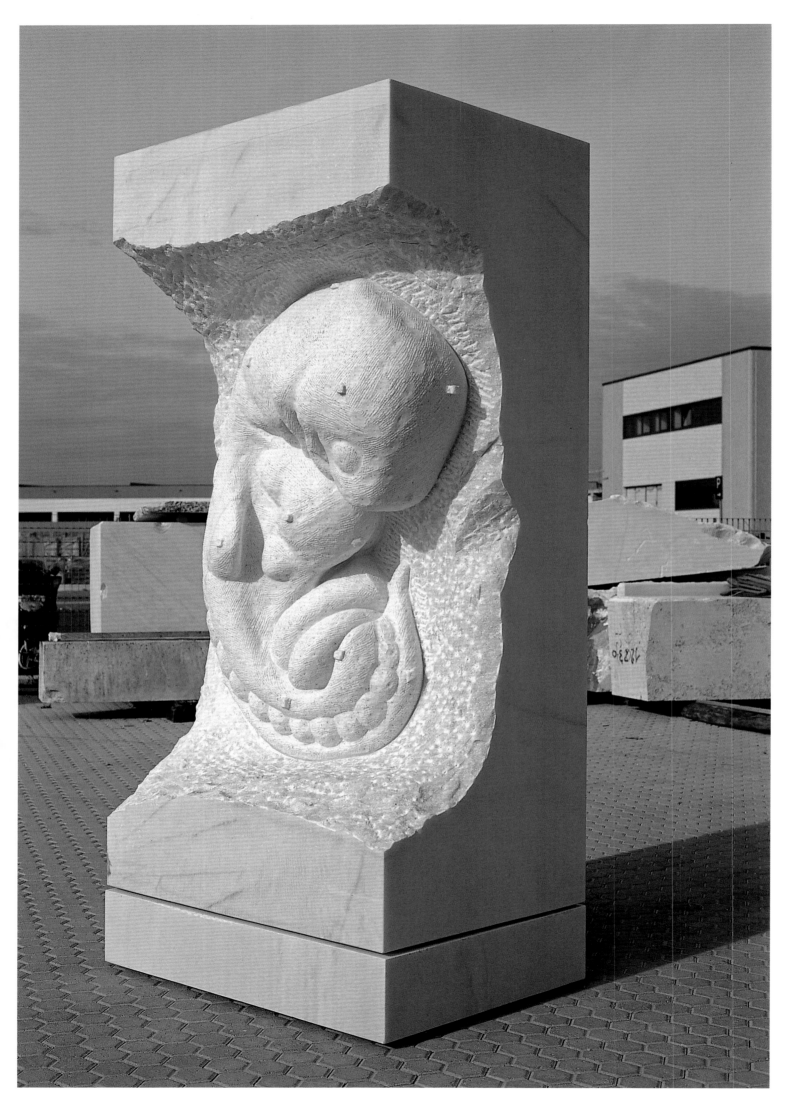

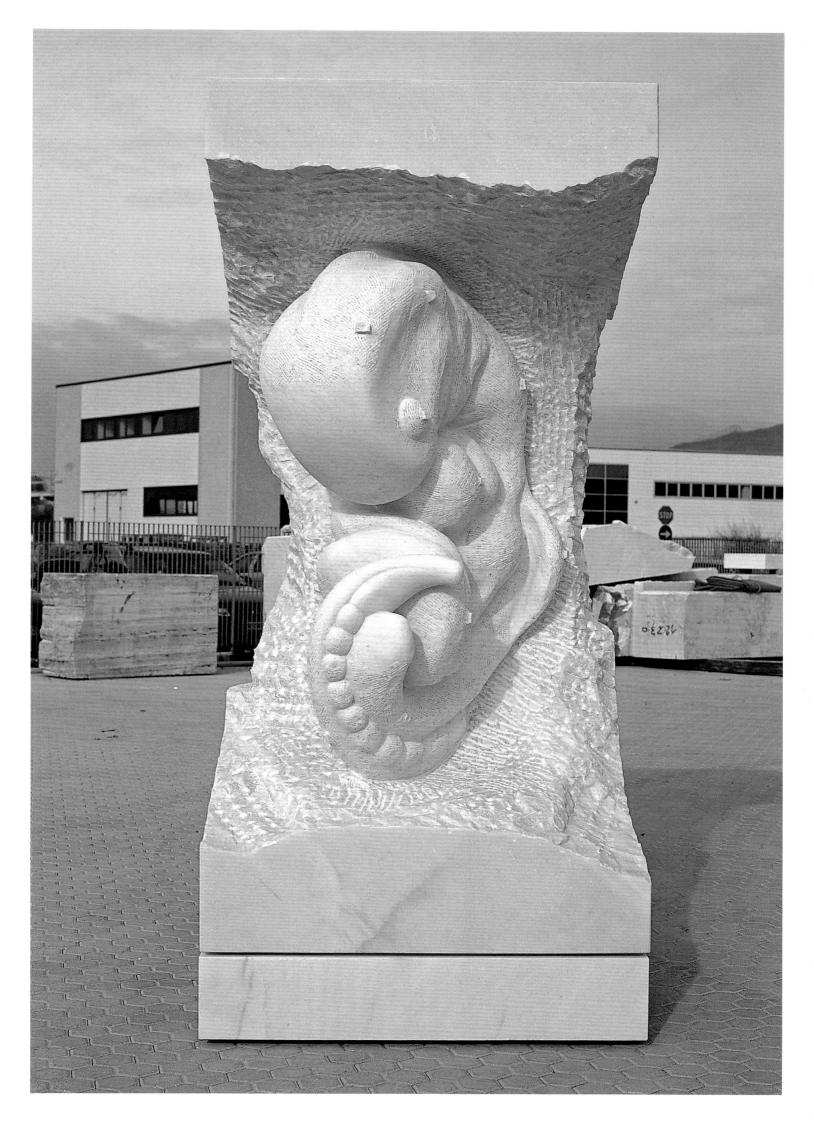

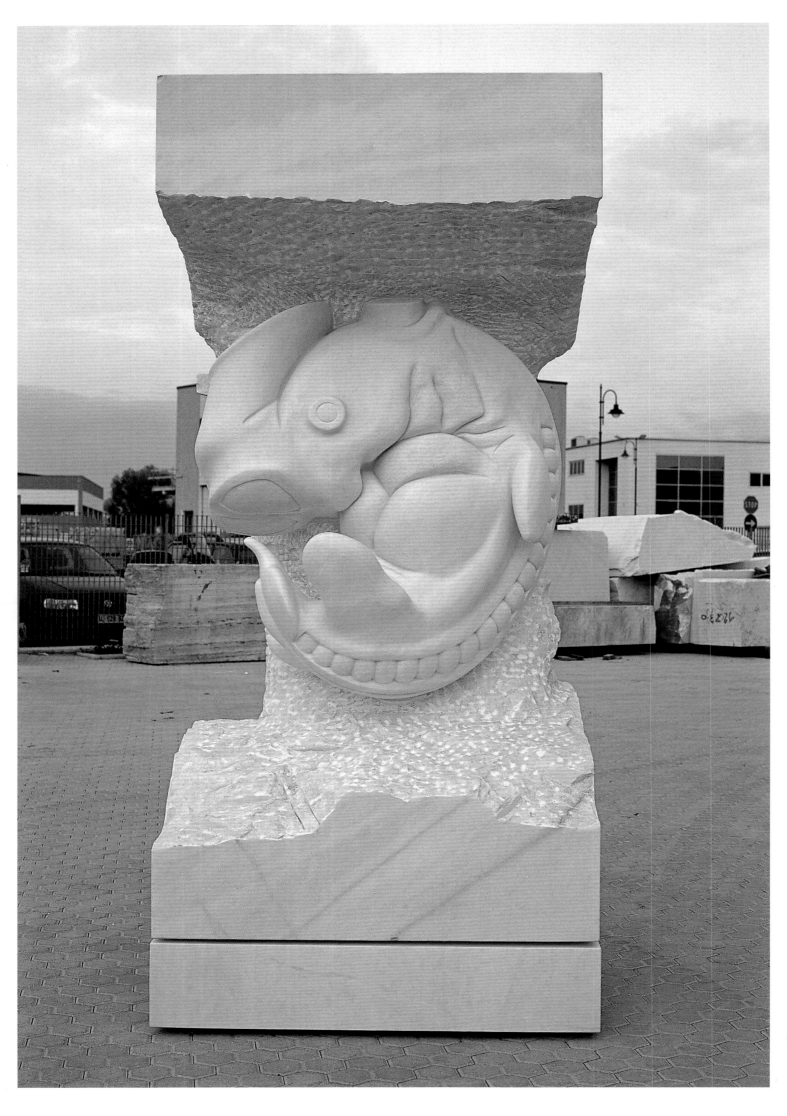

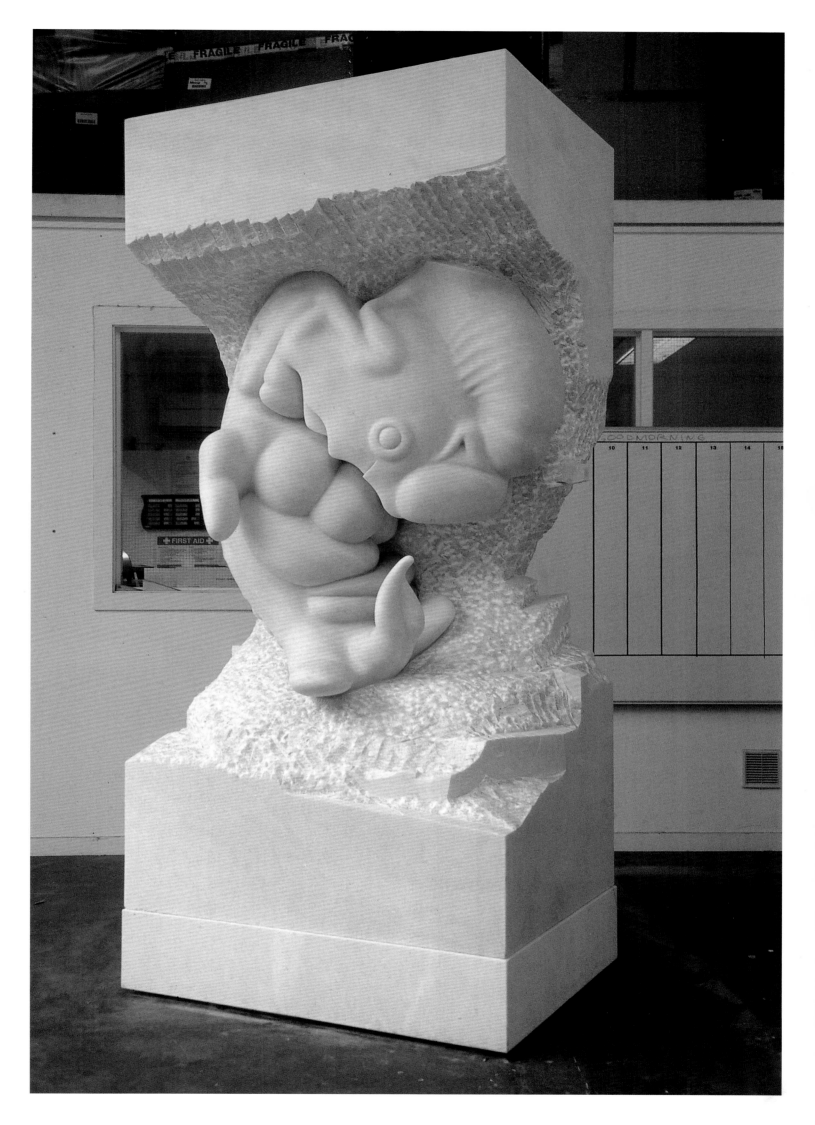

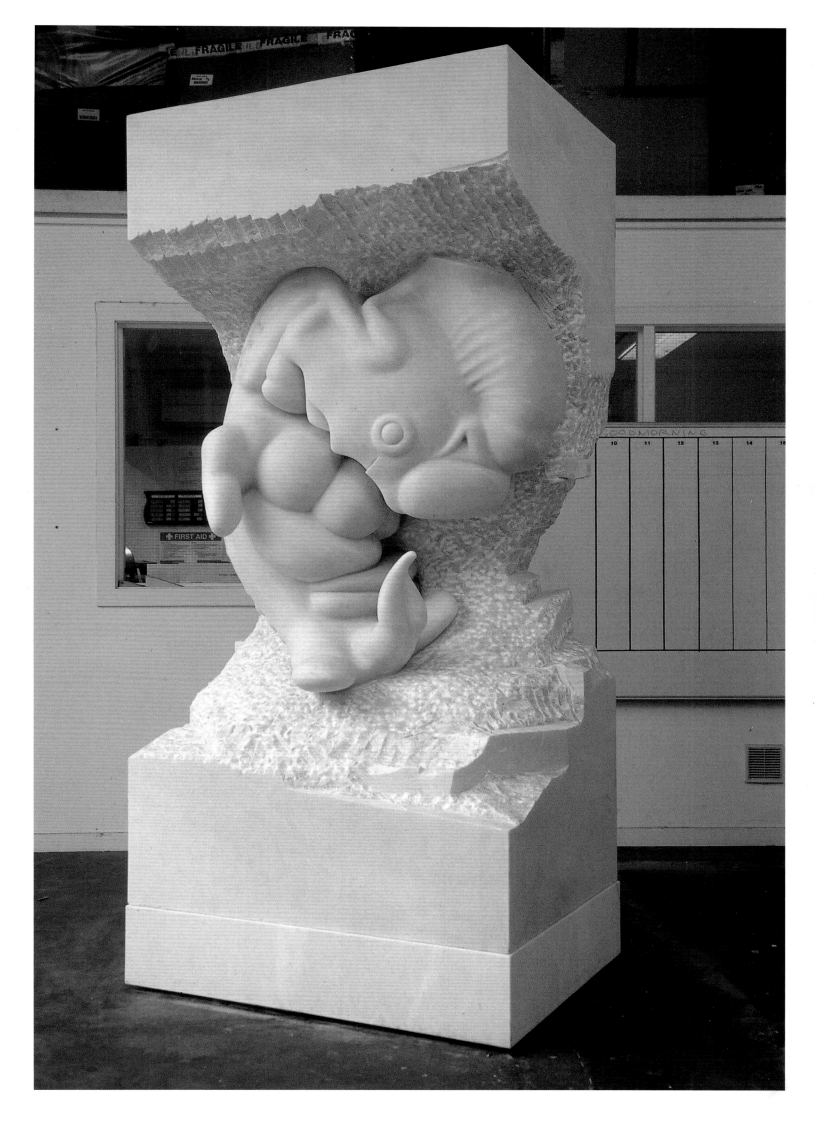

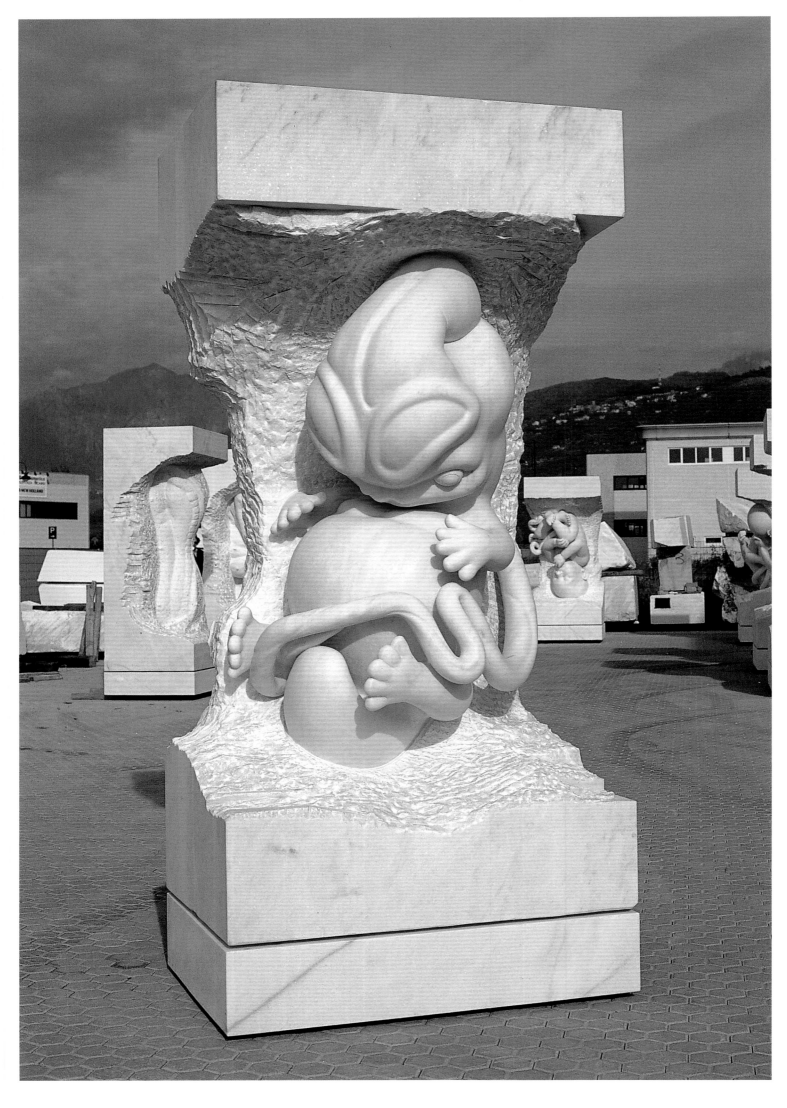

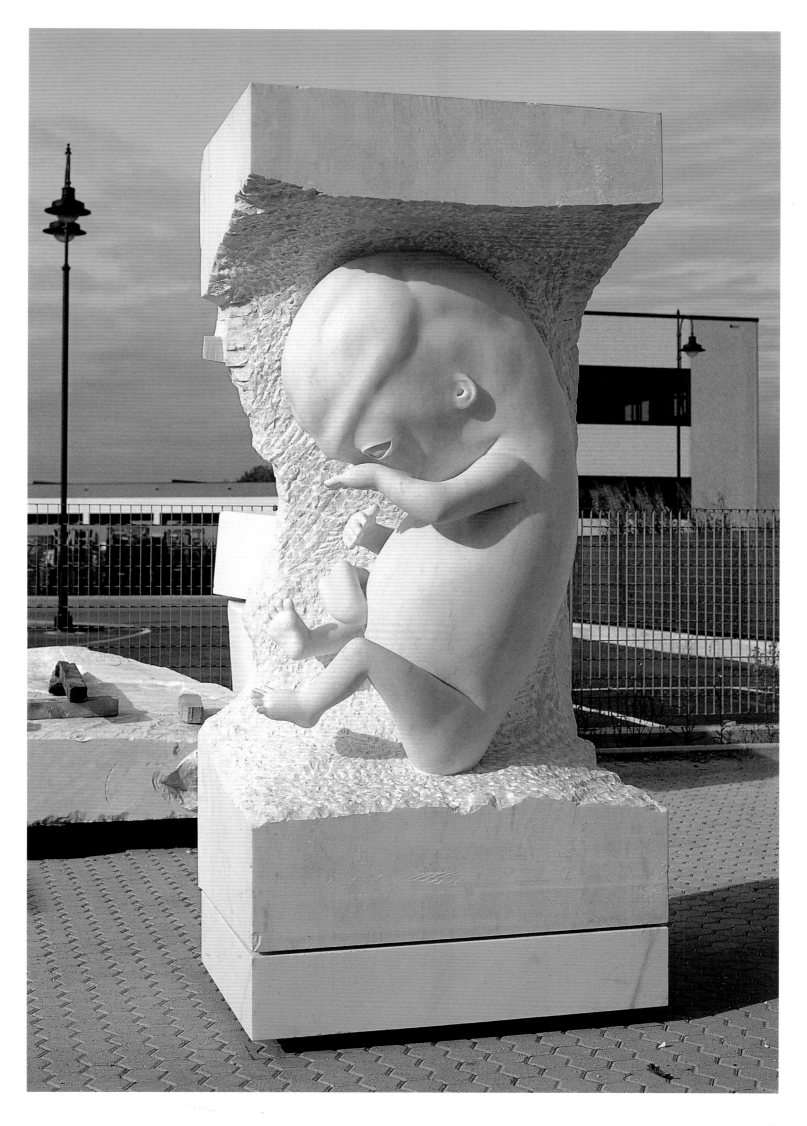

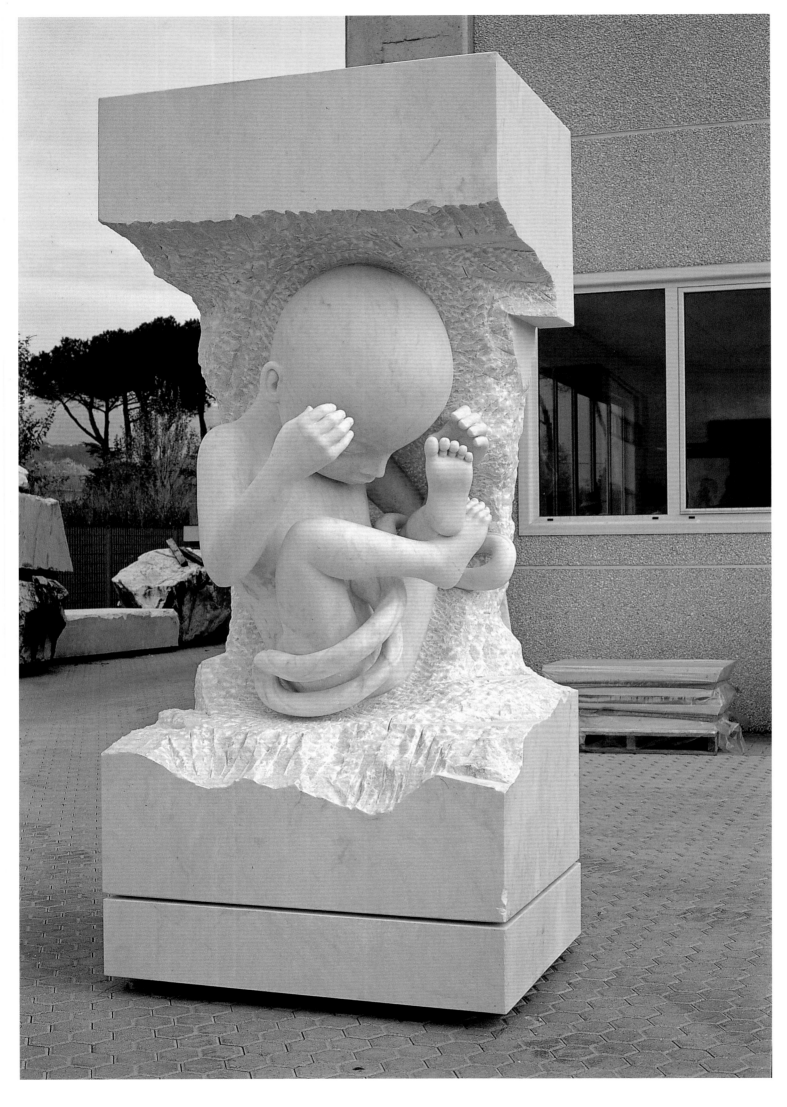

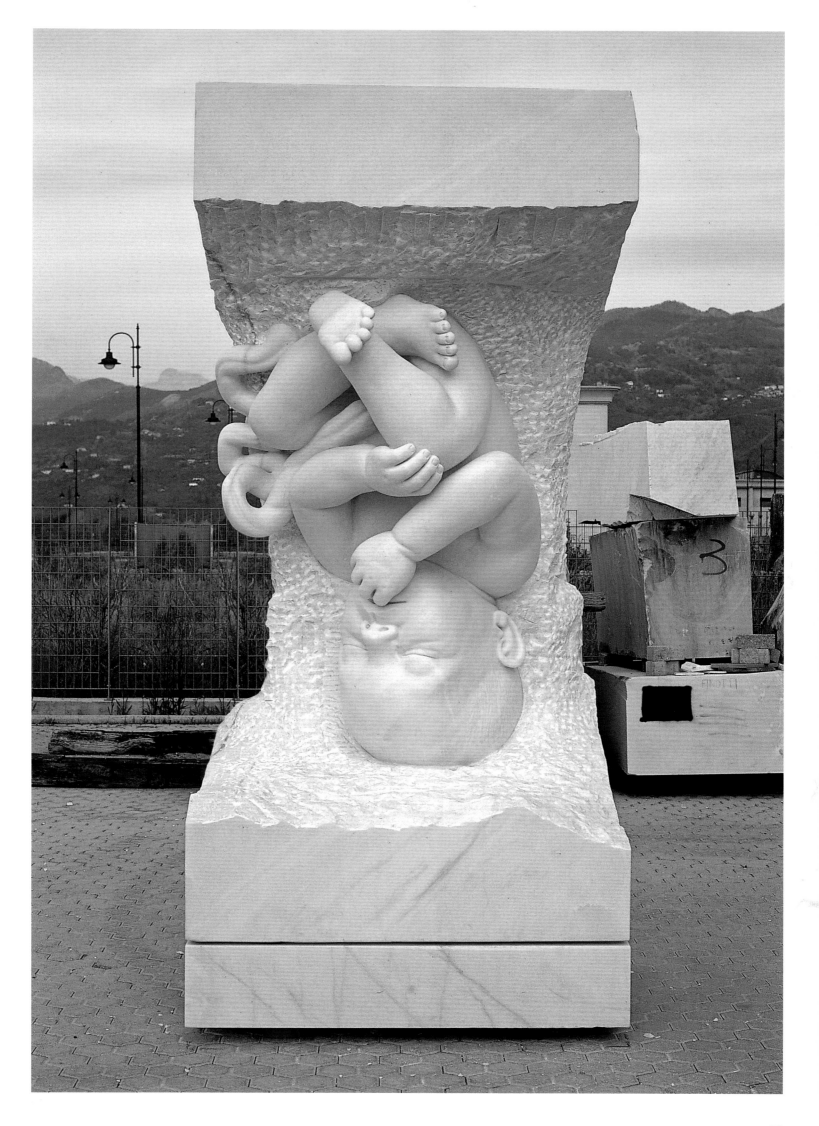

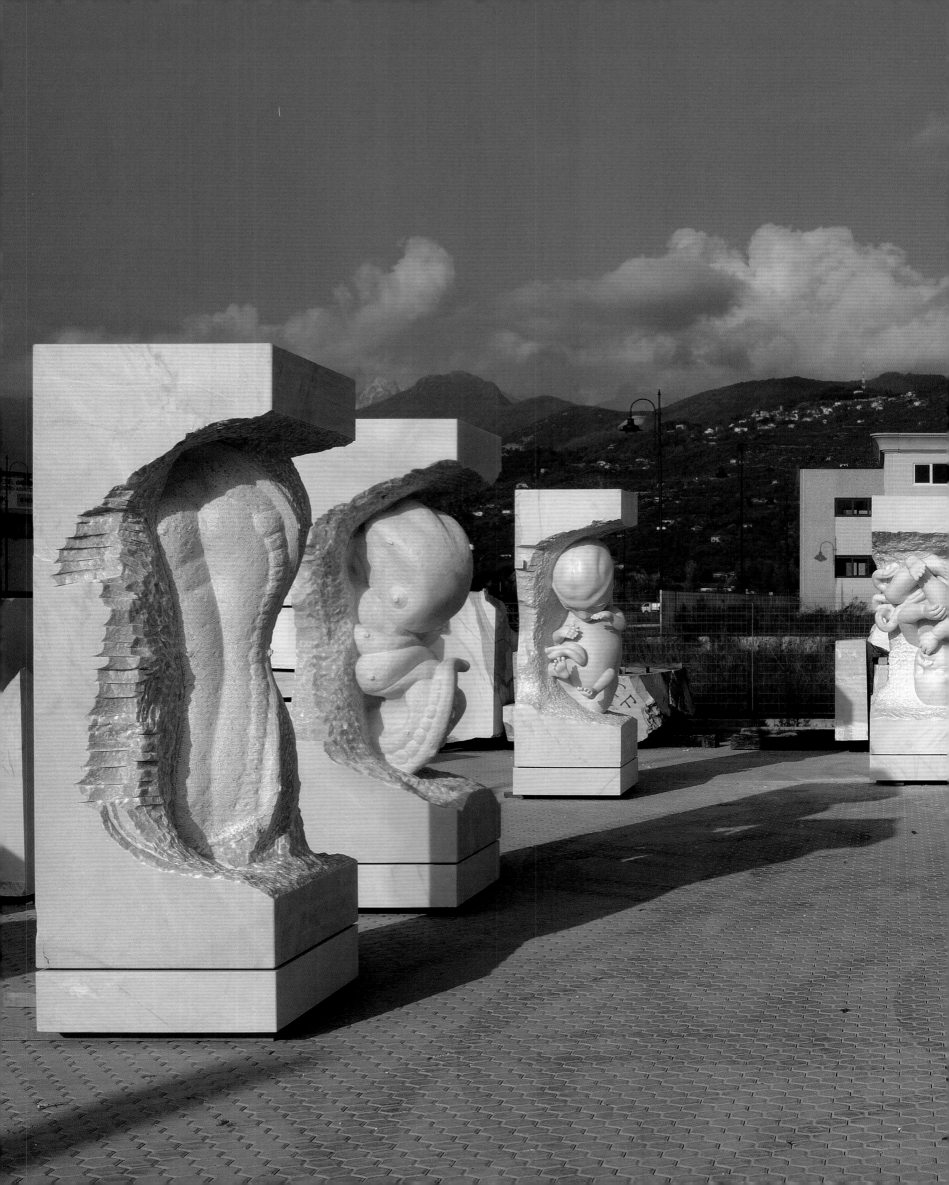

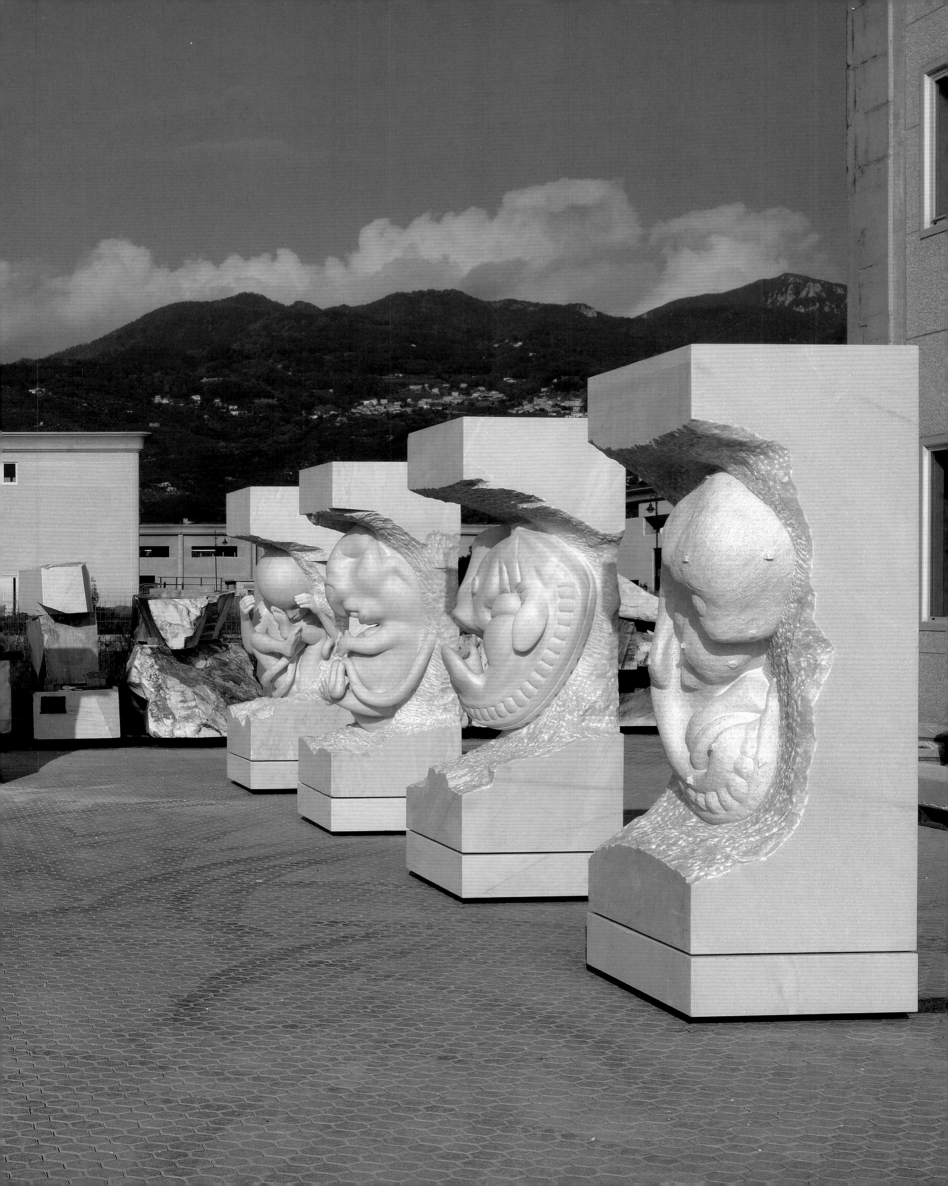

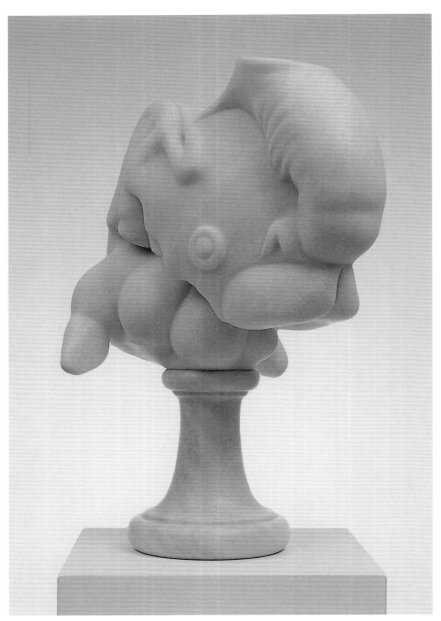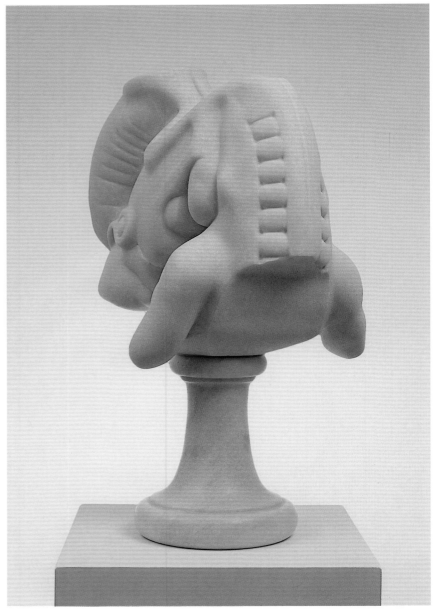

Early Self-Portrait
2007
Pink marble
24 7/16 x 11 x 17 3/8 in.
(62 x 28 x 44.2 cm)

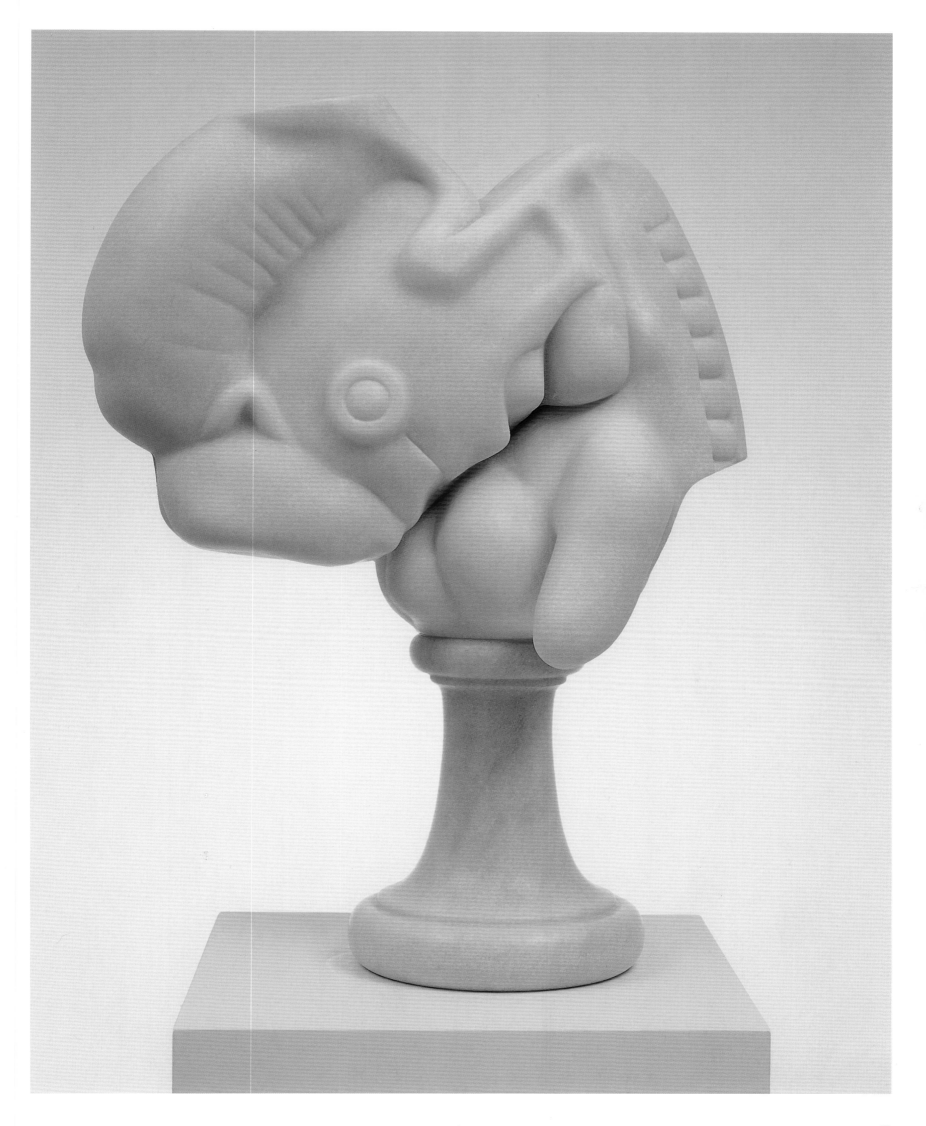

The Nurseries of El Dorado

page 69:

**The Nurseries of El Dorado
(solanumlycopersicumphaloenopsisanthuriumdiplosdiuea
ntithesisdomesctiapaphliopedliume14)**
2007
Cast bronze with heat-treated chrome patina
30 11/16 x 19 5/16 x 22 13/16 in. (78 x 49 x 58 cm)

pages 70–71:

**The Nurseries of El Dorado
(solaniumlycopersicumonfragariaphalaenopsissynopsisarth
uriumrossiogloriousgrandcanalchromerootussatvuium)**
2007
Cast bronze with heat-treated chrome patina
37 x 34 1/4 x 26 in. (94 x 87 x 66 cm)

pages 72–73:

**The Nurseries of El Dorado
(cucumissativuspaphiopedliumsolanumlycopersicumphale
nopsispotinaraanthuriumpyrus)**
2007
Cast bronze with heat-treated chrome patina
29 15/16 x 27 9/16 x 18 1/8 in. (76 x 70 x 46 cm)

pages 74–75:

**The Nurseries of El Dorado
(pyruspapaversonniferumsuryasamudraanthuriumlycophy
cophaninoxtroisfabergeassatviumaaggddcchybridphillipsla
mblliwflesvictorium)**
2007
Cast bronze with heat-treated chrome patina
37 13/16 x 26 3/8 x 11 13/16 in. (96 x 67 x 30 cm)

pages 76–77:

**The Nurseries of El Dorado
(musafragariadomesticviolenciazingiberalesdansksolunium
lylycpersiumpaphlipedliumsolexpelligrinoabsurdiumrexpa
phliopicklrpastaanthuriumelissamngfccggddaapostfacto)**
2007
Cast bronze with heat-treated chrome patina
33 7/8 x 25 3/16 x 16 1/8 in. (86 x 64 x 41 cm)

pages 78–80:

**The Nurseries of El Dorado
(malusdomesticacucmissativuspyrusphalaenopsispaphiope
dliumhybridanthuriumsextusaugustusemperatorvaticanos
onniferumvbgfhccggddaahoxton)**
2007
Cast bronze with heat-treated chrome patina
38 9/16 x 27 3/16 x 10 5/8 in. (98 x 69 x 27 cm)

page 81:

**The Nurseries of El Dorado
(papeaversonniferumpyrusfragarianepenthesmoicrovulgari
spaphiopedliumphalaenopsississyusrossioglossiumalumusf
rigtuiumromanus)**
2007
Cast bronze with heat-treated chrome patina
34 1/4 x 26 3/8 x 18 1/8 in. (87 x 67 x 46 cm)

pages 82–83:

**The Nurseries of El Dorado
(fragarianepenthesneglectaborneosolanumlycopersicumph
alaenopsispapavarsonniferumoptimaviciveniciliatapaphiop
edliumtambunanbasioninwedgewood)**
2007
Cast bronze with heat-treated chrome patina
31 7/8 x 24 7/16 x 18 1/2 in. (81 x 62 x 47 cm)

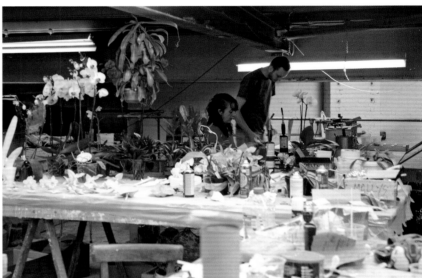
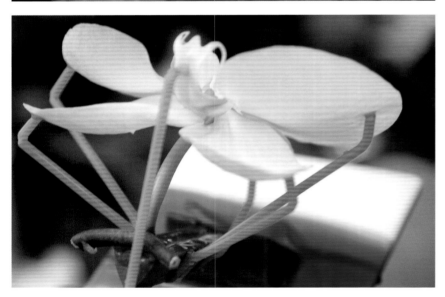
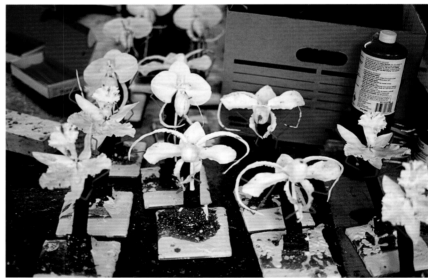

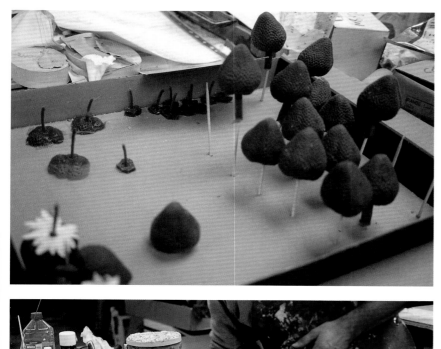
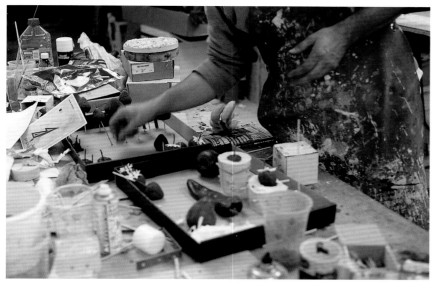
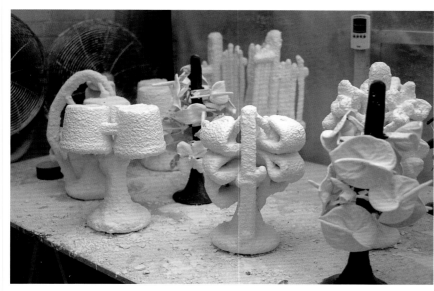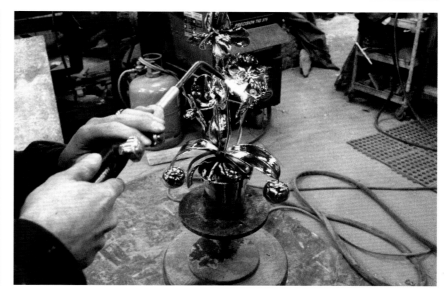

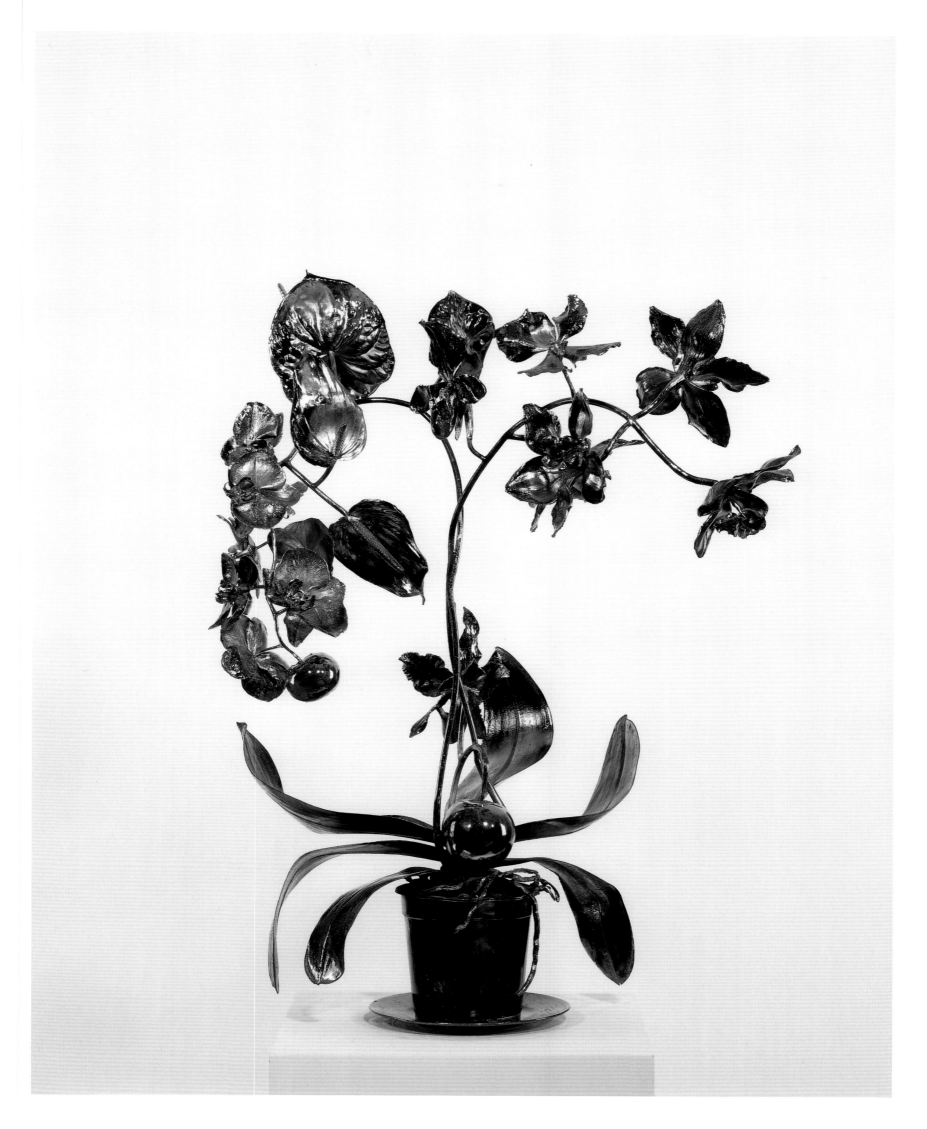

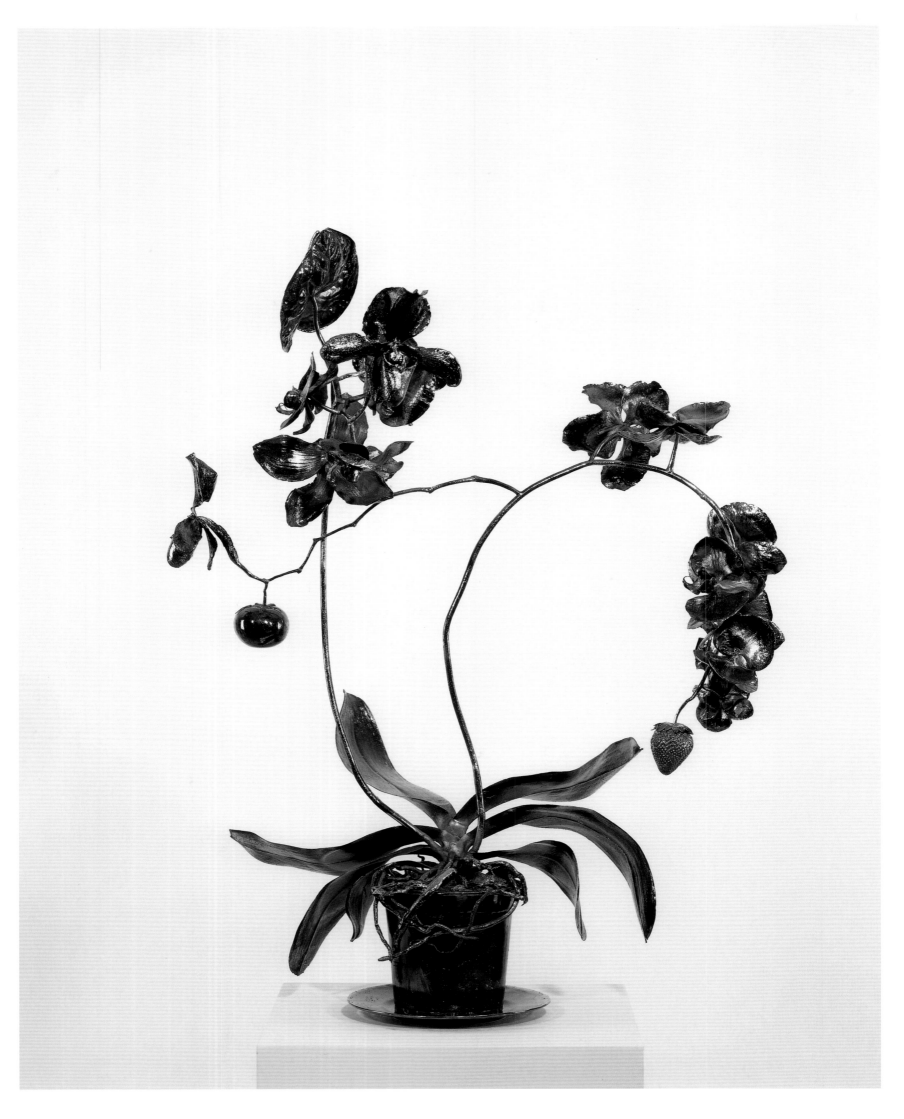

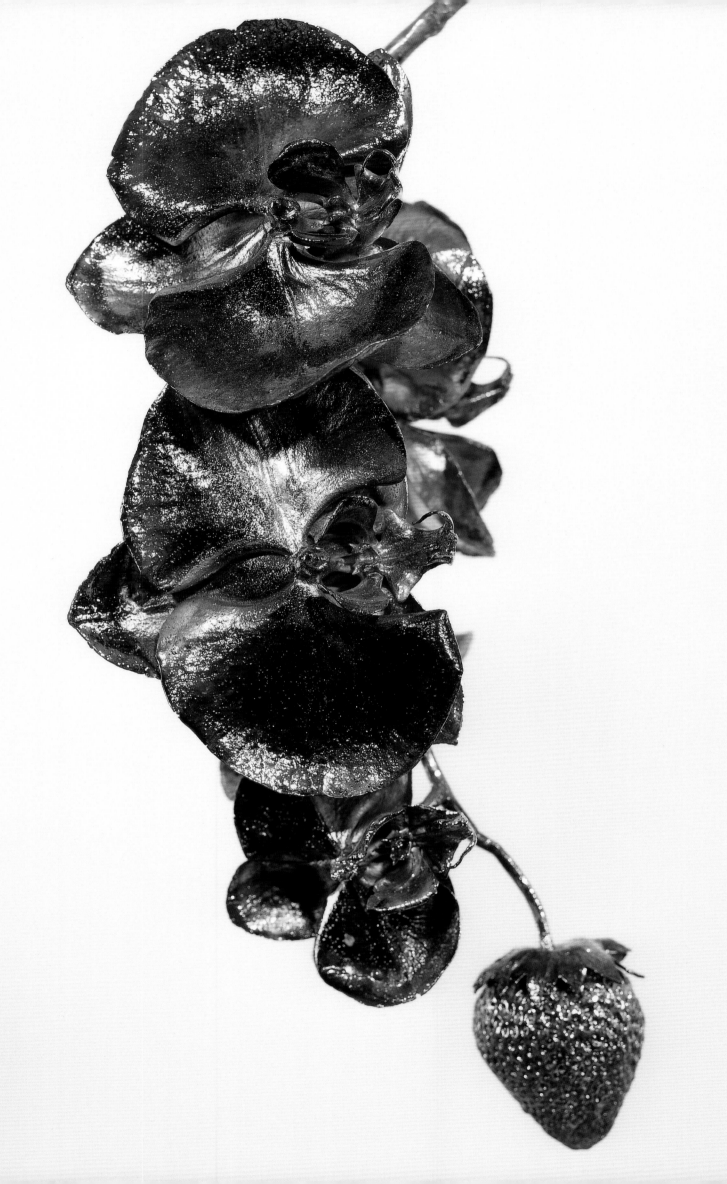

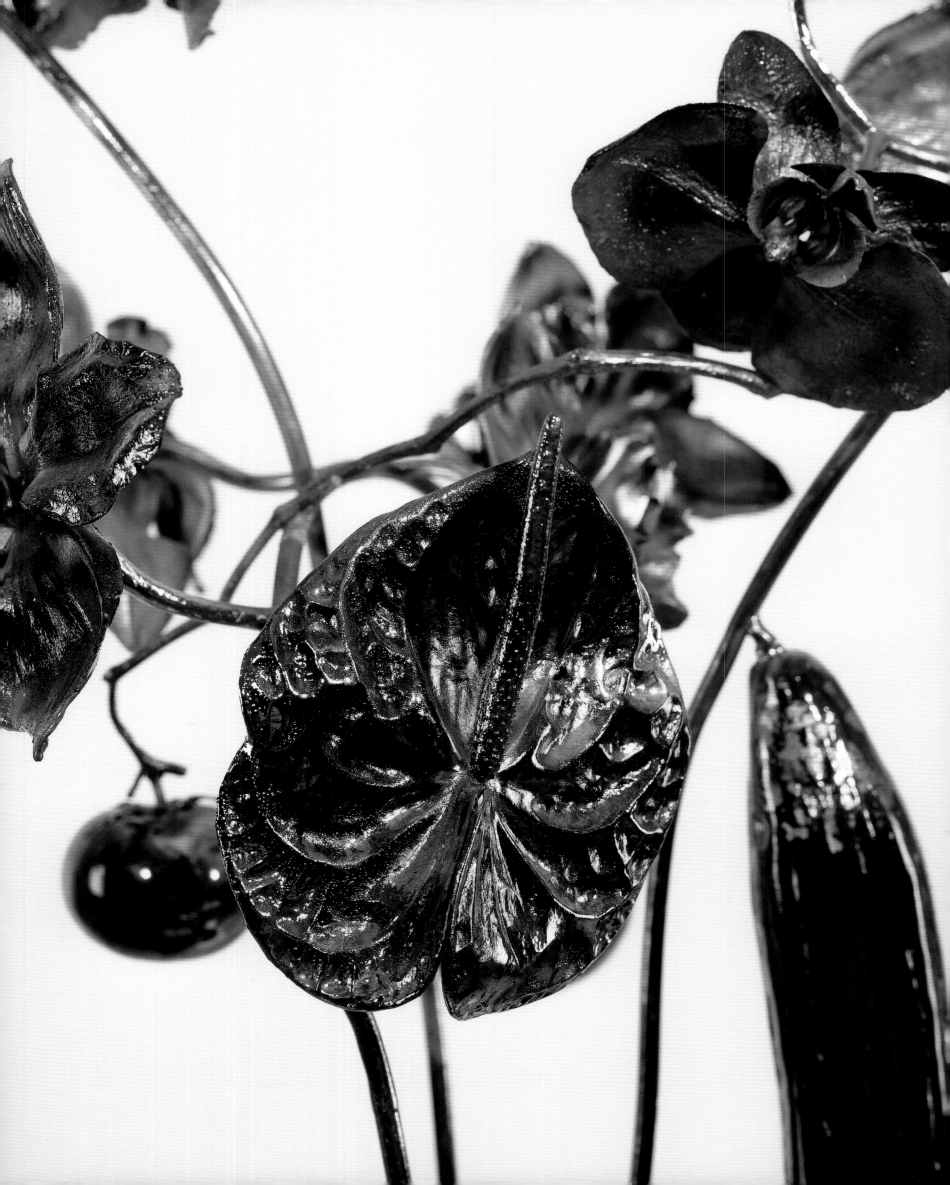

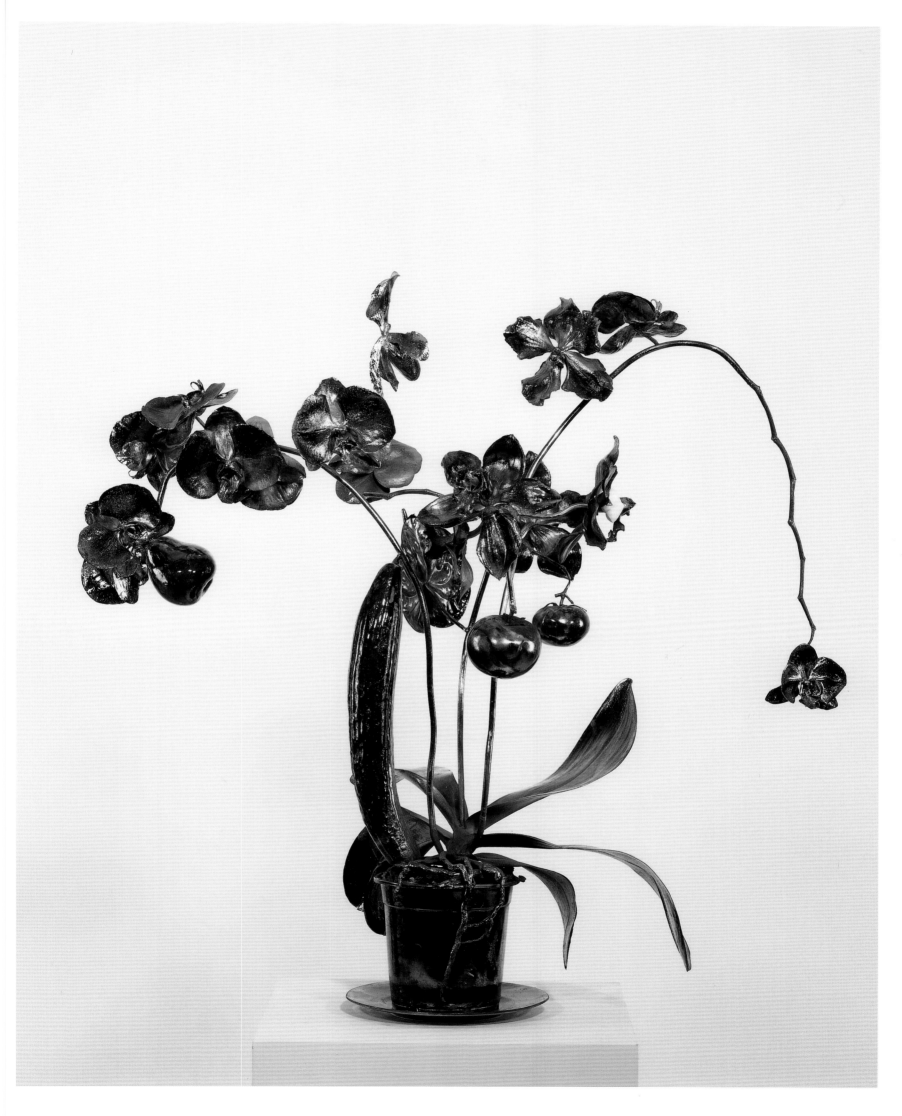

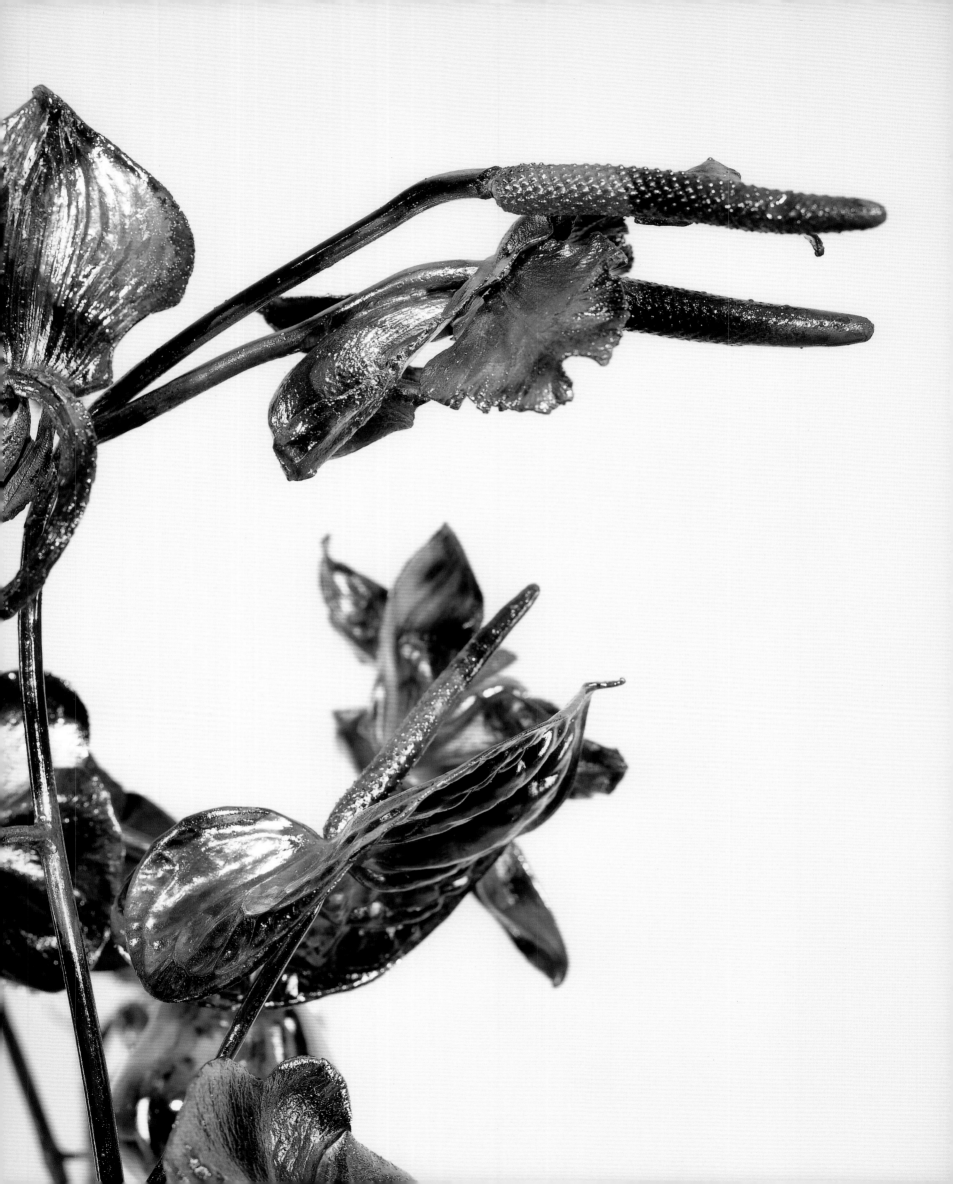

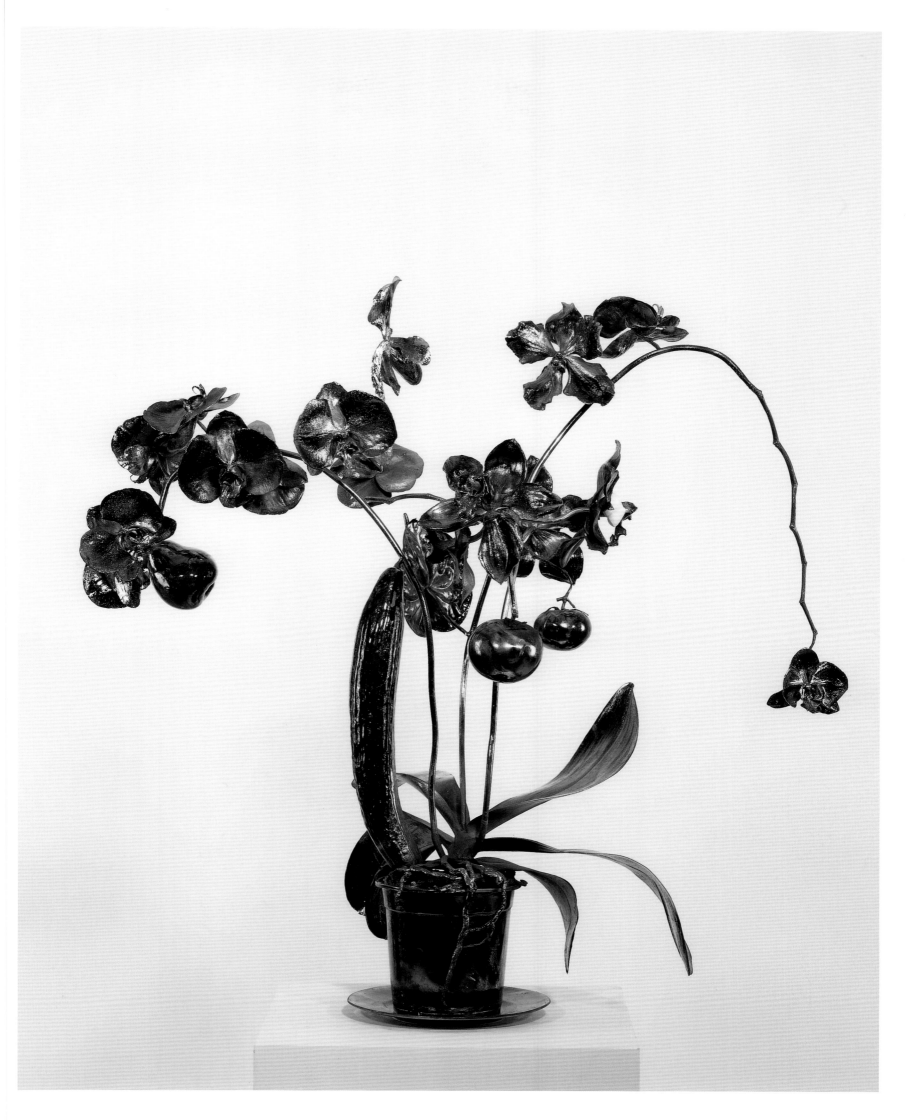

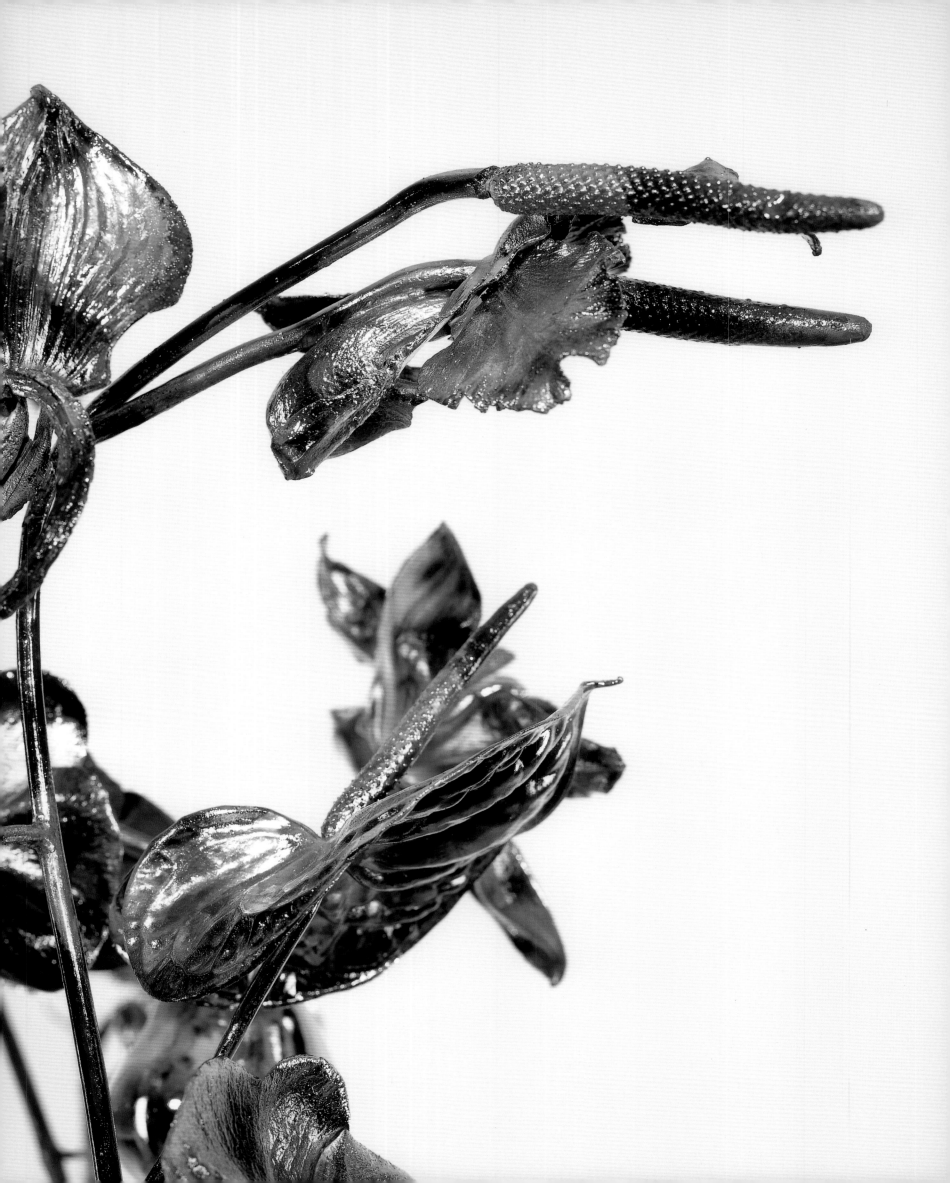

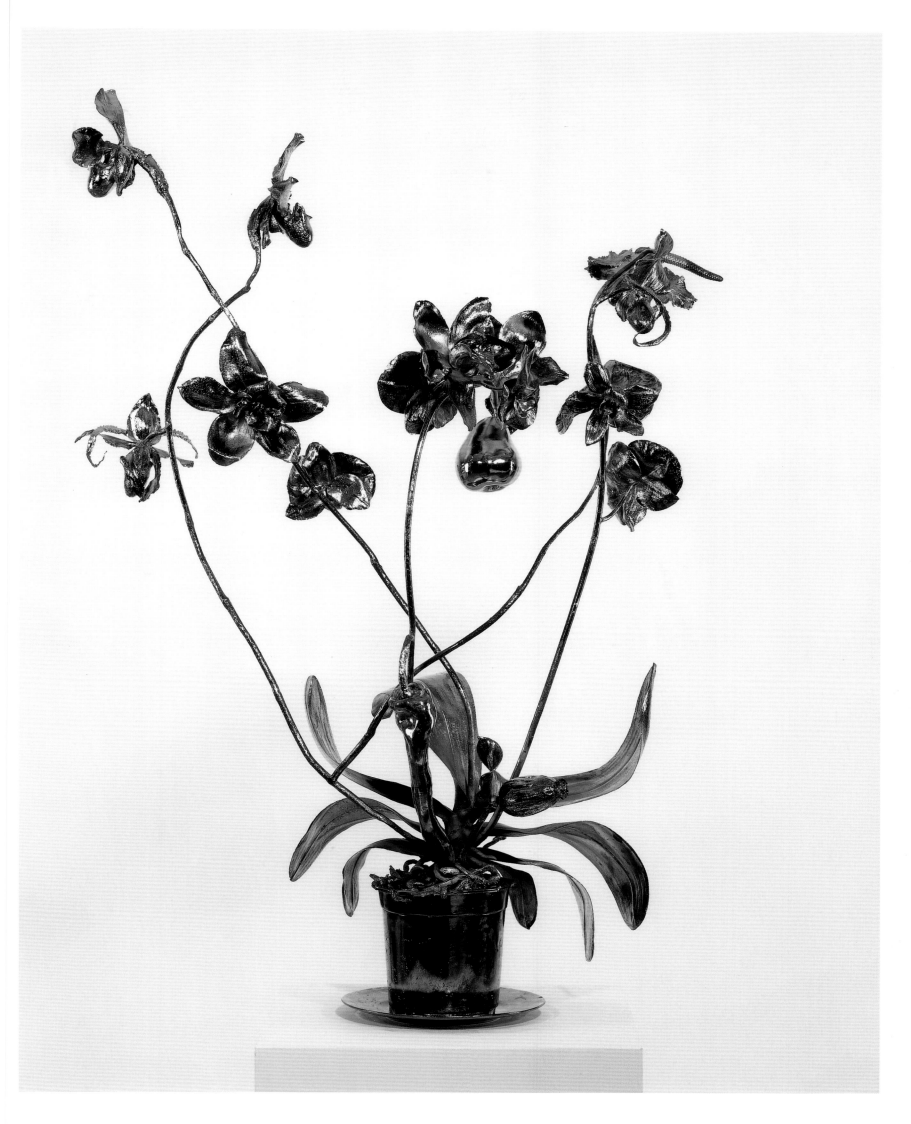

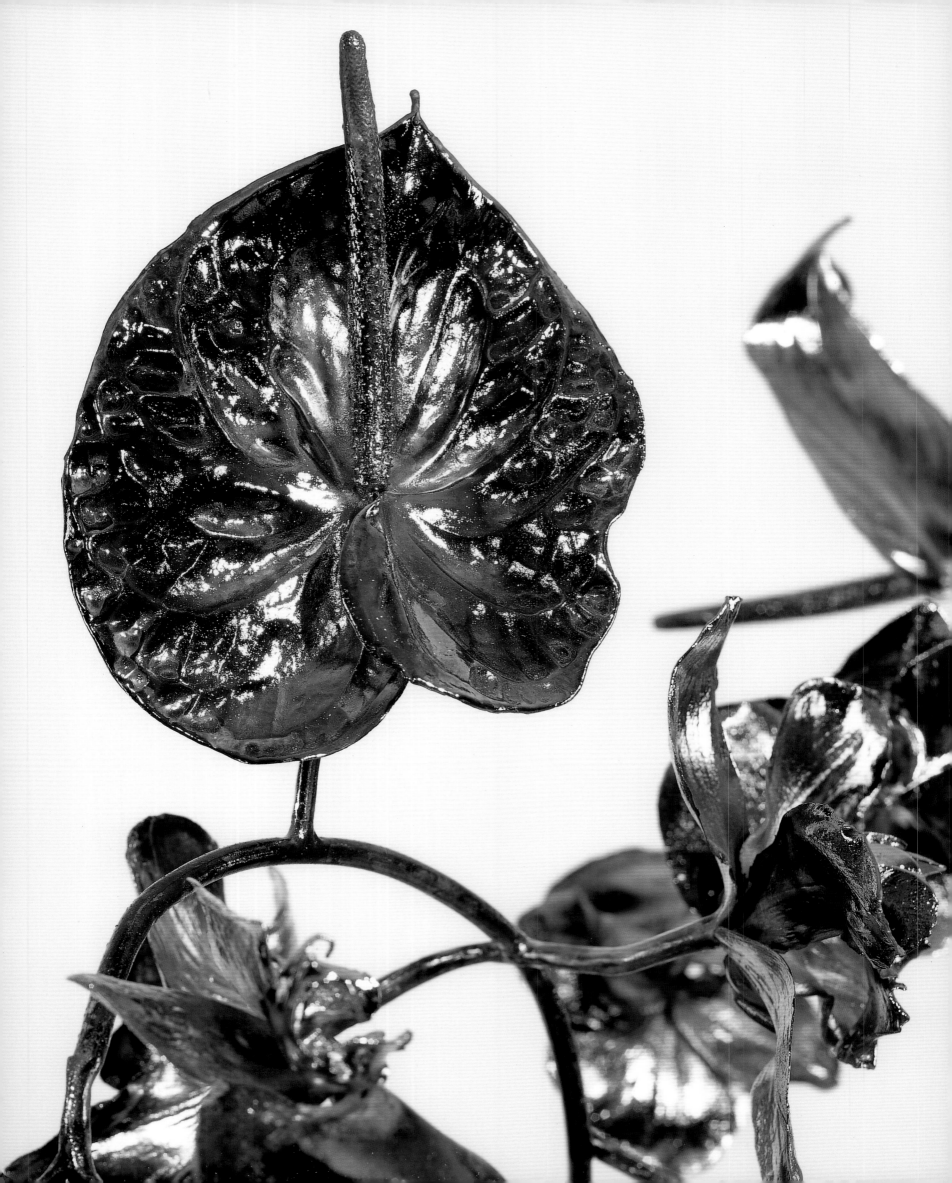

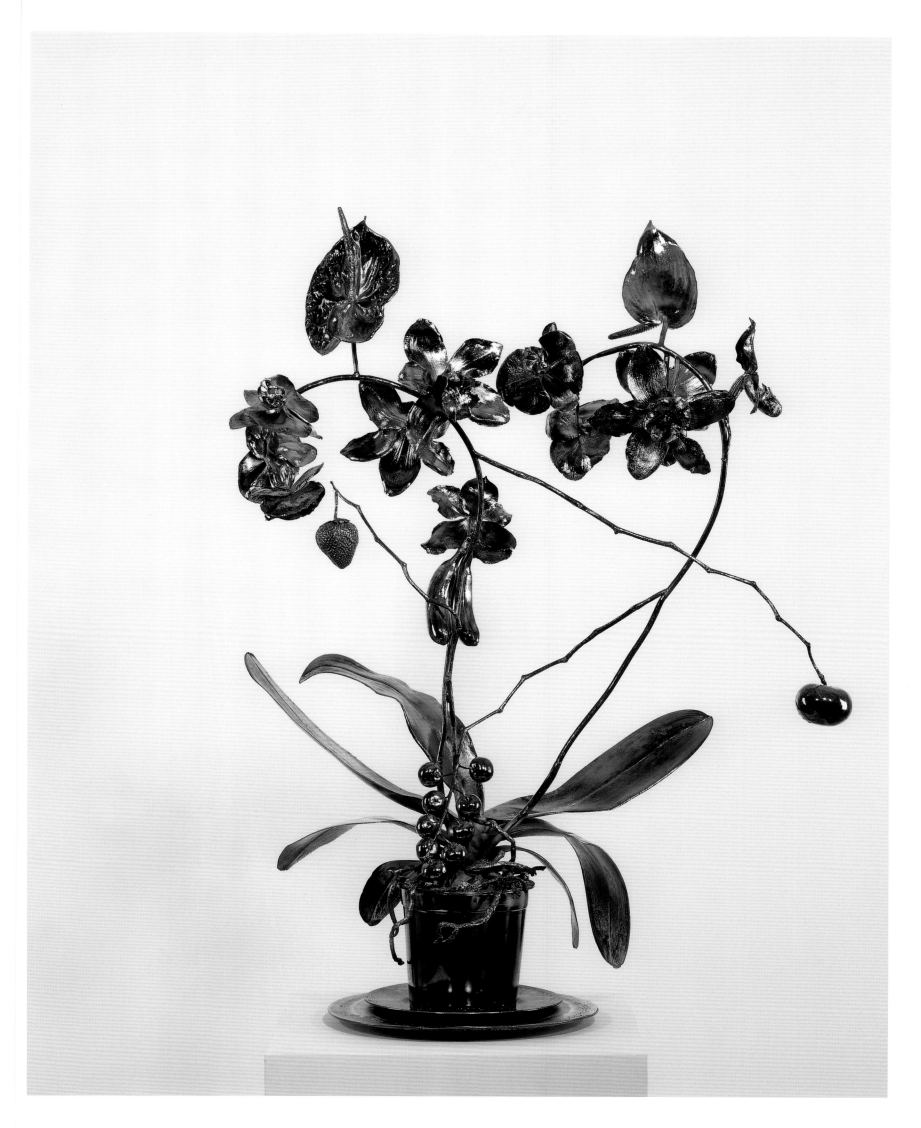

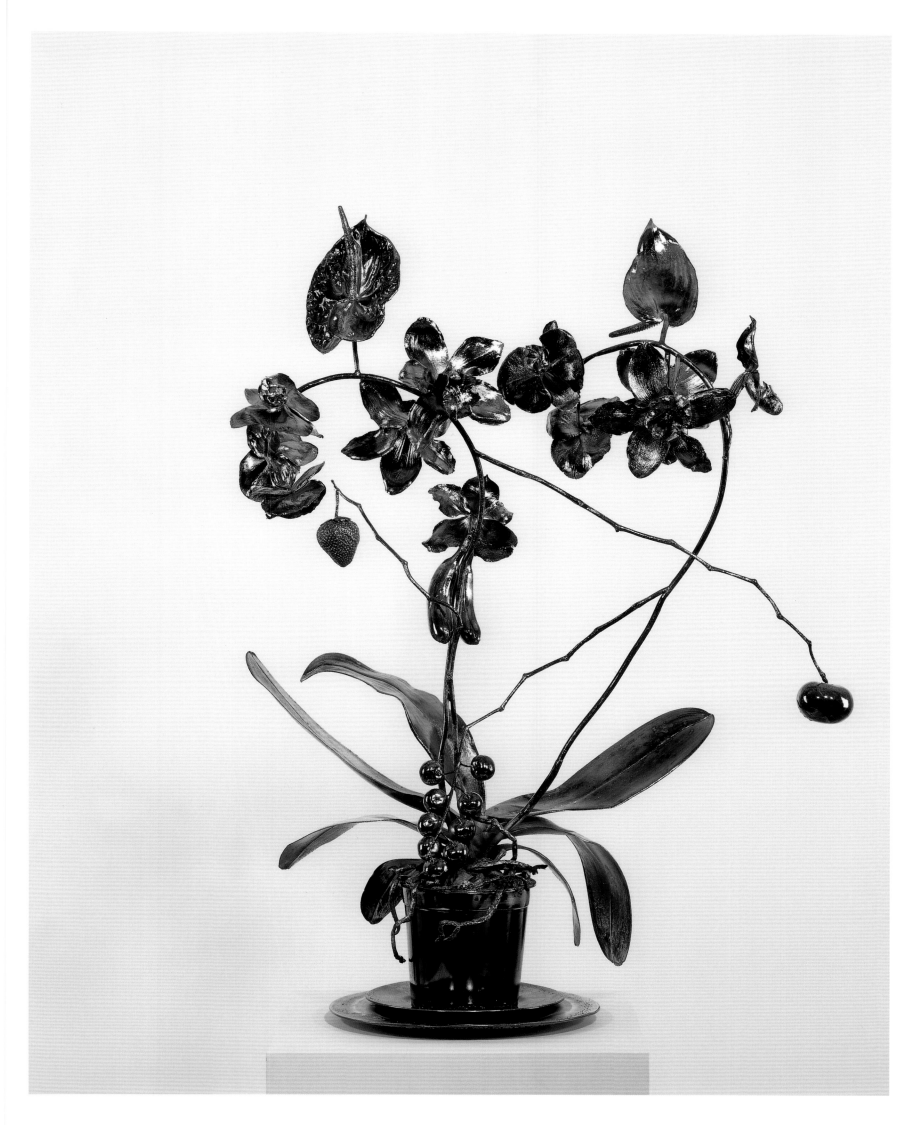

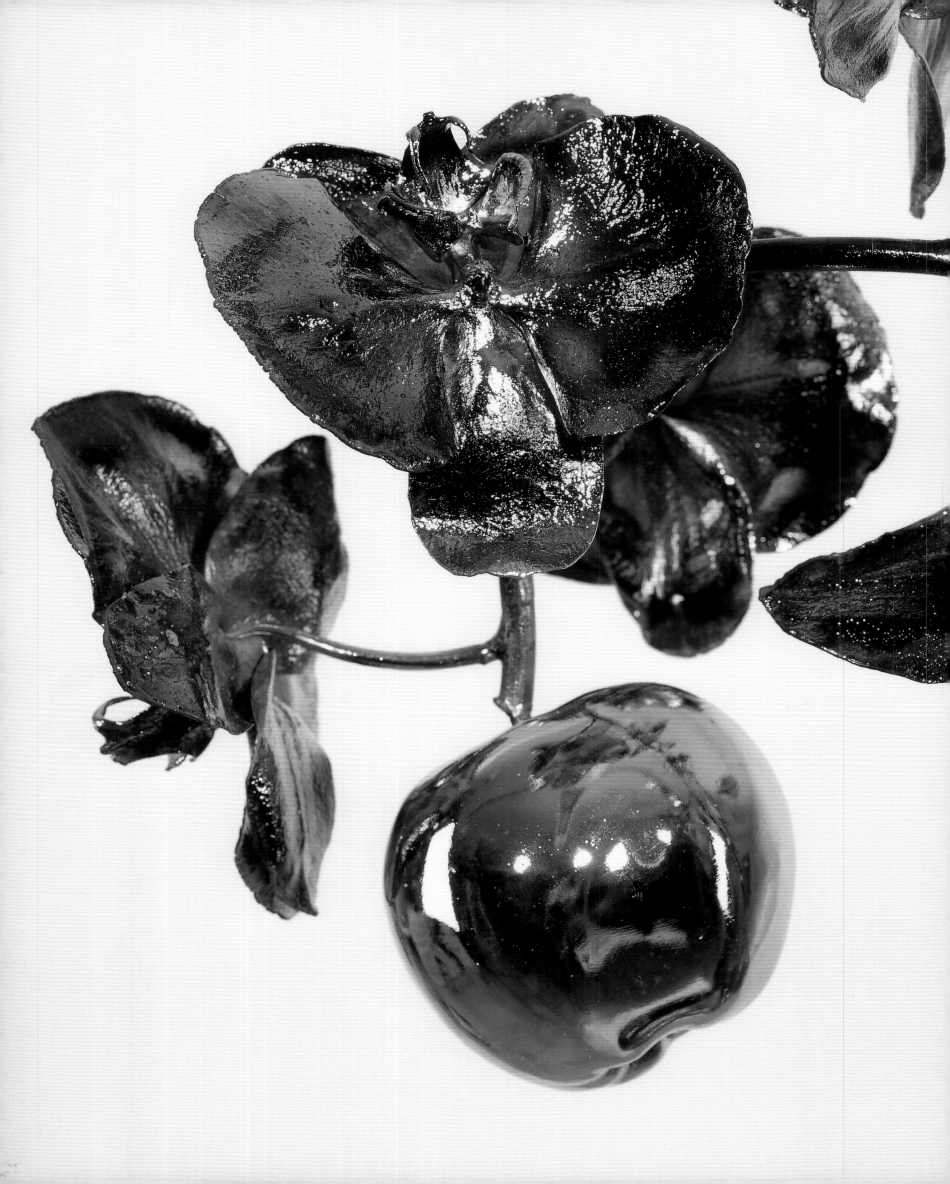

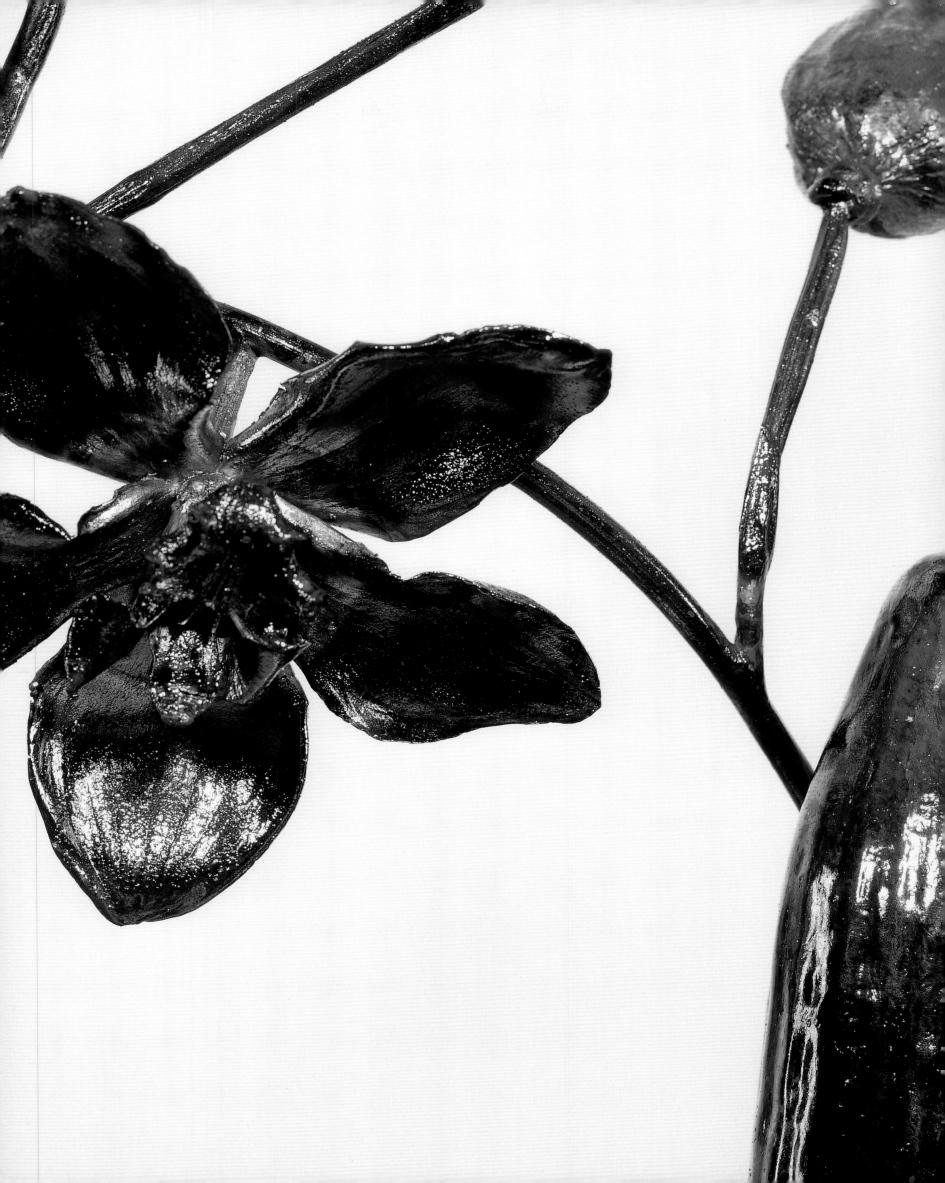

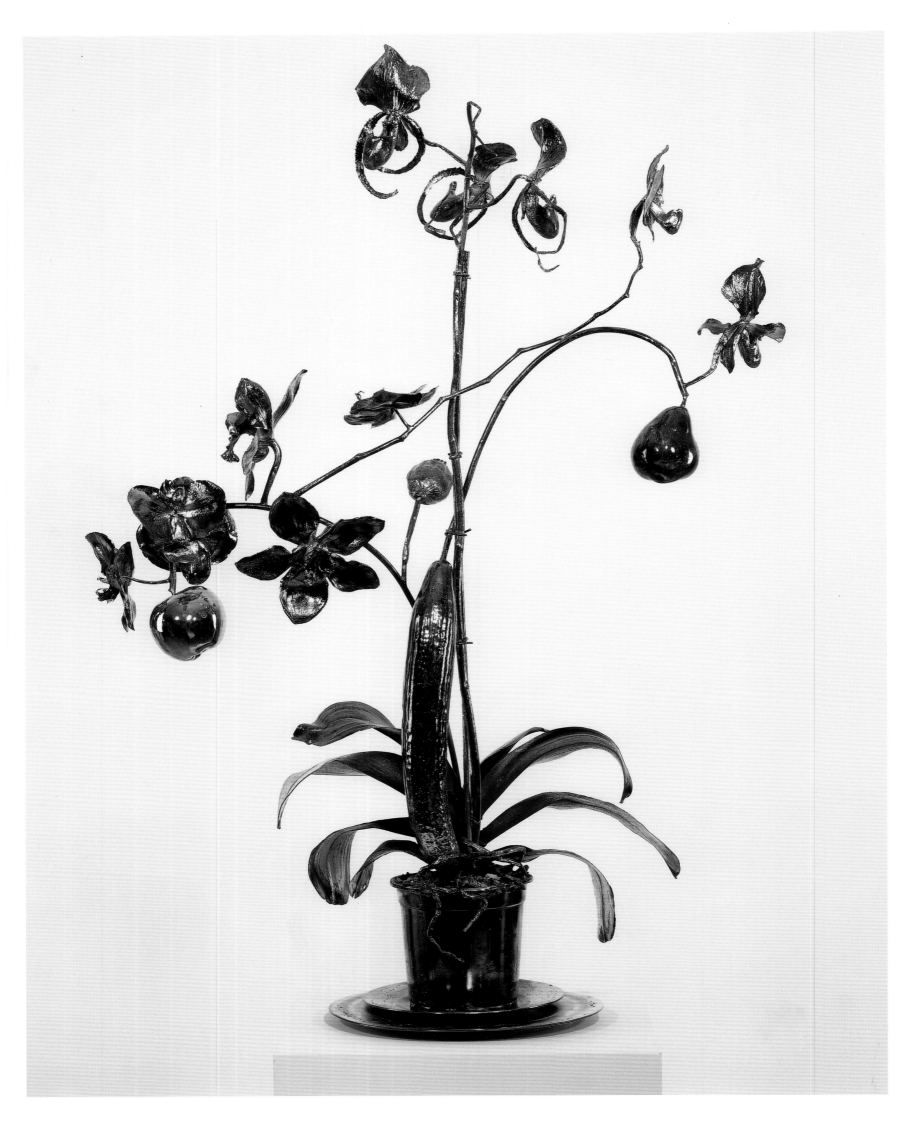

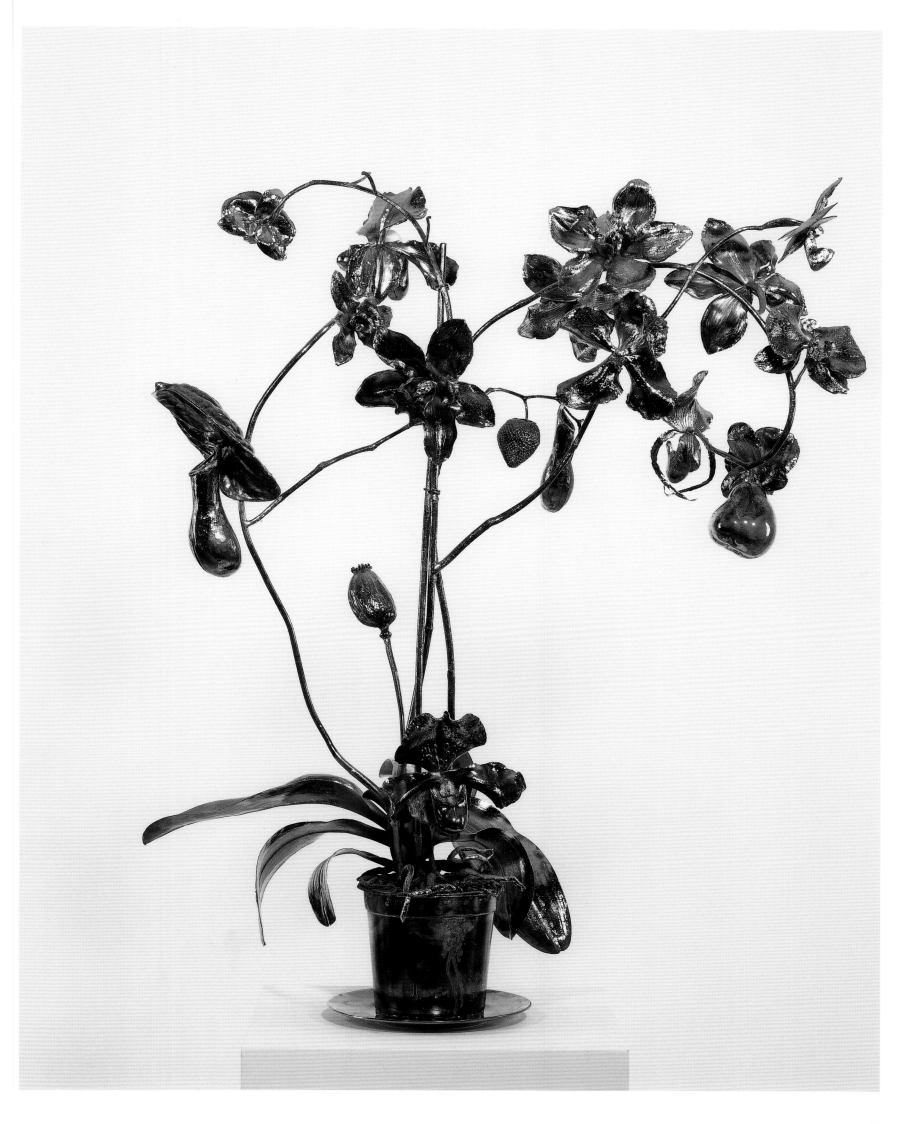

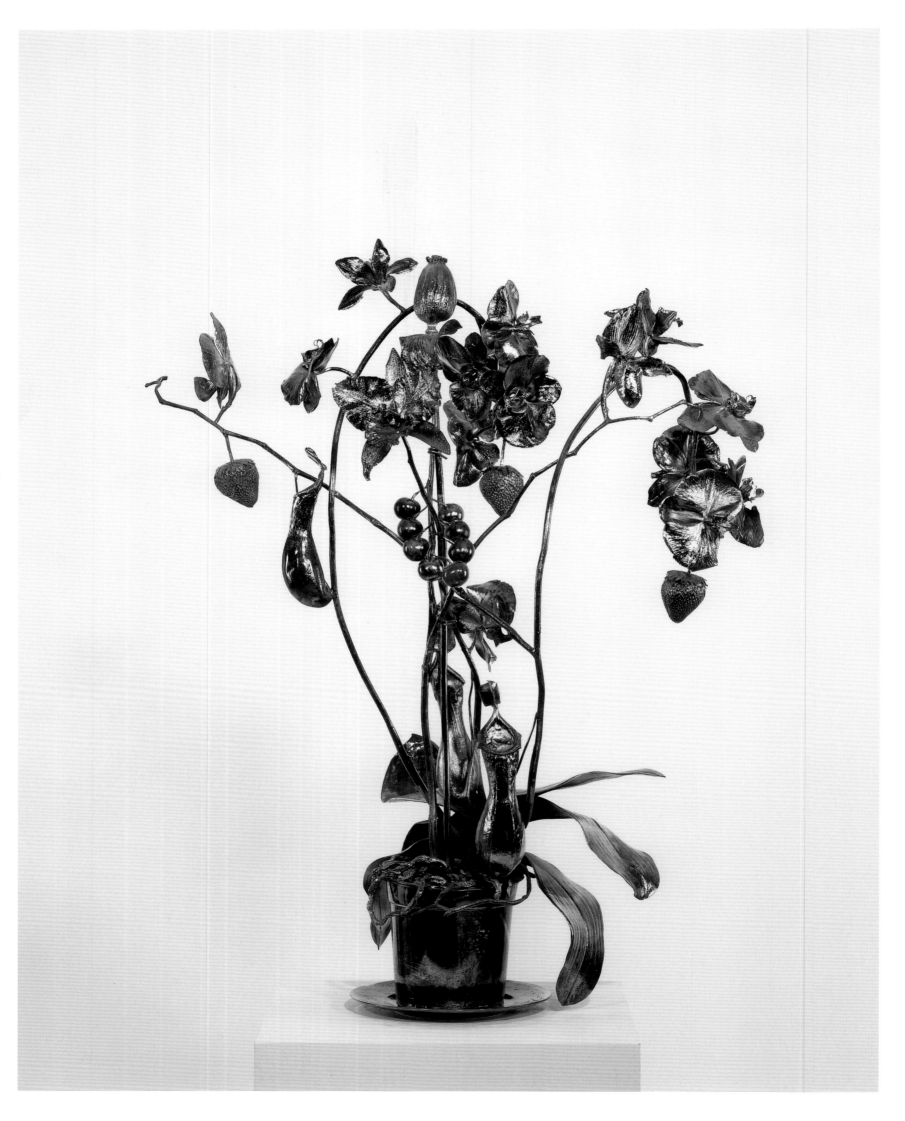

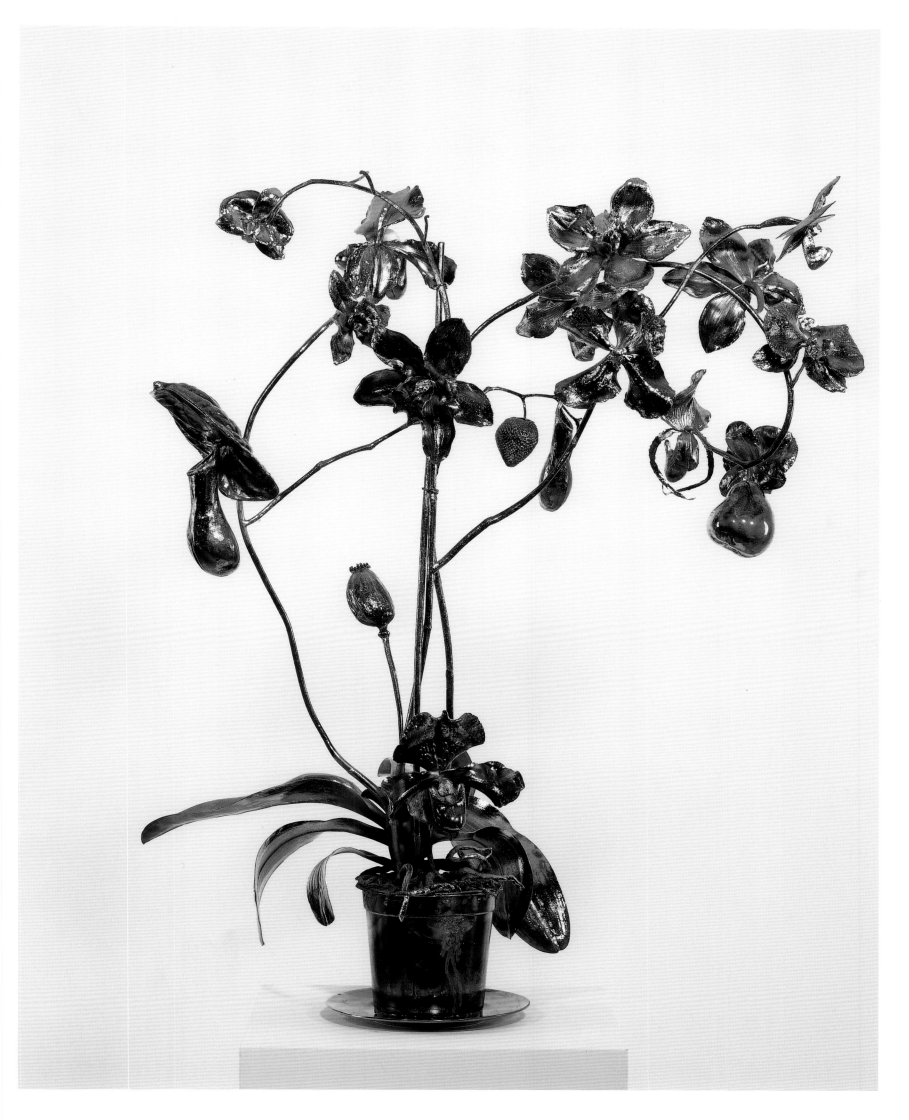

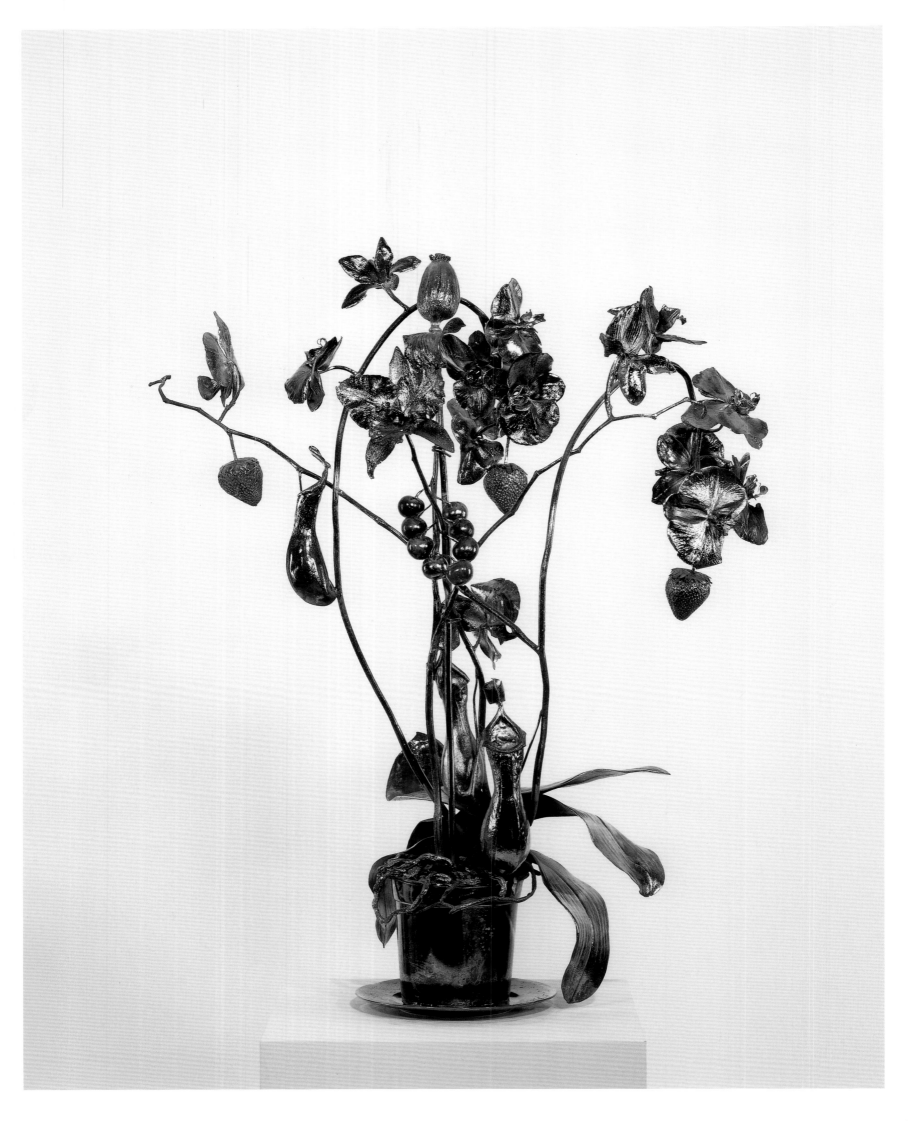

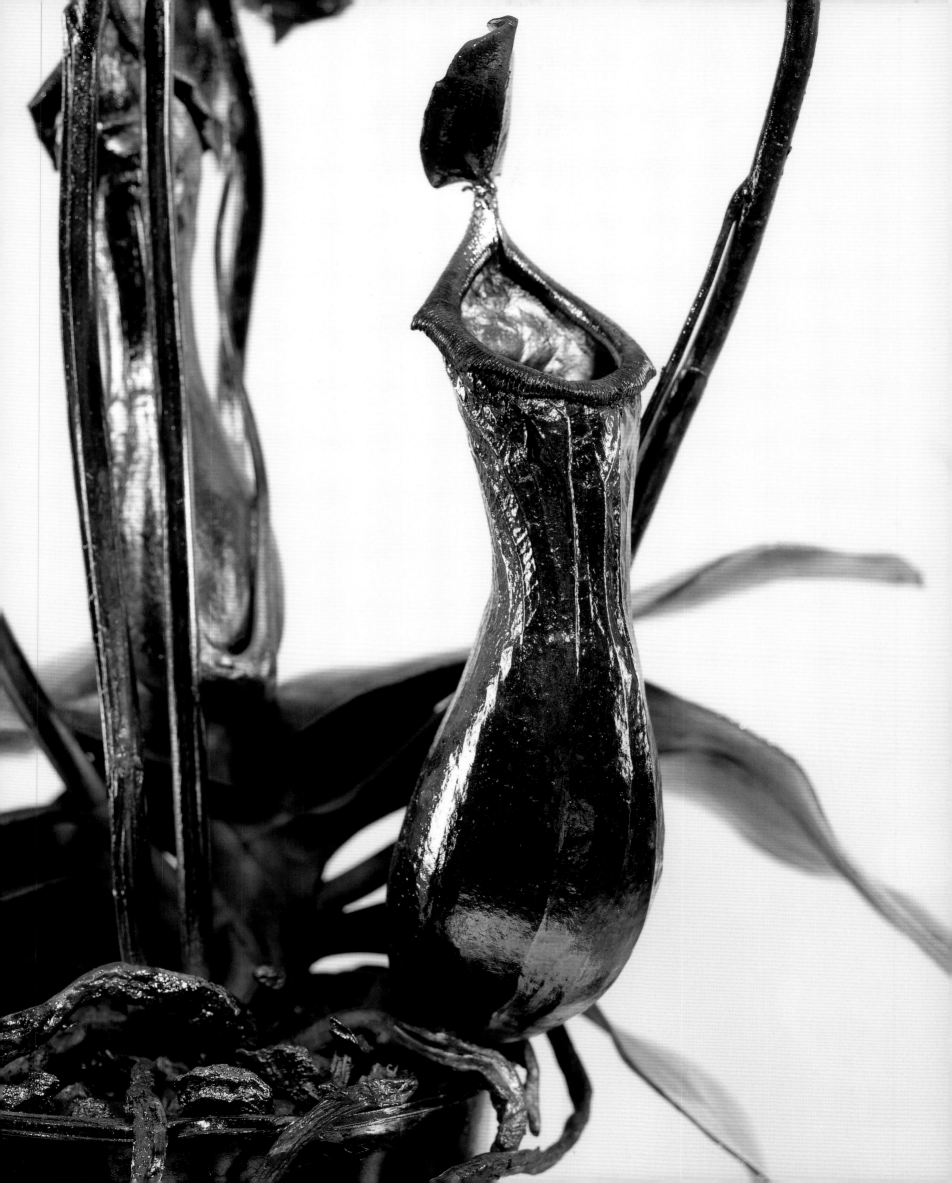

5th Season

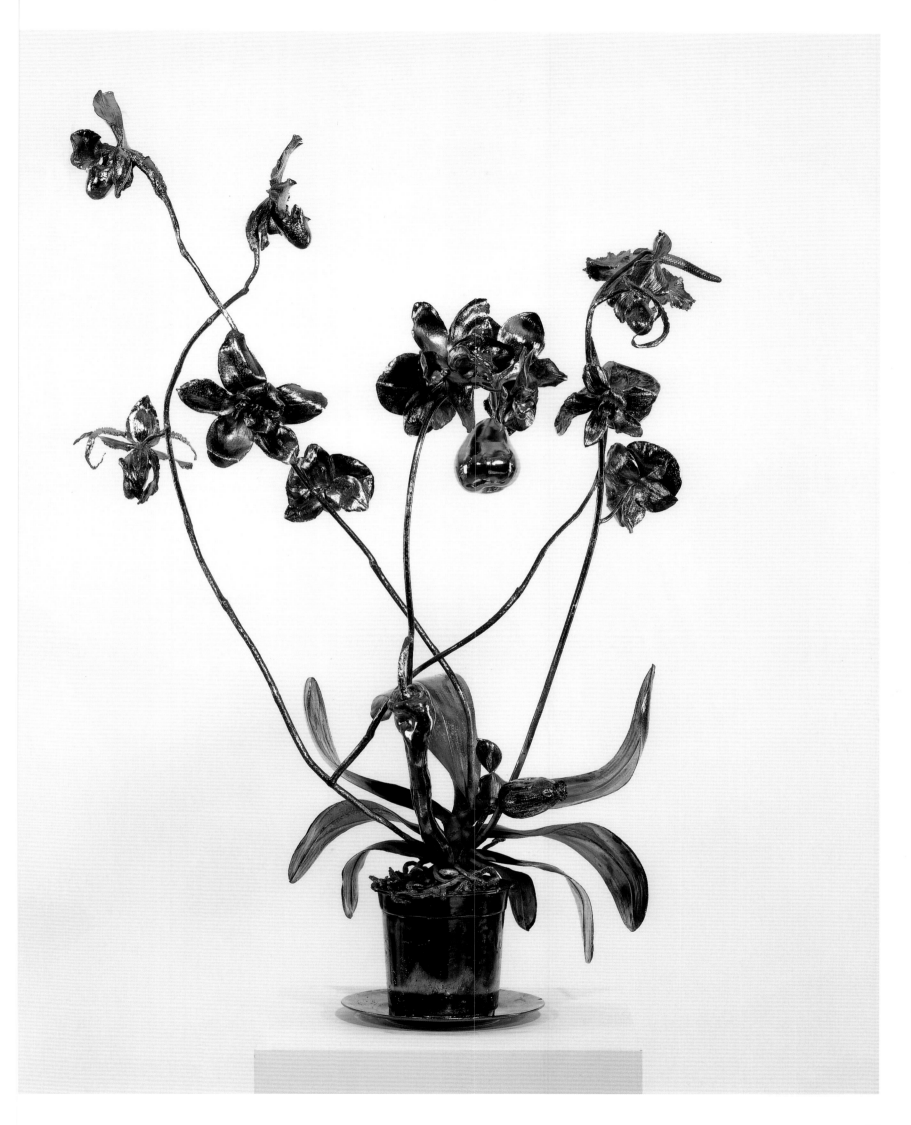

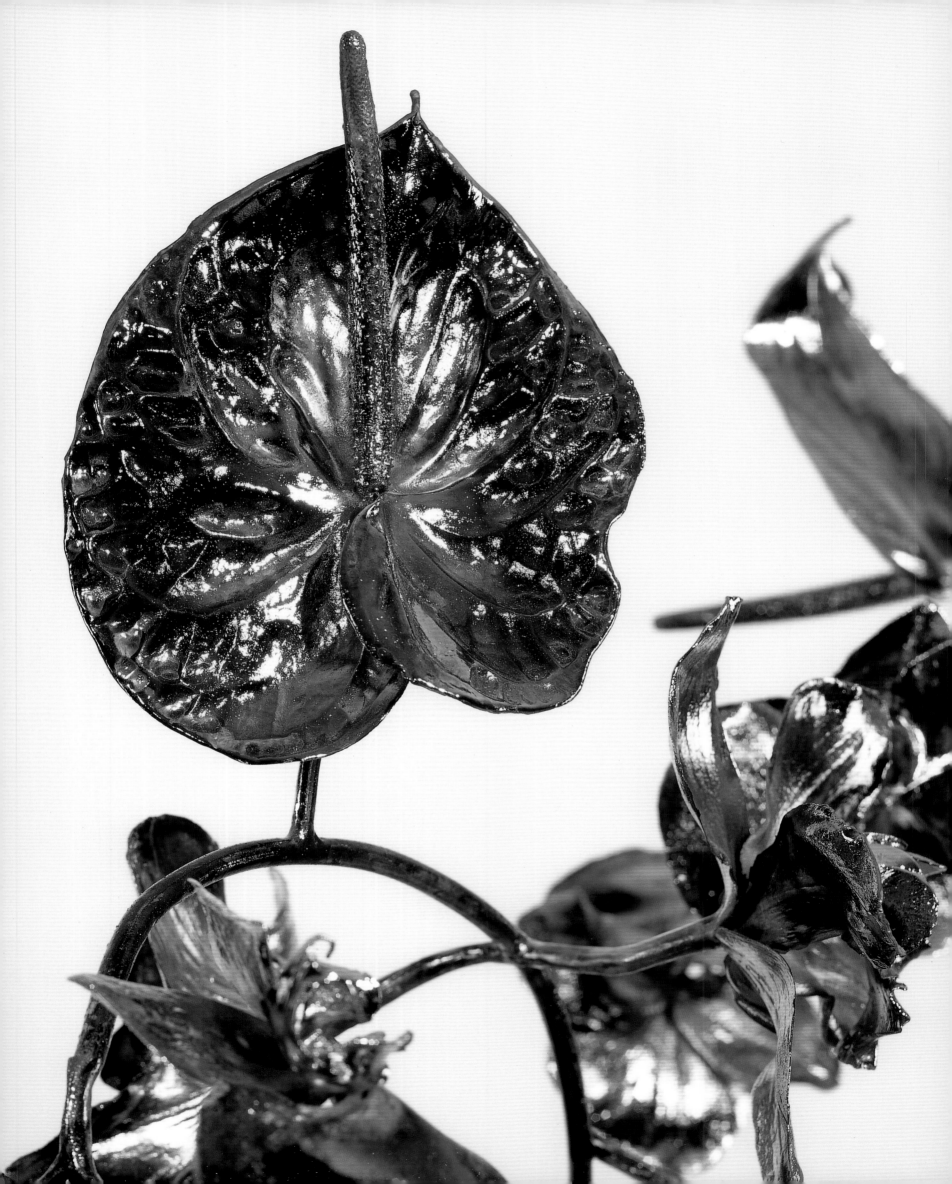

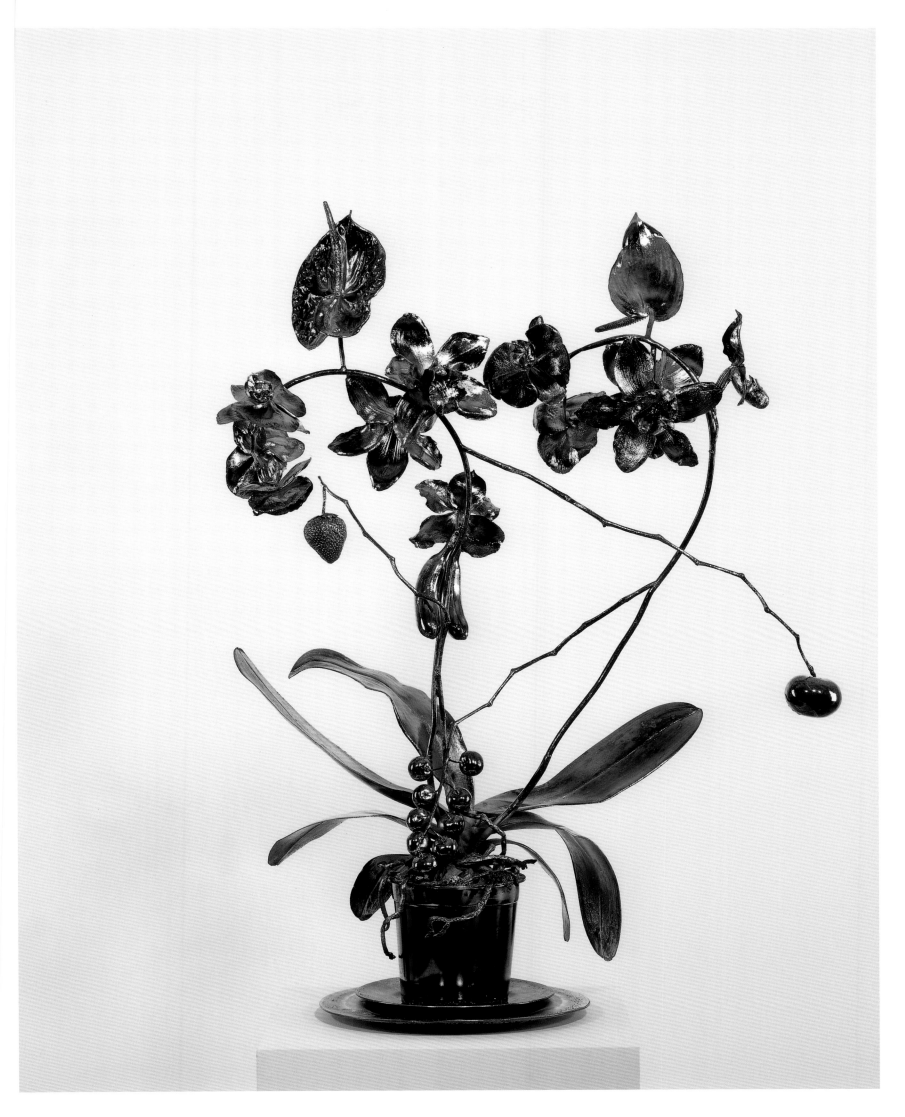

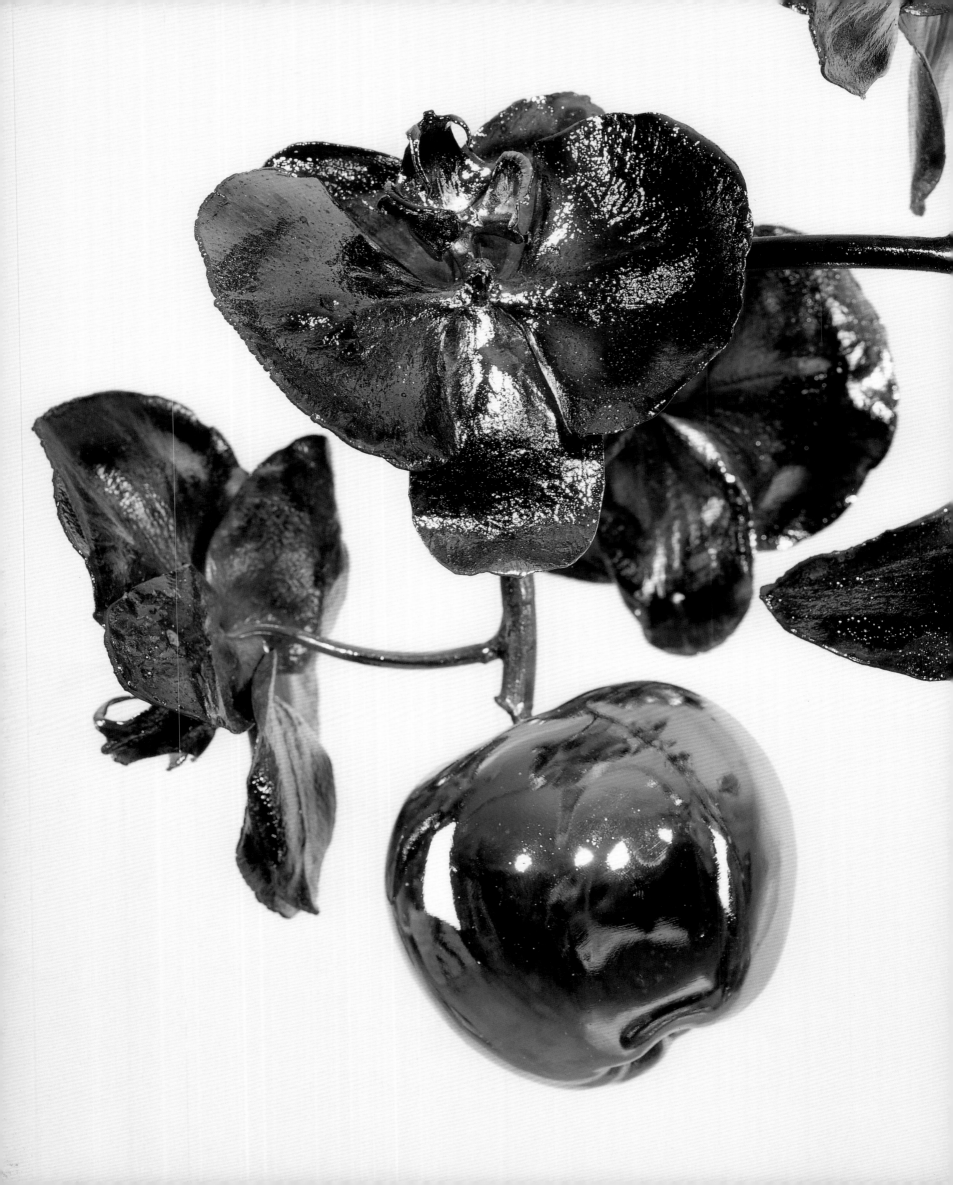

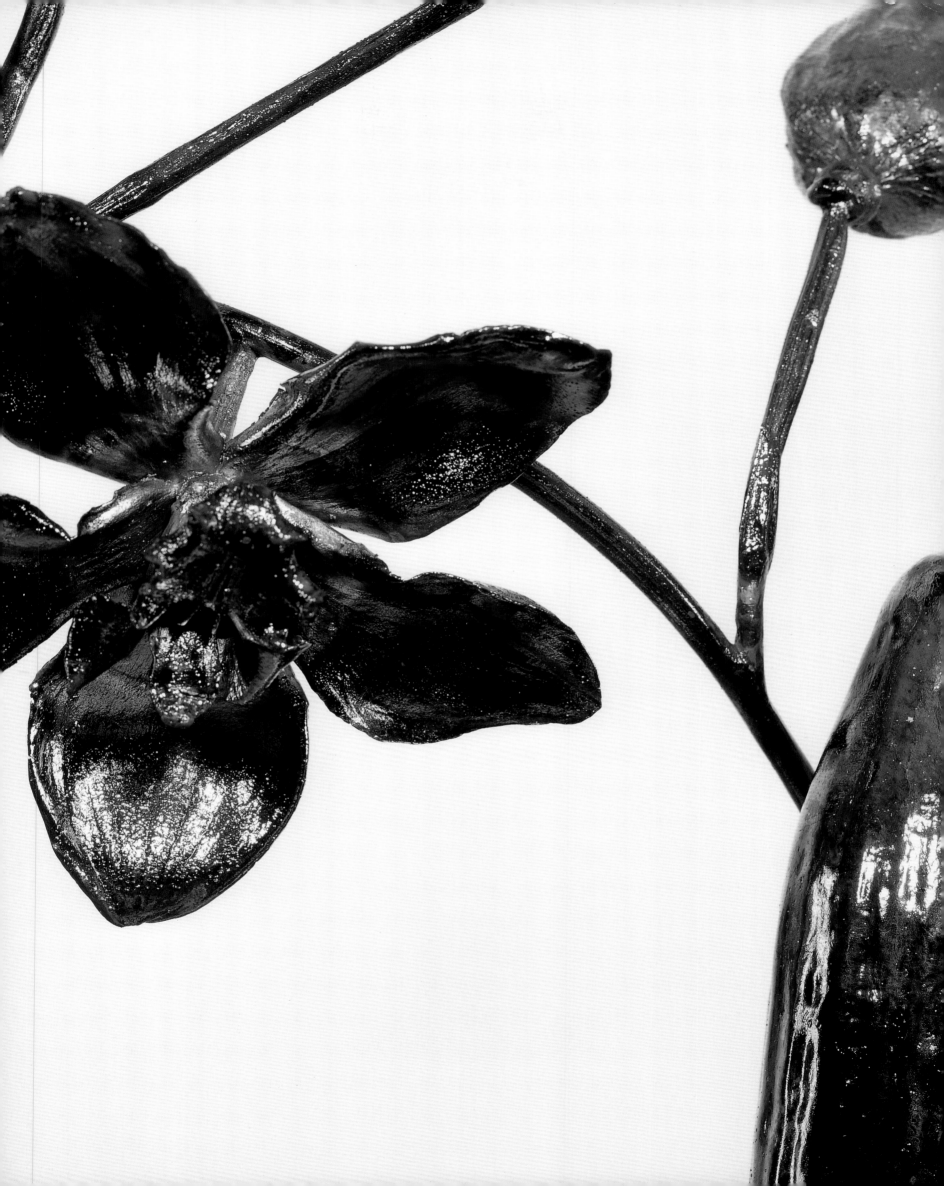

5th Season

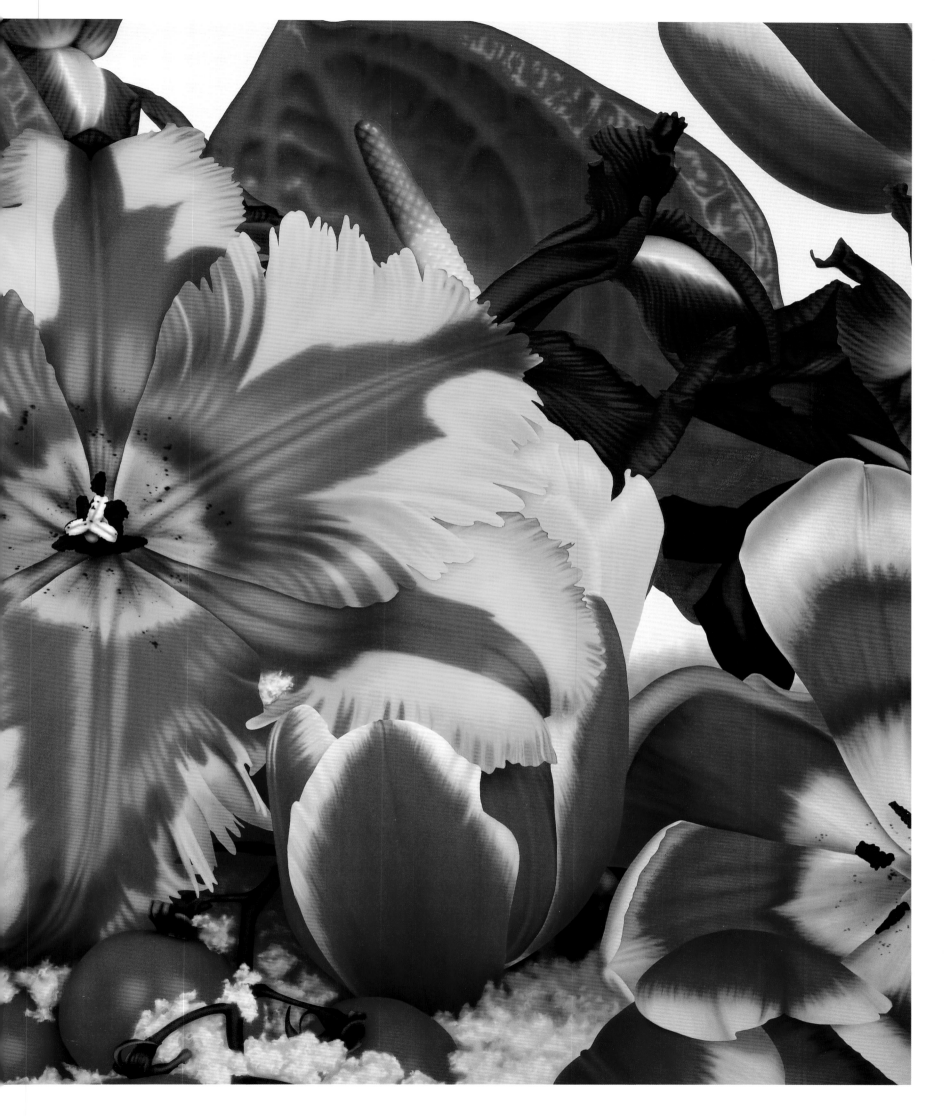

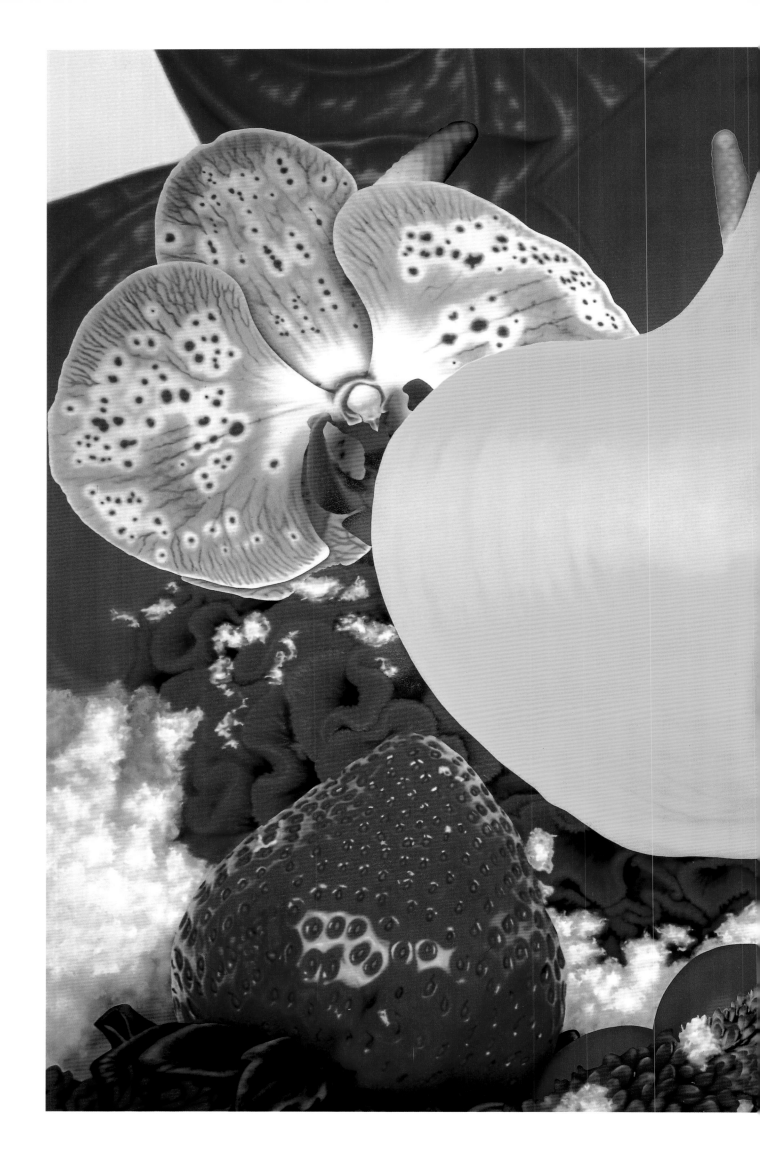

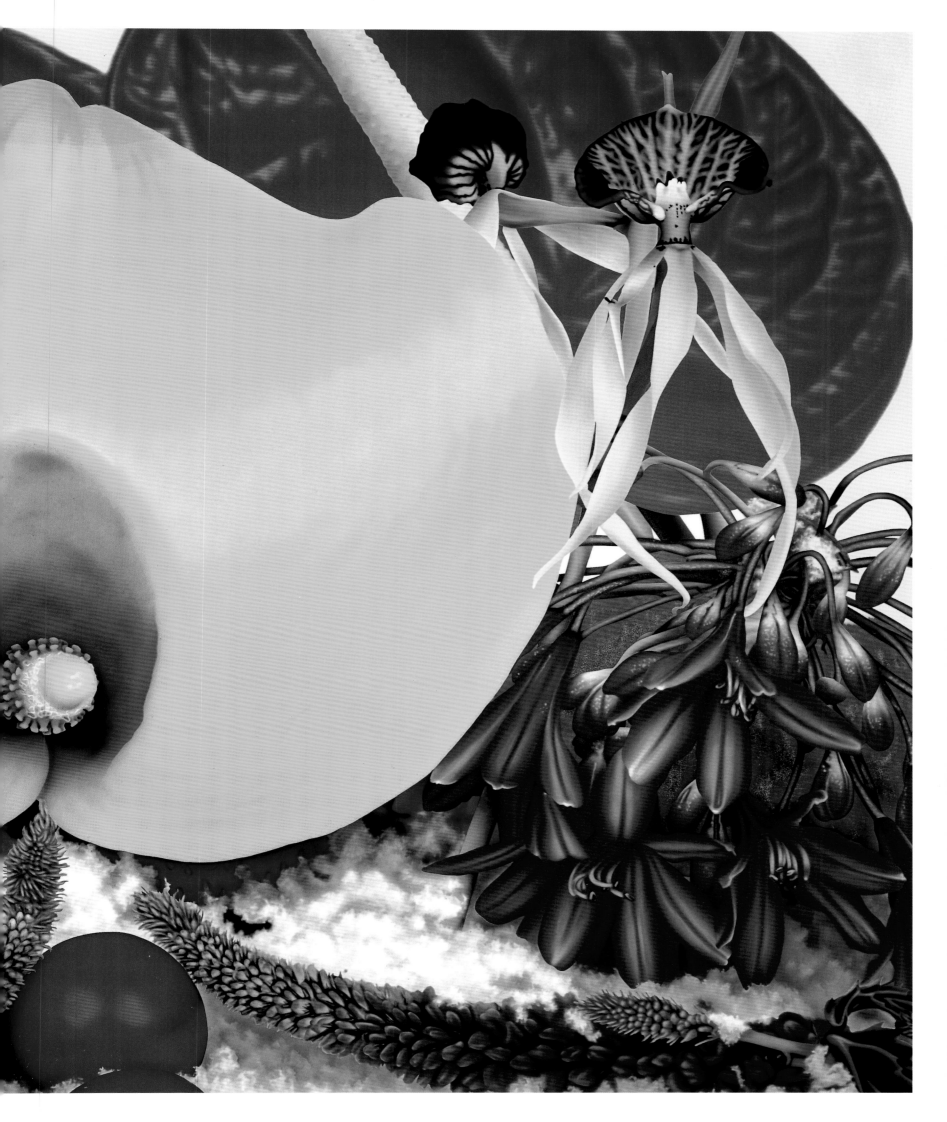

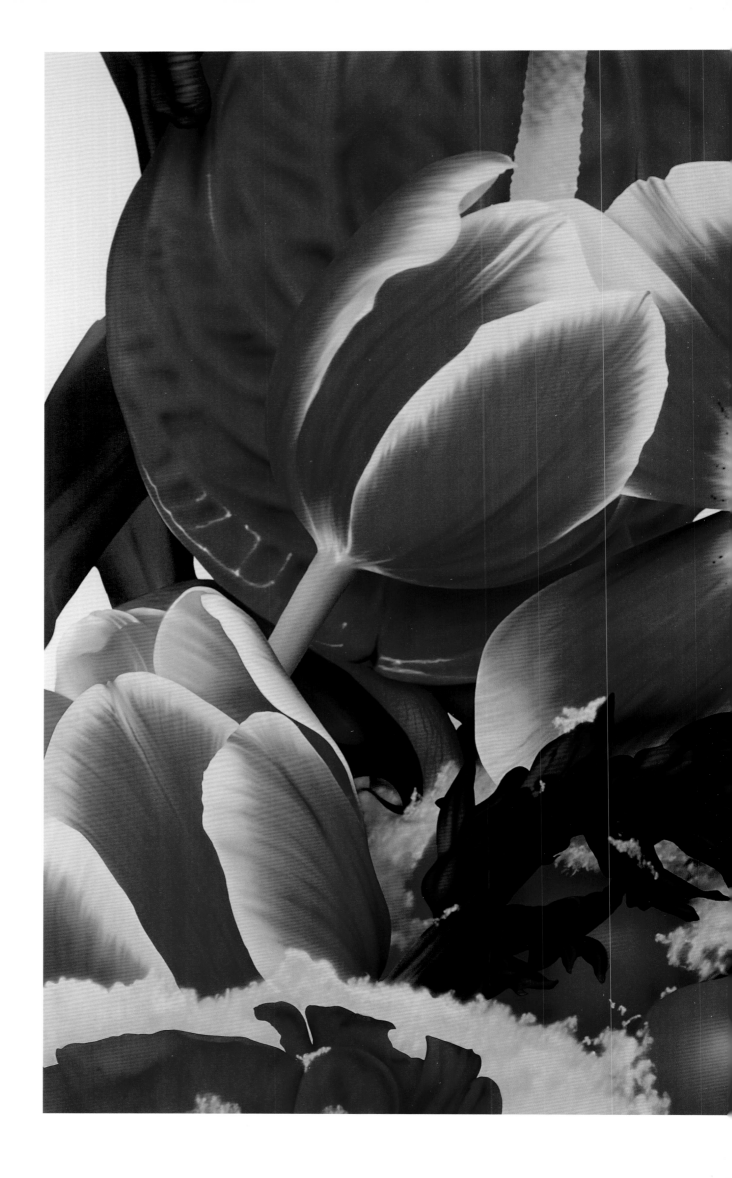

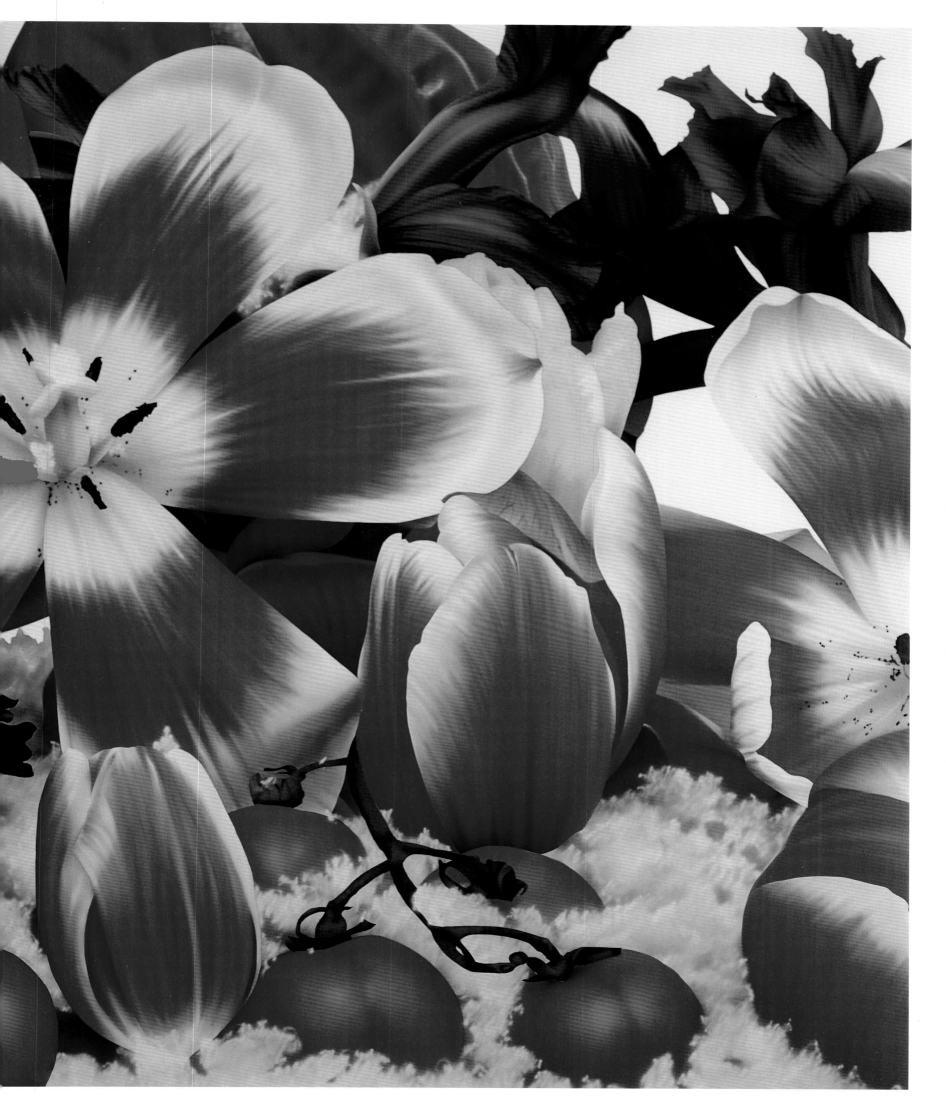

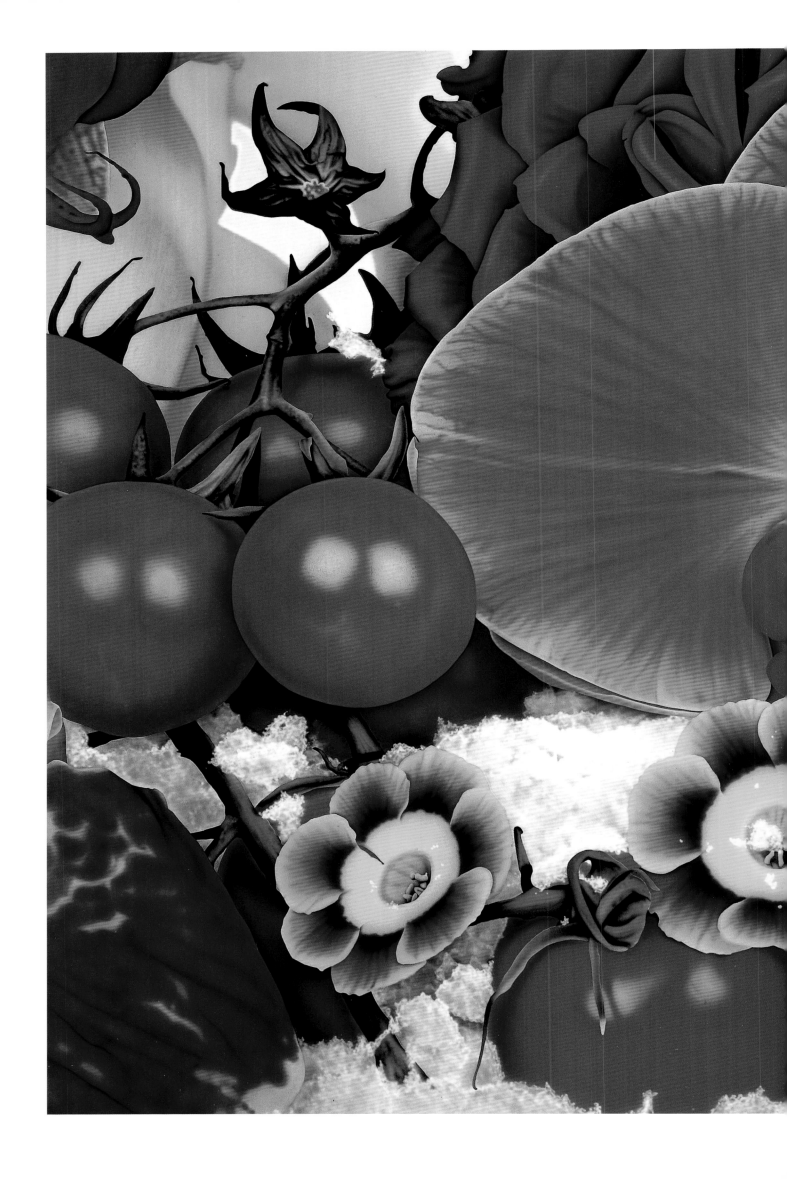

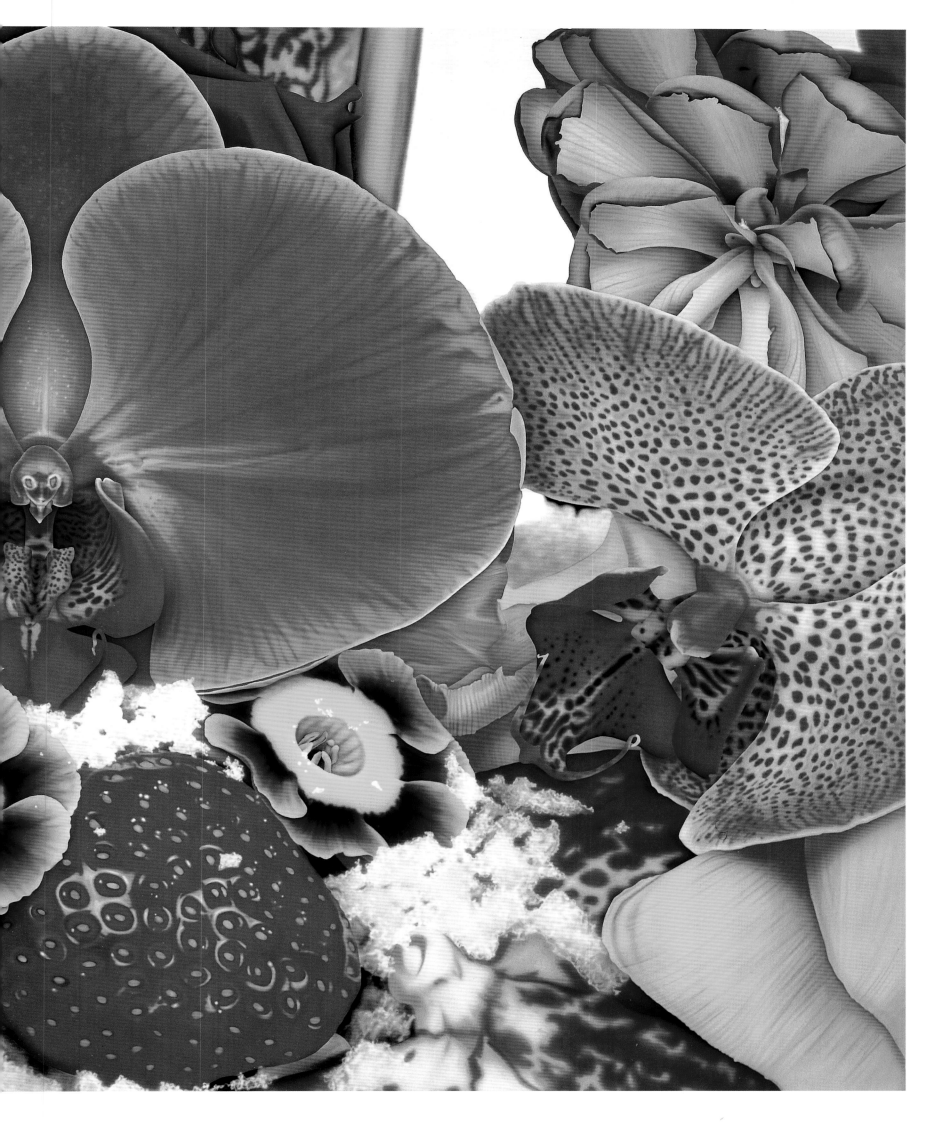